FIGHTING COCKPITS

Dedicated to the late Air Vice-Marshal Ron Dick, RAF (Ret.)

It's just like being in a knife fight in a dirt-floor bar. If you want to fix a fella, the best way to do it is to get behind him and stick him in the back. It's the same in an air fight. If you want to kill that guy, the best thing to do is get around behind him where he can't see you . . . and shoot him."

– *Captain William R. O'Brien, 357th Fighter Group, USAAF*

In the Pilot's Seat of Great Military Aircraft from World War I to Today

FIGHTING COCKPITS

DONALD NIJBOER
PHOTOGRAPHY BY DAN PATTERSON

ZENITH PRESS

CONTENTS

FOREWORD................6
By Eric Brown, CBE, DSC, AFC, Hon FRAeS, RN
Former Chief Naval Test Pilot, RAE Farnborough

INTRODUCTION.................7

1 WORLD WAR I
WIND IN THE WIRES... 8

Nieuport 28 16
Royal Aircraft Factory S.E.5 20
Bristol F.2B 24
Fokker Dr.I 28
Sopwith Camel 32
Sopwith Triplane 36
AEG G.IV 40
SPAD VII 42
Halberstadt CL.IV 44
Fokker D.VII 46

2 BETWEEN THE WARS
THE RISE OF
THE MONOPLANE50

Martin MB-2 56
Hawker Hind 58
Fiat CR.32 62
Boeing P-26 Peashooter 64
Curtiss F9C Sparrowhawk 66
Vought SB2U Vindicator 70
Westland Lysander 72
PZL P.11 76

3 WORLD WAR II
DEATH AT 30,000 FEET..78

Supermarine Spitfire 84
Messerschmitt Bf 109 88
Republic P-47 Thunderbolt 92
North American P-51 Mustang 96
Handley Page Halifax 100
Vickers Wellington 104
Focke-Wulf Fw 190 Würger 108
Fairey Firefly . 112
Fiat CR.42 . 116
Ilyushin Il-2 Šturmovík 118
Heinkel He 219 Uhu 122
Kawasaki Ki-45 Toryū 126
Curtiss SB2C Helldiver 130
Northrop P-61 Black Widow 134
Boeing B-17 Flying Fortress 138
Boeing B-29 Superfortress 142
Dornier Do 335 Pfeil 146
Messerschmitt Me 262 Schwalbe 150
Arado Ar 234 Blitz 154

4 COLD WAR TO THE PRESENT
MUTUALLY ASSURED DESTRUCTION 158

North American F-86 Sabre 164
Boeing B-52 Stratofortress 168
Grumman A-6 Intruder 172
General Dynamics F-111 Aardvark 176
Hawker Siddeley Harrier 180
McDonnell Douglas/Boeing F-15 Eagle 184
Grumman F-14 Tomcat 188
Fairchild Republic A-10 Thunderbolt II 192
General Dynamics/
Lockheed Martin F-16 Fighting Falcon 196
Mikoyan MiG-29 200
Rockwell B-1 Lancer 204
Lockheed F-117 Nighthawk 208
Lockheed Martin F-22 Raptor 212
Lockheed Martin
F-35 Lightning II Joint Strike Fighter 216

BIBLIOGRAPHY 220
ACKNOWLEDGMENTS 222
INDEX . 223

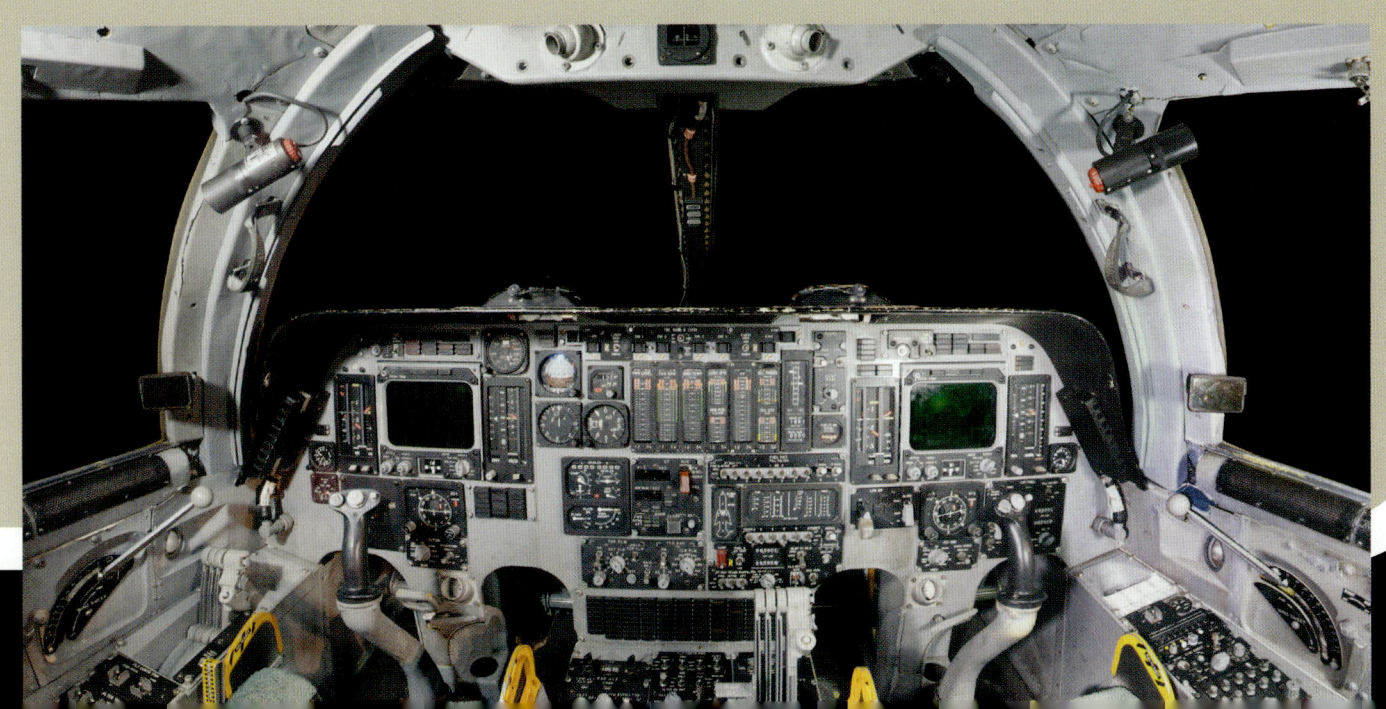

FOREWORD

The first time I approach an aircraft I am about to fly, I size it up by observing its beauty of line to assess aerodynamic cleanliness, then its "sit" to judge if its balance seems right, and next its engine(s) layout to consider if there could be a likelihood of torque or asymmetry problems. However, this is just a visual exercise—my mind is really full of anticipation for what the cockpit will be like, for this is the nerve center of any flight that is to be undertaken.

As a pilot, I look for an "all-round" view: comfortable and easy access to vital controls (control column, rudder pedals, throttle[s], fuel cocks, propeller feathering buttons), ejection methods, and an all-weather instrument panel. These may sound like obvious requirements, but they are by no means always met in the complexity of modern cockpits.

Ergonomics is the study of the application of logic to environmental engineering and had its beginnings in World War II. I remember well the first such practical examples I saw were Germany's Heinkel 219 night fighter and United Kingdom's Martin Baker 5 prototype fighter, but the life of aircraft designers was easier in those far-off days. The modern designer, however, does have the flexibility of computerization to aid in this increasingly difficult task.

In examining the history of cockpit development, Donald Nijboer has divided aviation into four logical eras, and provides a chapter on each of beautifully written and astute observations on almost every aspect of flight and its incredible progress over the last one hundred years.

Nijboer is a master of the rare subject of cockpits, and his cooperation with Dan Patterson, one of the world's leading aviation photographers, guarantees an end product of such quality it will be an asset to grace any aviation buff's bookshelves.

Eric Brown,
CBE, DSC, AFC, Hon FRAeS, RN
Former Chief Naval Test Pilot,
RAE Farnborough

Sublieutenant Eric Brown in the cockpit of his Martlet Mk I (F4F Wildcat) aboard the Royal Navy's first escort carrier, HMS *Empire Audacity*, fall 1941. During the course of three-plus decades, Brown flew 490 different types of aircraft, including almost every major (and most minor) combat aircraft of World War II. He also holds the world record for carrier landings–2,407.
Author collection

INTRODUCTION

The origins for the term "cockpit" are unknown. Some say it was taken from the nautical term for a depression in the deck of a ship for the tiller and helmsman. Another source comes from the bloody sport of cockfighting. According to *Jane's Aerospace Dictionary* the cockpit is defined as "space occupied by pilot or other occupants, especially if open at the top. Preferably restricted to small aircraft in which the occupants cannot move in their seat." That rather dry description doesn't come close to describing the place from which the fighting cocks of the aviation world waged their vicious battles.

The fighting cockpit was never designed for comfort or pleasure. From the canvas and wood structures of World War I to the high-tech all-glass cockpits of today, the cockpit remains a solitary, mysterious, and dangerous place.

From the very beginning of air combat, the cockpit was one of the last parts of the aircraft to which designers turned their focus. Their concerns were engine power, armament, and aerodynamics. The pilot had to go somewhere and it was almost always over the center of gravity. For World War I pilots, the cockpit was composed of nothing more than a wicker seat, canvas sides, a control column, rudder pedals, one or two instruments, and a machine gun. It was a cold, noisy, unforgiving space. Here, the pilot's biggest fear was being burned alive. Many carried a pistol, and parachutes weren't used until the end of the war and then only by the Germans.

The 1930s saw the advent of the all-metal monoplane fighter and bomber. With its enclosed cockpit pilots reached new speeds and heights unimagined just a few short years before. They were also in greater danger—the cockpit was a more cluttered space with myriad instruments and controls. Little thought was given as to how a good functioning cockpit should work. Pulling the wrong lever or bumping a switch often meant a crash landing or worse.

During World War II the cockpit had developed to some degree, but most of the designs were still from the 1930s. A Battle of Britain Spitfire pilot would find few surprises in a 1944 P-51 or Tempest.

Fighter pilots have often described "bonding" with their aircraft—sitting snuggly in the cockpit and having the feeling of being one with their fighter. That snugness, however, had more to do with the structure of the aircraft and not the cockpit design. A streamlined Spitfire with its liquid-cooled Merlin had a slender fuselage and thus a tight cockpit. The P-47 Thunderbolt, with its giant R-2800 Double Wasp radial engine, had a more commodious front office.

The advent of jet combat, with the introduction of the Gloster Meteor Mk I and Messerschmitt Me 262 in 1944, ushered in a new era of military aviation. From the 1950s onward aircraft performance improved at a rapid rate and aircraft systems kept pace by becoming more complex. A pilot's workload increased and multirole aircraft only complicated the situation. Little thought was initially given to ensure the pilot/machine interface was properly designed. Accident rates were high, and most were attributed to pilot error.

Years would pass before designers turned their attention to the idea that pilots and aircrew had to be aware at all times of what their aircraft was doing both inside and outside the cockpit, or that the instruments and controls inside had to be logically arranged. Only then could flight and engine information be easily and quickly accessed, allowing for sensible and rapid decisions.

Today's modern fighter cockpit is a marvel of technology. Innovations like the heads-up display (HUD), multifunction display (MFD), hands-on throttle and stick (HOTAS), and forward-looking infrared (FLIR) have made the cockpit easier to fly and fight in. Digital computers do most of the flying. As F-22 pilot Lt. Col. Clayton Percle explains, "You're basically a voting member. You don't have the final decision."

This book is divided into four distinct periods of aviation, and each chapter introduction describes the evolution of the cockpit. Through Dan Patterson's amazing photographs we get to see this transformation up close, from the Blériot to the F-35. We also hear firsthand accounts from the "world's greatest pilot," Capt. Eric Brown RN (Ret.), as well as from combat veterans, test pilots, instructors, and current warbird pilots who describe what it's like to be in the cockpits of these amazing aircraft. The result is a rare intimate glimpse of what it must have been like to fly in some of the most feared and famous combat aircraft ever built.

CHAPTER ONE: WORLD WAR I
WIND IN THE WIRES

On August 4, 1914, German troops set foot on Belgian soil. Treaty-bound France, Britain, Italy, Austria, and Russia were irrevocably committed, and all of Europe was officially at war. It would be a war of extremes—of mud, mass slaughter, and stalemate; of technological marvels, and of the birth of a new type of warrior. Barely eleven years after the Wright Brothers took their first flight, this new war would take to the skies.

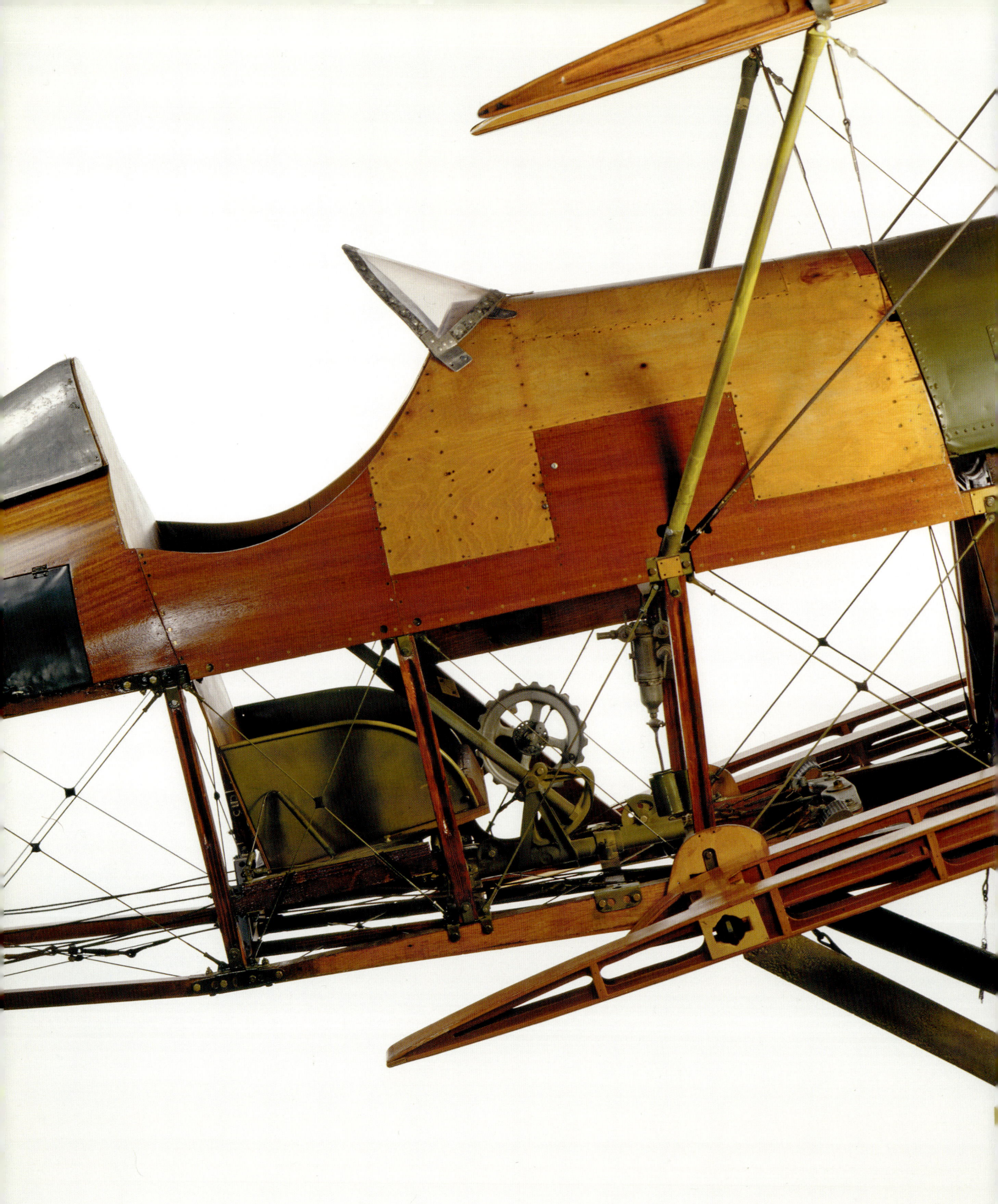

Army commanders on both sides believed the coming confrontation would be a land campaign. Air power, still an unknown, would play a minor role at best. Early experiments in 1910 had proven that the best role for the airplane would be reconnaissance. French army maneuvers in 1911 consistently showed that airplanes could locate enemy troops some 37 miles (60 kilometers) away.

After every war soldiers of all stripes disparage the generals and politicians for their lack of foresight and inability to properly prepare for the next war. The newly minted airmen of World War I drew especially bitter pleasure from this pastime. Often-repeated stories focused their venom on the great men who had dismissed the importance of the aeroplane. Britain's generals Sir William Nicholson and Sir Douglas Haig suggested before the war that aircraft would never be of any use to the army. In truth, however, the major world powers had already begun to build up their air forces with remarkable rapidity shortly before the opening of hostilities.

In August 1914 the nations of Europe mobilized more than six million men for battle. That total, however, included fewer than two thousand pilots and one thousand aircraft. The fragile wood-and-canvas open-cockpit planes that dominated both sides at the beginning of the war were all spectacularly slow. The Blériot XI, made famous by Louis Blériot when he flew across the English Channel in 1909, equipped seven British, eight French, and six Italian squadrons at the outbreak of war. For all its fragility, the Blériot XI was leading-edge technology. Cockpit "instrumentation" consisted of a watch and a map of the flight route rolled onto a scroll. Airspeed and altitude were left to the pilot's judgment.

What set the Blériot apart from its contemporaries was its flight controls. Rather than the prone position the Wright Brothers used in their *Flyer*, Blériot put the pilot in a sitting position and equipped him with left and right foot pedals to control the rudder and a single control stick (joystick) between the pilot's legs that moved forward and back, causing the nose to pitch up or down. It's a system that is used to this day.

Advanced as the Blériot was, it still represented stagnation in aircraft design. All design choices had tradeoffs in performance. A long-range aircraft needed to be large to hold more fuel and offer more for long-duration flights. To be fair, most airplane designers still had only a vague idea of how to design an airplane for a specific military job. In fact, they had no idea what types of aircraft would be needed for the upcoming war. Fighters and bombers didn't exist, and most believed aircraft would be used for reconnaissance only.

The focus on aircraft design and engine development left little time for the evolution of the cockpit. What the pilot needed to command his machine and what he had to endure while flying were afterthoughts. Throughout World War I designers were busy mastering the art of aircraft weight distribution. Critical items such as guns, bombs, fuel, and crew had to be carefully judged and applied to any new design. For example, the Sopwith Tabloid weighed less than 1,200 pounds (544 kilograms). The engine accounted for 38 percent of that weight; the airframe for 30 percent; and the fuel for 15 percent. The remaining 17 percent was allocated for the pilot and camera or armament. The cockpit—including its equipment and instrumentation—had to be simple and light

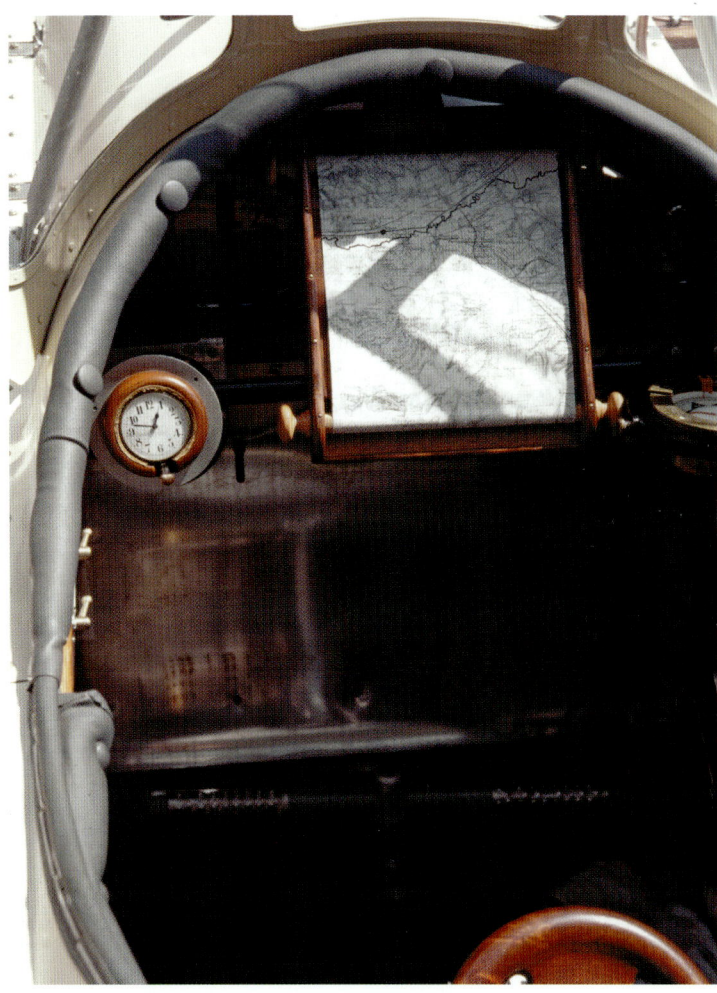

ABOVE: Blériots were widely used by the Allies at the outbreak of World War I. Instruments were unheard of in early aircraft and the Blériot was no exception. A watch and a map rolled onto a scroll were the pilot's only aids. Height and speed were left to the airman's judgment.

OPPOSITE PAGE: An S.E.5a cockpit section revealed. This simple, wire-braced, box-girder wooden construction was typical for a World War I scout.

In Britain the Royal Aircraft Factory led the way in designing, testing, and building most military aircraft. For reconnaissance the Royal Aircraft Factory believed the slowest possible speed an airplane could be made to fly was best. It seemed counterintuitive and as a result the Royal Flying Corps would use the Royal Aircraft Factory B.E.2 as their principal machine for the first two years of the war. Equipped with two open cockpits, it had a top speed of about 75 miles (121 kilometers) per hour and took more than half an hour to climb to 10,000 feet (3,048 meters). Cockpit instrumentation was sparse with just a clock, altimeter, and engine rev counter (tachometer). While inherently stable it was an unmaneuverable craft that made easy fodder for early German fighters. Baron Manfred von Richthofen (also known as "the Red Baron") feasted on the slow-flying B.E.2, which accounted for twenty-five of his eighty victories. The German equivalent of the B.E.2 was the Taube monoplane. Powered by a 120-horsepower Mercedes six-cylinder engine, it had a top speed of 62 miles (100 kilometers) per hour.

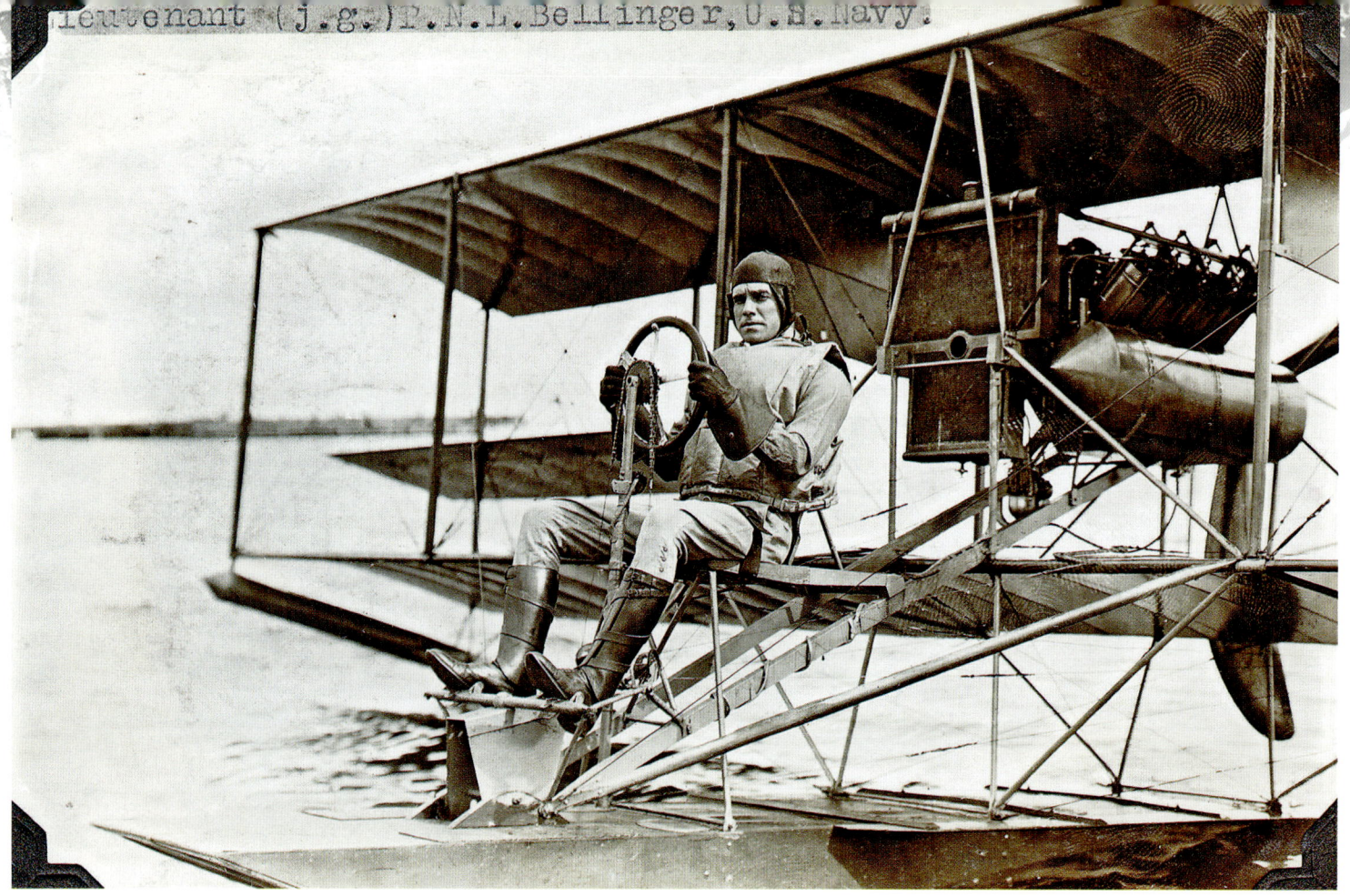

Many early aircraft had no cockpit whatsoever. Patrick N. L. Bellinger, naval aviator No. 8, is pictured in a Curtiss A1 seaplane in 1915. The A1 had no fuselage or canvas protection for the pilot; he sat exposed to the elements, with just a safety belt and life preserver as lifesaving equipment. *National Naval Aviation Museum*

Flying during World War I was a physically demanding job. Very little was available, via cockpit design, to mitigate the situation. The airstream in an open cockpit could be brutally cold, especially during winter. Frostbite was common, forcing pilots to smear their faces with thick layers of grease for protection, and heavy clothing was also mandatory. Pilots flying at high altitudes often suffered from dizziness and blackouts. In addition, rotary engines sprayed castor oil into the airmen's faces, often inducing chronic nausea and diarrhea.

Physical exertion was constant for the pilot, with the rotary engine–powered aircraft being the most punishing. The gyroscopic force of the engine had to be continuously countered in order to maintain straight and level flight. There was no equipment or instrumentation to relieve the discomfort.

And while pilots experienced the joy and grandeur of flight, they also faced death in particularly gruesome manners. The odds of a pilot dying, becoming injured, or being captured was no better than fifty-fifty. If not killed outright by an explosive or incendiary bullet, the biggest fear was death by fire. Exposed fuel lines and gas tanks were almost always fitted in front or above the cockpit. An airman caught in a burning machine had three options: jump, stay and burn to death, or shoot himself with a revolver. For some, however, there was a lifesaving solution.

Parachutes had existed since the end of the eighteenth century and were used for exhibition jumps from balloons. In 1912 jumps from aircraft proved successful, and during the war parachutes were issued to airship and kite balloon observers. The Germans eventually adopted the parachute for airplane pilots, but the British never did (their pilots were given a revolver—not exactly a morale-boosting device). The *Deutsche Luftstreitkräfte* (German Air Force) began issuing parachutes to pilots and observers in the spring 1918. By that summer Allied pilots watched with envy and consternation as German pilots jumped from their burning machines and parachuted slowly and safely to earth. The Allies' disregard for the parachute was criminal. Not a single Allied aircraft parachute was issued during the war.

Before the war aircraft typically had no more than one or two flight instruments in the cockpit. During the war few aircraft had more than seven: airspeed indicator, altimeter, bubble lateral level, compass, fuel-pressure gauge, pulsometer for monitoring engine performance, and clock. But as the war progressed more controls, equipment, and switches were added.

Aerial reconnaissance—observation and artillery spotting—were the prime missions flown by both sides in the early stages of World War I. In a few short months these missions became indispensable, which meant a new task for the pilot. Box cameras were mounted vertically to the starboard outsides of cockpits, allowing the pilot to change glass plates while in flight. Entire attack and artillery-fire plans were meticulously formulated based on the photographic evidence gathered by airmen—and that's when the shooting started.

World War I aviators soon realized they could do more than simply wave as they passed one another in the air. Some wasted no time in trying to shoot down their foes. Pistols, rifles, and even hand grenades were soon brought aloft but with mixed results. What began as something of a game suddenly took on a more serious military purpose. By 1915 the British General Staff reported that aerial "fighting would be necessary on an ever increasing scale to secure liberty of action for

our artillery and photographic machines, and to interfere with similar work on the part of the enemy." The fighter plane was born.

The world's first true fighter aircraft appeared in the form of the German Fokker E.I monoplane. A new piece of equipment was introduced into the Fokker cockpit, and on August 1, 1915, soon-to-be-ace Max Immelmann scored the first success with it. What set the Fokker E.I apart from all Allied armed aircraft was its synchronized machine gun firing between the propeller blades. The Fokker's single 7.92-millimeter LMG 08 machine gun, which was mounted on the cowling directly in front of the pilot, also solved another problem: aiming. Many airmen were convinced that the most efficient way to point a gun in the air was by having the plane itself do the aiming. The Fokker proved them right, and the fighter arms race was on. When future high-scoring ace James McCudden encountered the *Eindecker* (monoplane) for the first time he was impressed.

By 1916 Allied aero-engine manufacturers had finally hit their stride. The persistent calls for larger engines were being met. New fighters like the British S.E.5a, powered by a 200-horsepower engine, and the French SPAD XIII pushed top speeds above 130 miles (209 kilometers) per hour. The cockpit also evolved. More equipment was added, all designed to aid the pilot in his deadly task.

While the British cockpits were well furnished, their German counterparts had a more spartan appearance. Germany's best fighter, the Fokker D.VII, had fewer instruments and controls, but it introduced artificial horizon and round counters for the machine guns. The cockpits of French fighters and two-seaters fell somewhere in between.

For fighter pilots the cockpit offered a new and different place from which to kill. For the soldier on the ground, the killing was indiscriminate and could come at any moment—actually seeing an enemy soldier was extremely rare. Air combat, however, was at close range, brief, and with no apparent physical carnage. Unlike ground soldiers, who fought in units, most pilots believed that they alone controlled their own destiny.

It quickly became apparent that flying and fighting required a specific set of traits. One had to first overcome fear, but more importantly, one had to be truly fearless. In each squadron there were always a small number of pilots who did most of the scoring. Available data suggests that no more than a few percent of fighter pilots shot down more than half of all enemy aircraft accounted for. It was during these air battles that the "aces" were born. Glorified for their abilities, men like William "Billy" Bishop, William "Billy" Barker, Manfred von Richthofen, Max Immelmann, Edward "Mick" Mannock, and René Fonck became the war's first aviation celebrities, the chivalrous "knights of the sky."

> **Fighting in the air is not sport. It is scientific murder.**
>
> —*Capt. Eddie Rickenbacker, American ace*

TYPICAL COCKPIT CONTROLS
CIRCA 1918

By 1918 the cockpit of a typical British fighter was equipped with most of the following instruments and controls:

- Ring-and-bead sight
- Aldis sight
- Signal pistol
- Foster mounting for Lewis gun
- Foster mounting unlocking pull ring
- Arming lever for Vickers gun or guns
- Triggers on control column for Vickers and Lewis guns
- Starter magneto
- Ignition switches
- Tail-trimmer
- Sutton harness
- Wicker seat
- Oxygen mask
- Oxygen-supply valve
- Airspeed indicator
- Altimeter
- Inclinometer
- Oil-pressure gauge
- Fuel-pressure gauge
- Pump handle for Constantinesco-Colley interrupter gear (gun synchronization)
- Fuel-system selector cocks
- Fuel-pressure release cock
- Fuel-tank pressure pump handle
- Compass
- Clock
- Throttle

NIEUPORT 28

Nieuport 28 C.1 | National Museum of the US Air Force | Replica

Designed by Gustave Delage for the Société Anonyme des Établissements Nieuport, the small Nieuport 28 was a highly maneuverable rotary-engine fighter. Built to replace the successful Nieuport 17, it had a more powerful engine, twin Vickers machine guns (which were offset to the left and could fire through the propeller), and a new wing structure. For the first time a Nieuport fighter was fitted with conventional two-spar wings instead of the sesquiplane V-strut found in the Nieuport 11 and 17. Ailerons were fitted to the lower wings and several dihedral settings for the top wing were tested. Several prototypes were built and evaluated with different engines, including the 300-horsepower Hispano-Suiza 8Fb, the 170-horsepower Le Rhône 9R, the 275-horsepower Lorraine-Dietrich 8Bd, and the 200-horsepower Clerget 11E.

Ultimately fitted with the rotary 190-horsepower Gnome Monosoupape 9N, the Nieuport had a top speed of 123 miles (198 kilometers) per hour, but like all rotary engines the 9N was notoriously thirsty and had limited operational life. Never considered a great fighter, the Nieuport 28 was rejected by the French Air Service in favor of the SPAD VII and XIII.

When the United States entered World War I, it had no combat aircraft whatsoever. Though eager to acquire the SPAD VII and XIII, the Americans had to settle for the Nieuport 28 instead, purchasing 297 aircraft that were sent to the 94th and 95th Aero Squadrons in March 1918. Four more pursuit squadrons followed, along with the first air-to-air victories. On April 14, 1918, two pilots from the 94th each shot down an enemy aircraft over their own airfield at Gengoult. Future American aces began their careers flying the Nieuport 28, including twenty-six-victory ace Capt. Eddie Rickenbacker. Between April 29 and May 30, 1918, he shot down six enemy aircraft flying the Nieuport 28 before transitioning to the SPAD XIII.

Unfortunately for the Americans, the Gnome Monosoupape rotary engine proved unreliable and caught fire easily. Structural problems emerged with the top wing as well. When pulling out of a sharp, speedy dive, the leading edge of the top wing would break away, taking most of the fabric with it. Another problem was the absence of a throttle. All rotary engines were controlled by means of a "blip" switch, which had two settings: flat out or stopped. First Lieutenant Louis Simon of the 147th Aero Squadron reported, "The Nieuport 28 has the rotary motor and is the hardest to fly in formation with because you can't regulate your speed. . . . In those with stationary motors, formation flying is much easier because of not having to 'S' so much."

By the end of August 1918, all four American squadrons were fully equipped with the more powerful and superior SPAD XIII.

PILOT IMPRESSIONS
Andrew King, Aircraft Restorer

I've been around World War I aircraft since I was five years old. I learned to fly before I could drive and the first biplane I flew was the de Havilland Tiger Moth. Over the years I've flown a variety of World War I aircraft: the Fokker Triplane, Fokker D.VII, Nieuport 17, Sopwith 1½ Strutter, and of course the Nieuport 28.

Flying the Nieuport 28 is an awesome experience mostly due to the engine. It's loud. The Monosoupape rotary is easily the loudest engine of World War I. As a low-speed engine, it doesn't have an idle speed on the ignition selector. From idle to full power is extremely quick. On takeoff that's a lot of horsepower and torque at the same time. It really pushes you back into your seat.

Both the Nieuport 17 and 28 have some of the smallest World War I cockpits. I'm 6 feet 2 inches and about 220 pounds (188 centimeters and 100 kilograms), so the Nieuport 28 is pretty tight. As far as can I tell, the Nieuports came out of the factory with just a tachometer and pulsator glass. In the field, pilots tended to add compasses, altimeters, clocks, and other things. It seems to be a

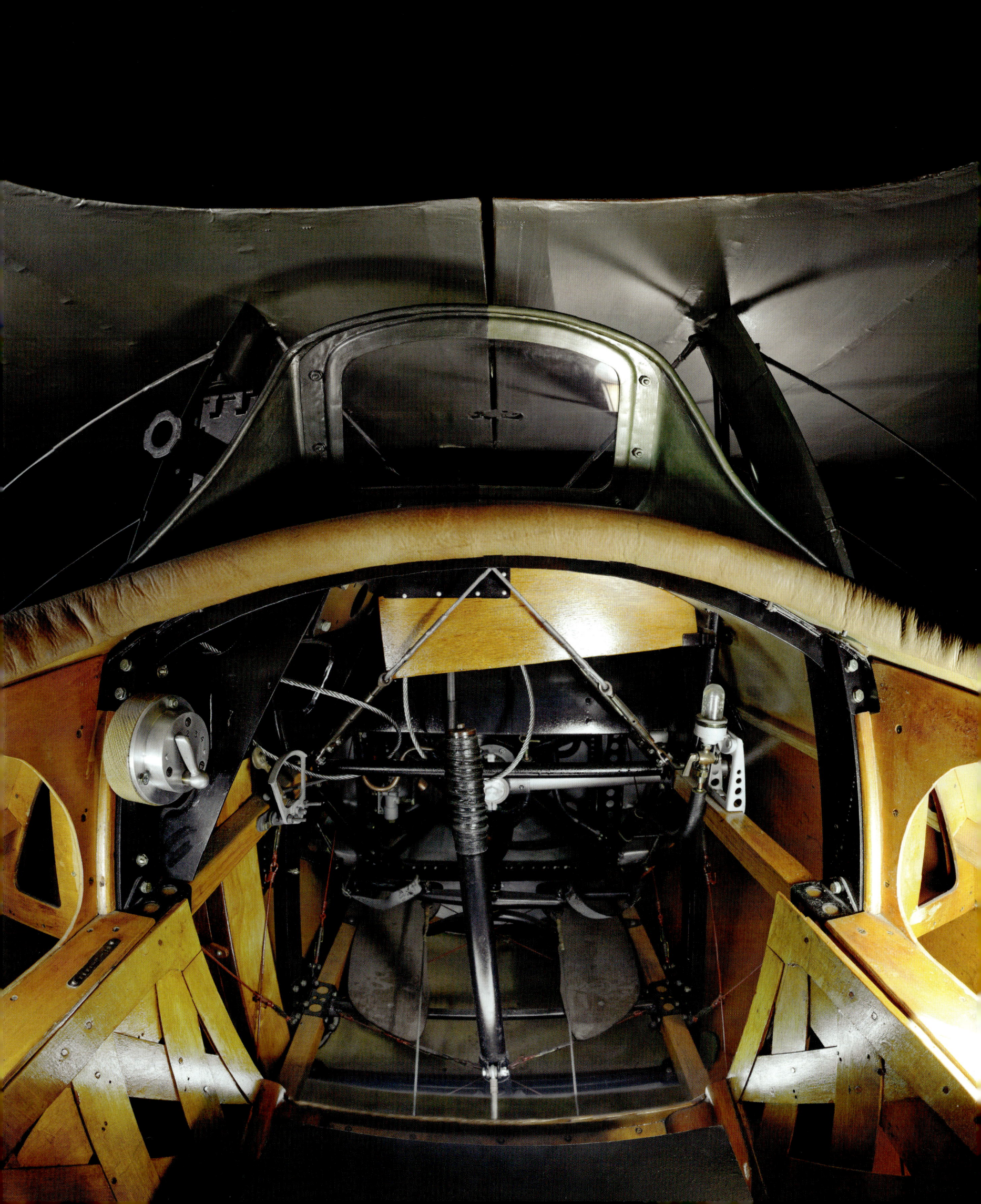

ABOVE: Nieuport 28s of the 95th Aero Squadron ready for another patrol. The United States purchased 297 Nieuport 28s, and four squadrons flew them operationally from March to August 1918. *National Museum of the USAF*

OPPOSITE PAGE: High-speed dives in the Nieuport 28 could rip the fabric from the upper wing. Here a young pilot from the 94th Aero Squadron poses in front of his heavily damaged 28. *National Museum of the USAF*

nationality thing—both the French and the Germans didn't seem to care much about instruments.

The Nieuport cockpit was fairly well laid out with the throttle on the left side. It's a simple environment with very few instruments. Interestingly, the British were far more into instruments and dashboards.

The view from the Nieuport 28 isn't too bad, but as a biplane the lower wing is always going to block out a good portion of your view. A lot of World War I fighters had the top wing located close to the fuselage in front of the pilot. That allowed the pilot to have a better view up and forward. The Nieuport 28 had dihedral in the top wing so the center section was lower than the wing tips. I don't know why they did that but it does contribute to a better view.

Most World War I airplanes fly alike. For the majority, the ailerons don't work very well and are fairly heavy. Generally speaking, the rudder and the elevators are, by modern standards, too big, sensitive, and powerful. The Nieuport 28 shares those characteristics. The ailerons are heavy, but they work okay. In combat it would've been a real workout to fly and fight the Nieuport 28. It's also tail heavy. I'm not sure if that's on purpose, because the more tail heavy an airplane is, the more maneuverable it becomes.

I like the Nieuport 28. The World War I pilots who flew it liked it as well. It was a formidable airplane. They had problems, of course, with the wing fabric and wing failures, but as far as performance and flying qualities, both American and French pilots thought highly of it. When it came time to trade in their Nieuports for the new SPAD, many pilots simply refused. Apart from the structural failures in the upper wing, I think they would have built a lot more Nieuport 28s and used them more extensively.

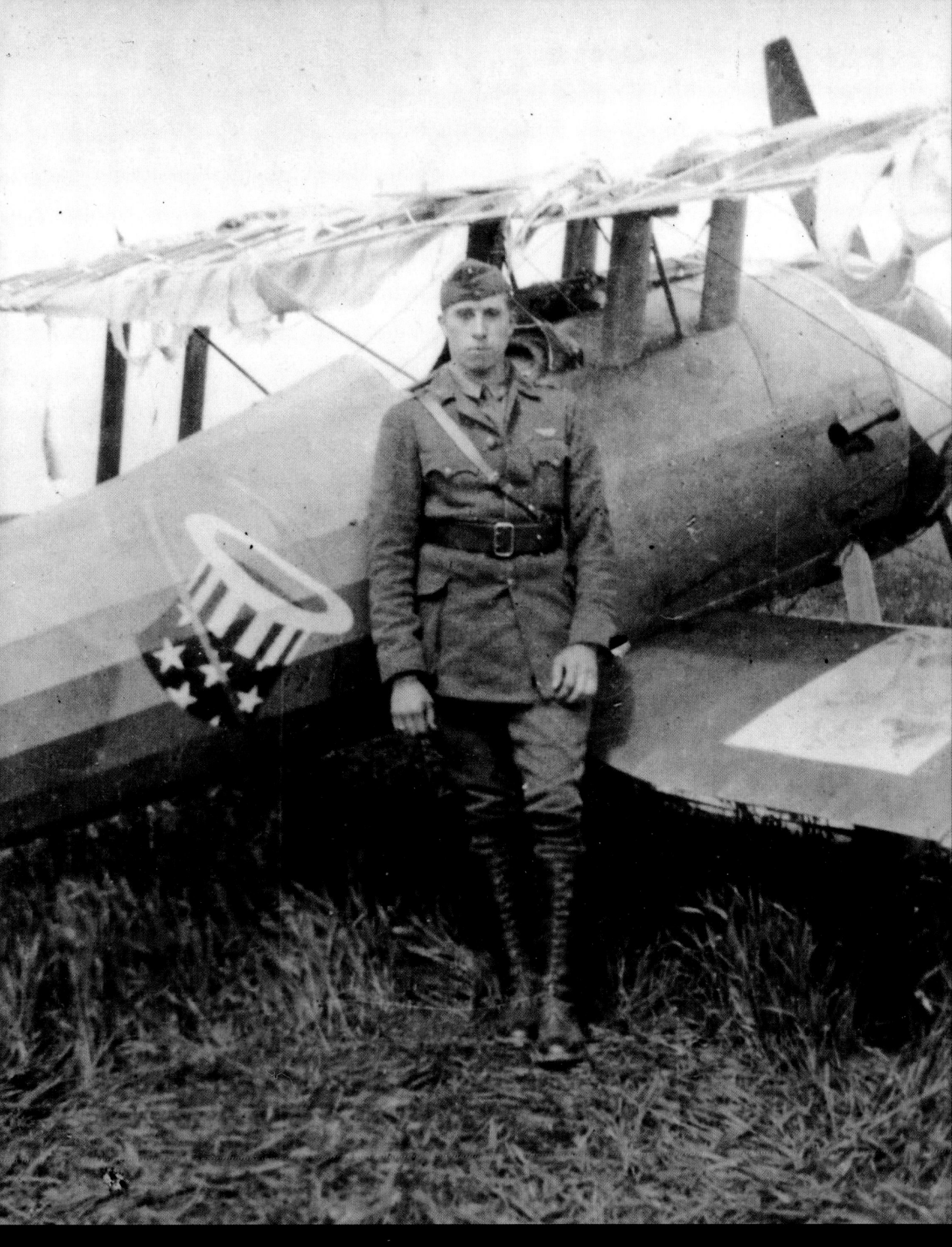

ROYAL AIRCRAFT FACTORY S.E.5

Royal Aircraft Factory S.E.5a Scout | Musée de l'Air et de l'Espace | Original restored

While the Sopwith Camel was more famous, the Royal Aircraft Factory's S.E.5 was arguably the best British-built fighter of World War I. Compared to the squat, light, and agile Camel, the S.E.5 was all angles and squares, and heavy by comparison. These were virtues, however, and meant the less nimble S.E.5 was easier to fly, could out-dive and outclimb the Camel, and it could sustain more battle damage. It also could withstand high-G maneuvers and remain intact, and was much more stable in flight than the Camel. Its only failing was its Hispano-Suiza 8A engine, which proved highly unreliable.

Captain James McCudden of No. 56 Squadron claimed more than fifty victories with the S.E.5 and S.E.5a. In July 1917 he praised the machine in his diary following his first patrol in one:

> The S.E.5 was a most efficient fighting machine—far and away superior to the enemy machines of that period. It had a Vickers gun shooting forward through the propeller, and a Lewis gun shooting forward over the top plane, parallel to the Vickers, but above the propeller. The pilot could also incline the Lewis gun upward in such a way that he could shoot vertically upwards at a target that presented itself.
>
> Other good points of the S.E.5 were its strength, its diving and zooming powers and its splendid view. Apart from this, it was most warm, comfortable and an easy machine to fly.

When first issued to No. 56 Squadron in March 1917, the new S.E.5s were equipped with a large "half-greenhouse" windscreen that enclosed half of the forward cockpit area. Most of the pilots in the squadron considered it cumbersome and a danger in a crash. Before the squadron moved to France, the "glasshouse" was discarded and replaced with a more standard windscreen.

No fewer than 5,125 S.E.5s and S.E.5as were built in just eighteen months. They served in twenty-two British and American squadrons on the western front.

PILOT IMPRESSIONS
"Dodge" Bailey, Chief Pilot of the Shuttleworth Collection

You mount the S.E.5a like horse: left foot in the stirrup on the bottom longeron and step up reaching for the Foster mount of the Lewis gun. When climbing in and out of the cockpit, you have to be careful not to apply too much weight to the cockpit edges, which are of light plywood construction. You also need to avoid banging your head on the Foster mount.

When I first strapped into the S.E.5a cockpit, I thought it was pretty good—a bit tight on the shoulders for some, depending on their back length, but it all feels about right. Common to all World War I aircraft of my acquaintance, there is no seat or rudder adjustment. If you cannot reach anything, seat cushions may help.

The primary flight controls, spade grip stick, and rudder bar are well positioned. Immediately ahead of the stick is the inclinometer (lateral level) intended to assist in balancing turns. Longitudinal trimming is achieved by adjusting the incidence of the tailplane using a large indexed wheel to the left of the seat. You should not attempt to move this when you're in the cockpit on the ground. It will strain the mechanism. You have to make sure it's full and free and set it to take off before boarding.

The throttle and compensator (mixture control) are on the left side where you would expect to find them. The throttle moves in the conventional sense. We don't need to alter the compensator, but it's arranged in the British manner, i.e., rich to the rear. An interlock plate is designed to return the mixture to rich as the throttle is shut. Above the throttle quadrant are the radiator shutters. On the instrument panel there is a fuel selector and adjacent to this is the air exchange, which allows the pilot to manage the delivery of air pressure to the main fuel tank. The fuel has to be pushed from the main tank to the engine by air pressure in the top of the tank. There is a small emergency tank up in the center section, which gravity feeds the engine should the main supply

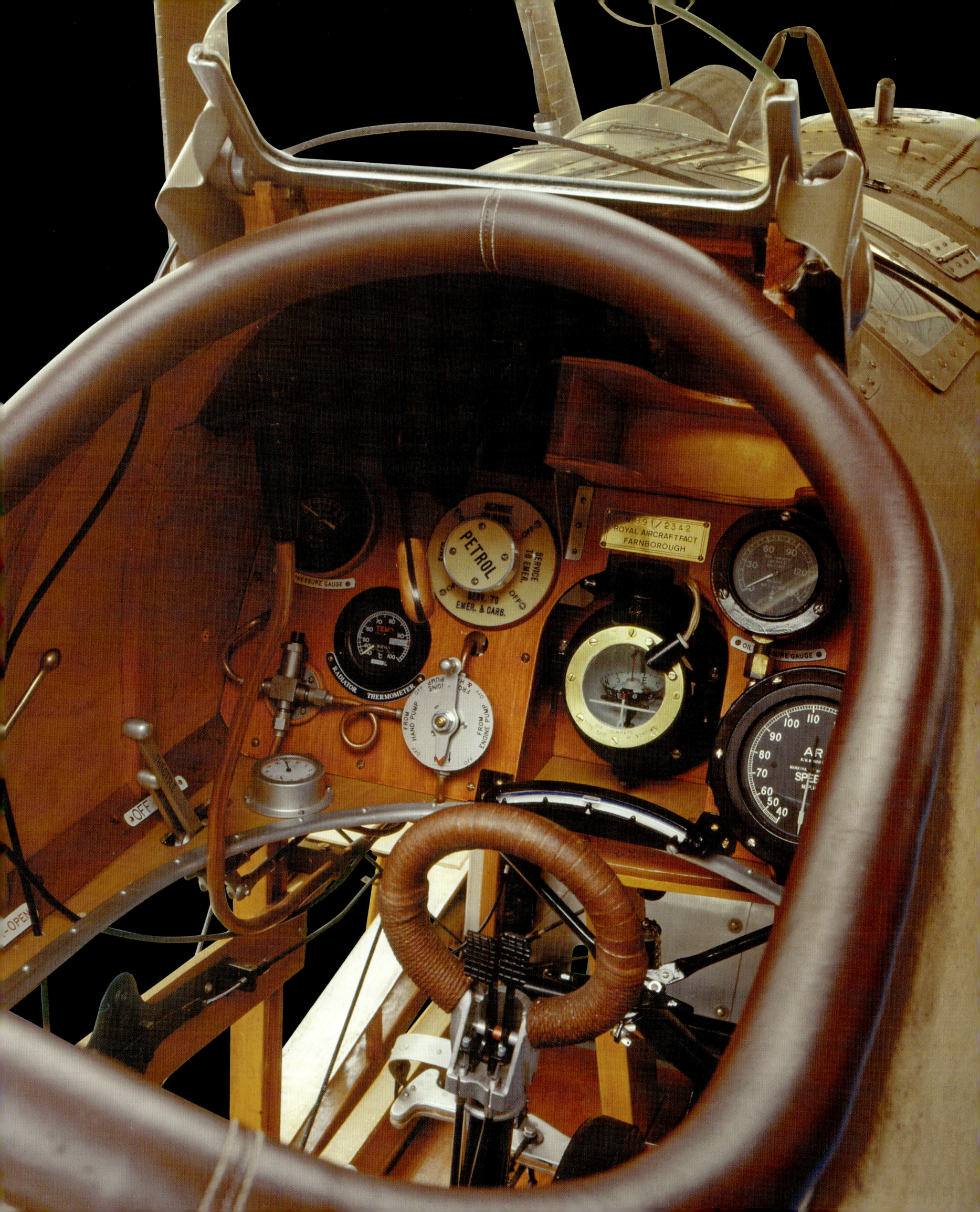

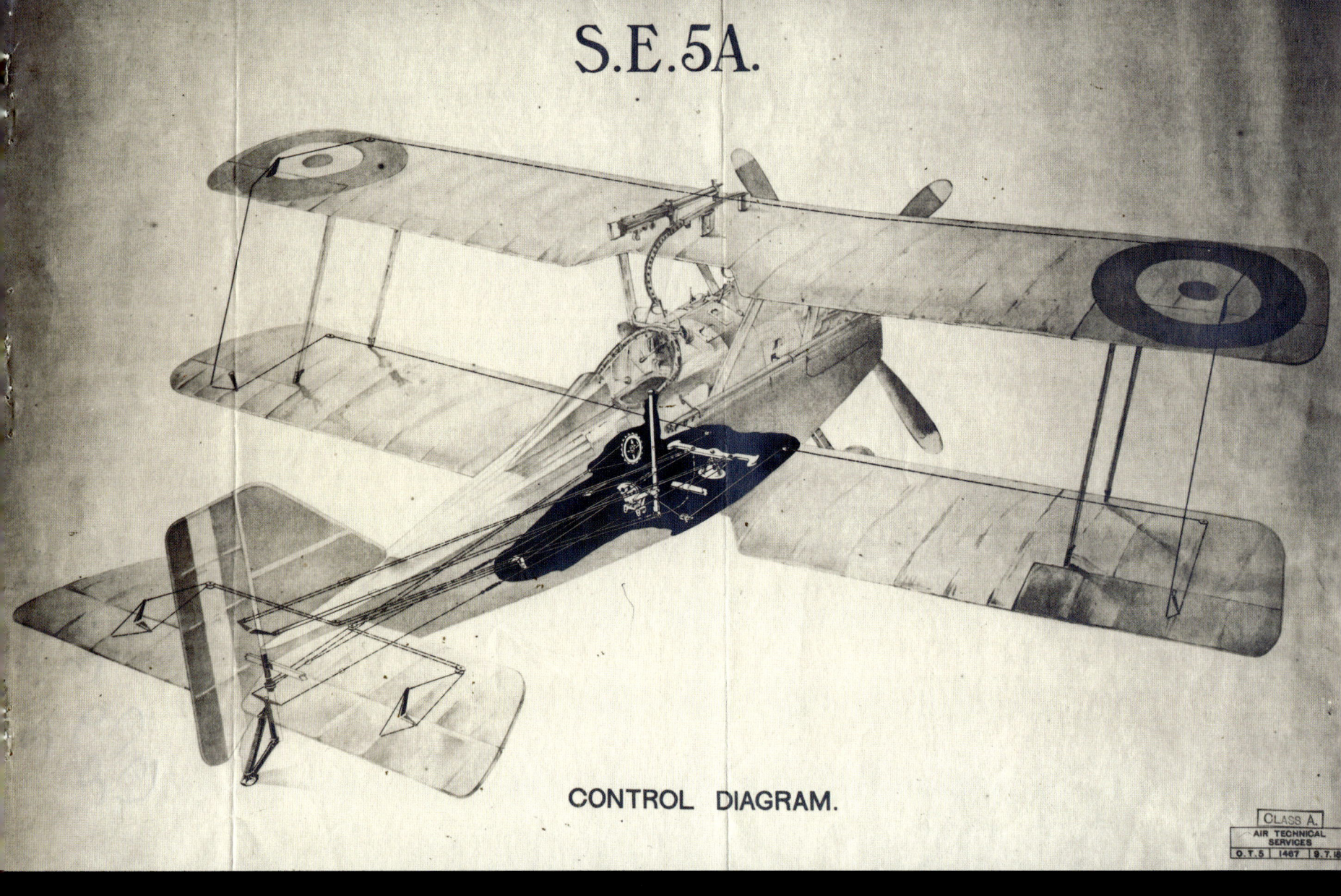

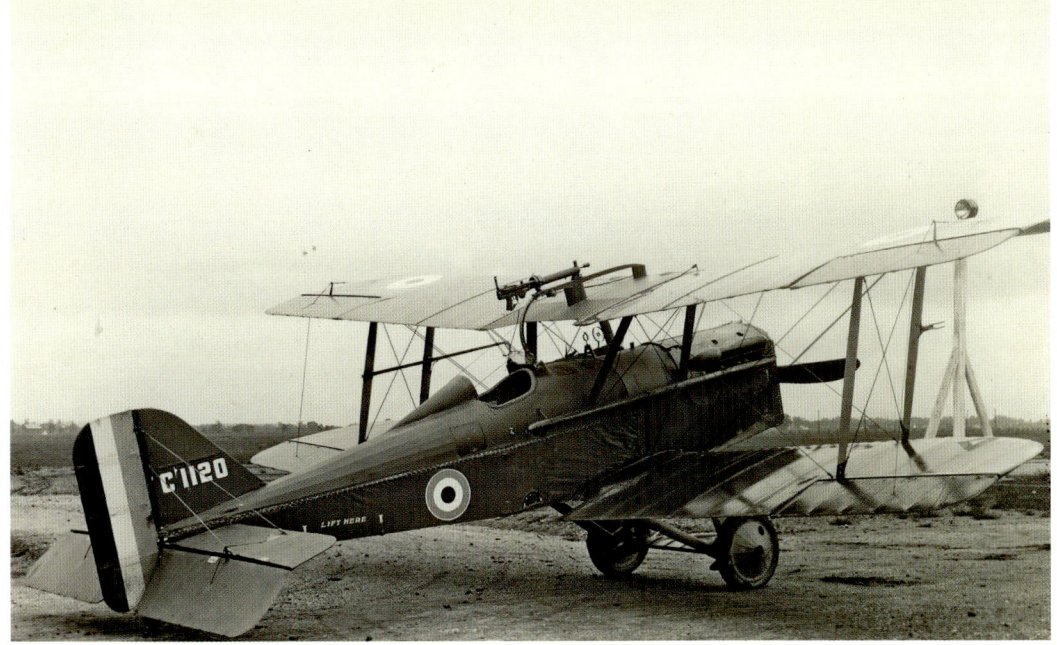

LEFT: he S.E.5/5a was a muscular, angular fighter. Fast, strong, and well armed, it was flown by 217 aces with no fewer than 20 of them scoring more than twenty victories. *National Museum of the USAF*

BELOW: Strong in design and construction, the S.E.5A was an excellent gun platform. Not quite as maneuverable as the Sopwith Camel, it was nonetheless one of the fastest aircraft of World War I.

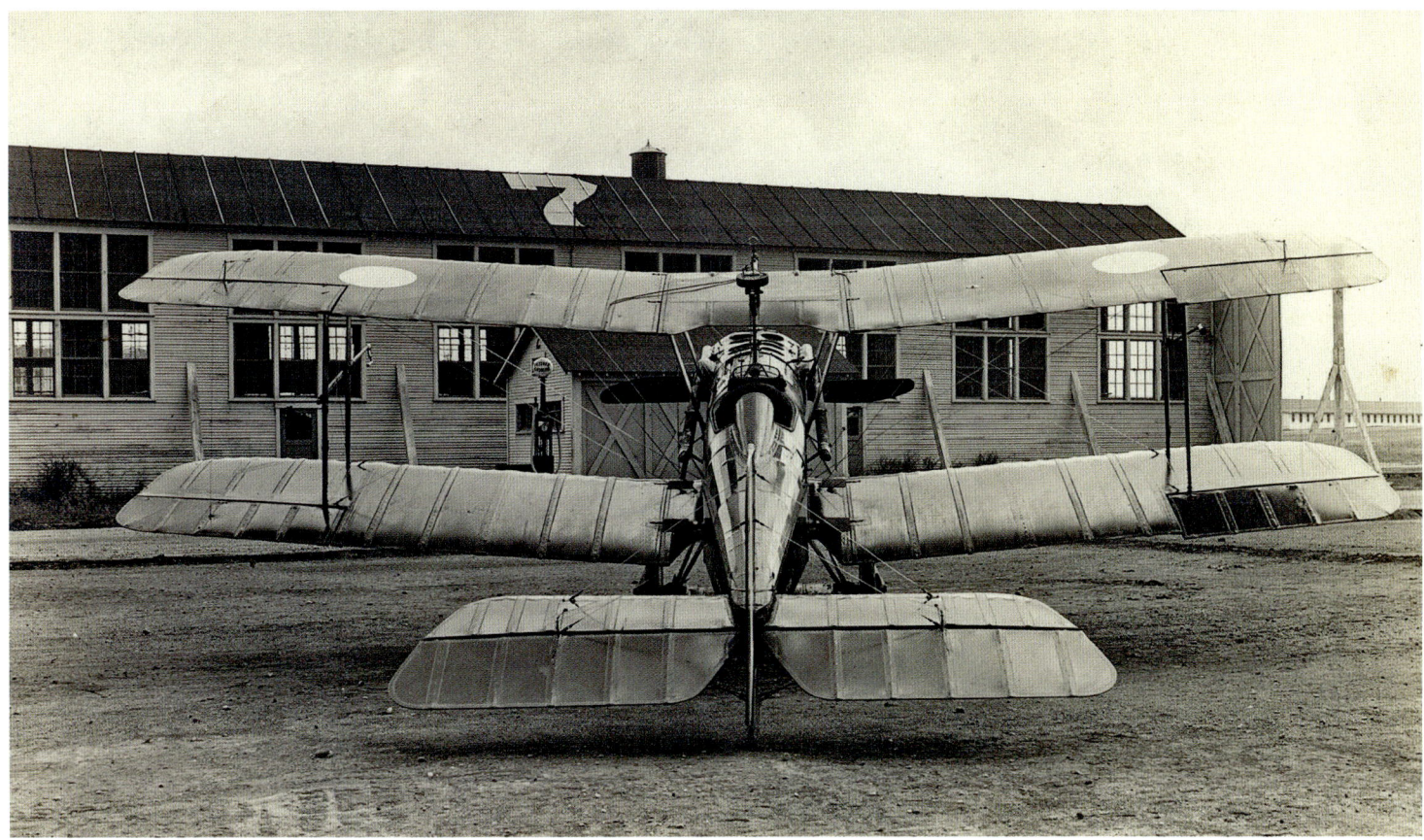

fail. There is a hand pump on the left that is used to pressurize the main fuel tank before the engine-driven pump takes over after start, or in the event of the engine pump failing.

Like most World War I aircraft, a compass and altimeter are provided but are of very dubious value. The tachometer and oil-pressure and airspeed indicators are the most scanned instruments, but the pilot is well advised to monitor the radiator temperature and fuel air pressure frequently. Unfortunately, the instruments are set low in the cockpit, making scanning the airspeed something of a challenge on the approach.

Like all biplanes, the view is compromised by the wing, but the pilot's seat is placed well behind so that you can look above or below the top wing without too much blanking. Because it's a tail-dragger, the forward view is restricted when on the ground.

The engine is fitted with long exhaust pipes that greatly reduce the engine noise. The windscreen is effective in shielding the pilot from prop wash most of the time.

The S.E.5a has somewhat similar handling qualities to a DeHavilland Tiger Moth, but with better excess power. As with the Tiger, part of the pilot's workload—particularly when maneuvering—is keeping the aircraft in balance, as directional stability is lacking and adverse yaw is significant.

Overall, I would say the S.E.5a cockpit is the best of the bunch from that era.

WIND IN THE WIRES

BRISTOL F.2B

Bristol F.2B | Canada Aviation and Space Museum | Identification No. D7889

With the agility of a single-seater and the heavy firepower of a two-seater, the Bristol F2.B radically changed air-to-air combat over the western front. Built to replace the obsolete two-seater types that had become "Fokker fodder," the new Bristol F2.A was armed with a single synchronized Vickers .303-caliber machine gun that fired through the propeller arch, and a single .303-caliber Lewis gun (two guns soon became the standard) mounted on a Scarff ring immediately behind the pilot.

The combat debut of the F.2A in April 1917 proved disastrous. Using the standard tactics of tight formations and relying on the rear gunners to provide mutual defensive fire, the new F.2A was just as vulnerable as the obsolete B.E.2c. The early setbacks could have put an end to the new Bristol fighter, but frontline pilots took matters into their own hands and revised their tactics.

The new F.2B entered service in May 1917. Embracing the aircraft's speed and maneuverability, crews now had the performance of a single-seater with double the armament. Emulating the aggressive tactics of their Camel and S.E.5/5a cousins, F.2B pilots had the luxury of aiming their fixed weapon while their observers kept enemy fighters off their backs.

Captain William Harvey of No. 22 Squadron had an astute observation regarding the F.2B's role as a combat aircraft: "The Bristol was a classic aeroplane in looks, in performance for its period," he commented, "and of a curiously perfect tactical design at a time when the future fighting requirements of a fighting aircraft were not fully understood. The back-to-back seating of pilot and rear gunner . . . made possible instant change from offence to defence and back again."

The Bristol F.2B was so effective the British War Office began to equip all its fighter-reconnaissance squadrons with the aircraft. By July 1918, nineteen units were equipped. A total of 5,329 Bristol F.2Bs were built and served with the RAF until 1931.

PILOT IMPRESSIONS
Rob Millinship, the Shuttleworth Collection

I was invited to join the Shuttleworth Collection as a pilot following a number of years flying private-owner vintage aircraft in Shuttleworth airshows. My background flying high-performance tail-wheel types, including twenty years flying Pitts Specials, was seen to be appropriate even though I was a civilian-trained pilot. Shuttleworth policy at the time was to recruit service-trained test pilots.

The F.2B is a big, complex biplane. My first impression was a sense of scary responsibility. It's a priceless historical artifact and my main concern was not breaking it. With all the Shuttleworth Collection airplanes, there are no dual checks. You're briefed by whoever is the type specialist and then off you go.

The instruments in the F.2B are easy to read, but bear in mind most pilots during World War I were probably shorter than we are now. I'm a little guy, so the cockpit is well suited to me. Bigger pilots would find it a bit cramped. Everything falls to hand. Our F.2B is devoid of the central gun. Normally it sits on the centerline of the engine with the breach in the cockpit. It makes it a whole lot easier when you're not sharing it with the back end of a Vickers.

The view from the cockpit is good. The Bristol fighter cockpit sides are set quite low giving you excellent side-to-side view. The only thing that is slightly unusual, particularly for pilots who fly Tiger Moths and that sort of thing, is the upper wing is very close to the fuselage. Your view forward is restricted. It's like looking down a letterbox. It could be a little claustrophobic, but generally the view from the cockpit is fine.

Comfort level in the cockpit is fairly good. When the airplane is flown in balance it's not particularly drafty and the small

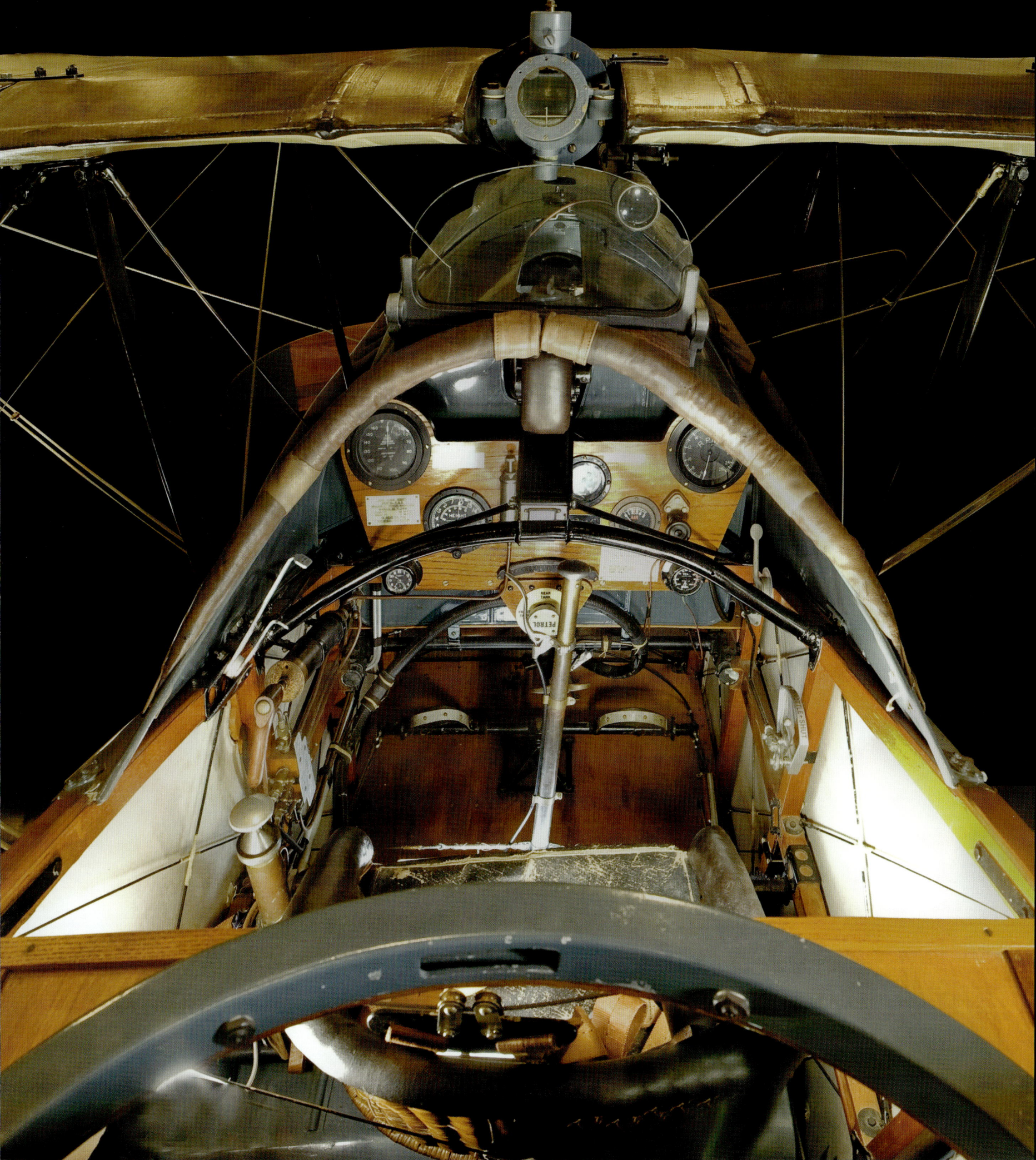

angled windscreen works really well. Compared to the Sopwith Pup cockpit, which is a real goggles-down, turbulent, noisy environment, the F.2B is a pleasure. One reason is the Rolls-Royce V-12 engine, which sits a long way in front of you. It's a smooth-running engine with very little vibration. For a World War I airplane that's pretty decent.

Once the airplane is airborne and in cruise, the workload in the cockpit isn't particularly high. The airplane's quite fast. It's not like a rotary-engined aircraft where you're constantly at it all the time. The big issue with all these airplanes is fuel pressure. Is fuel being constantly fed to the engine? You're constantly aware of fuel levels and fuel pressure.

The other issue is the liquid-cooled engine. Coolant temps are important. There's no automatic shutter control on the radiator. You've got to be ahead of the game in terms of keeping the engine coolant at the right temperature. Because the shutters don't take effect immediately you have to adjust them early, in order to keep the engine temperature under control.

The cockpit layout was in advance of any established conventions for instrument placement at the time. Everything really falls to hand and there's nothing I would really want to change.

Would I want to go to war in it? That's a different matter! Of all the World War I airplanes I have flown, the most logical, cockpit-wise, are the Bristol fighter and the S.E.5.

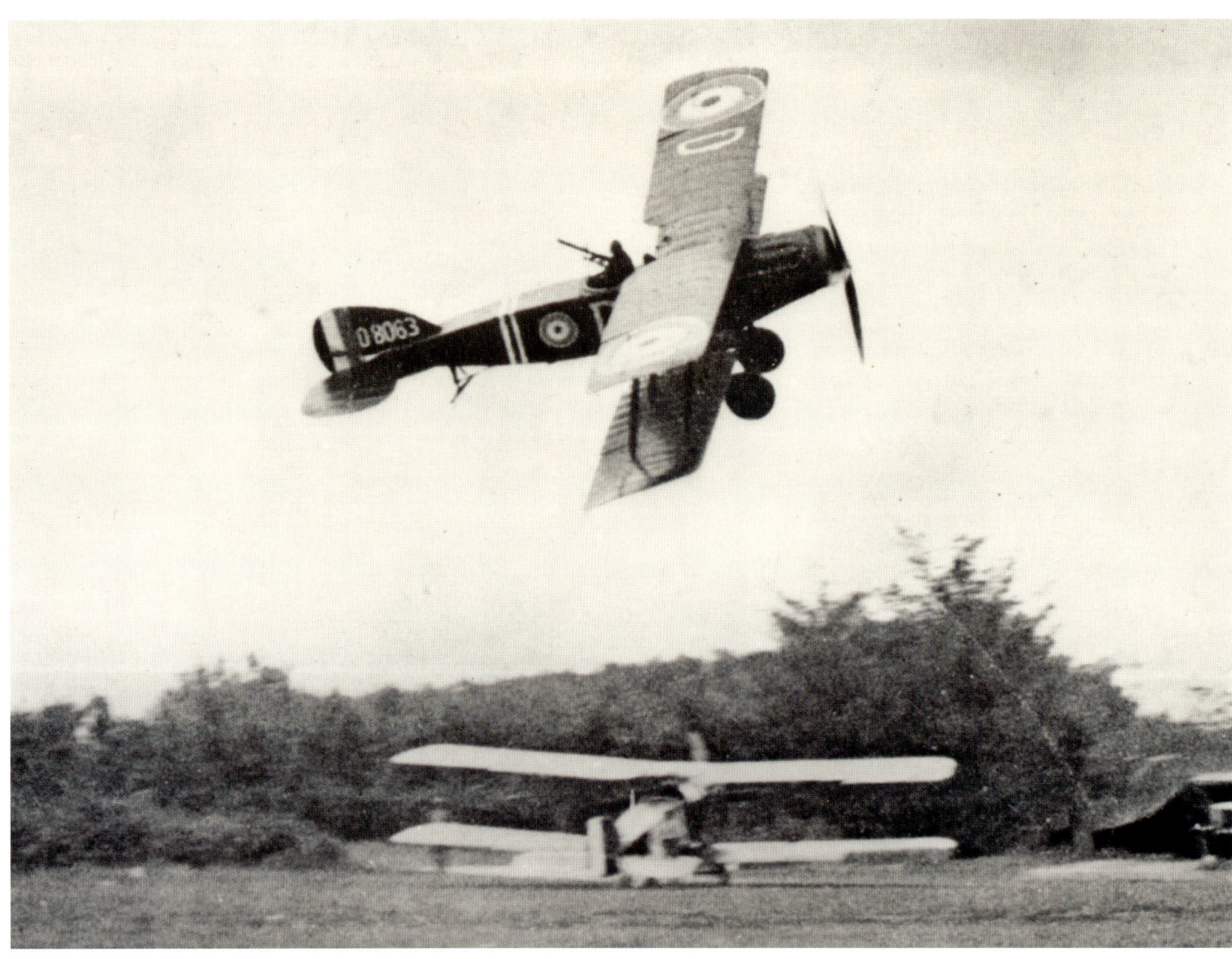

Canadian ace Capt. William G. Barker, chief officer of No. 139 Squadron RAF, takes the Prince of Wales up for a flight over Villa Veria Aerodrome in his Bristol F.2B (serial number D8063) in September 1918. *Jon Guttman*

ABOVE: William Frederick James Harvey's F.2B banks for the camera. Flying with No. 22 Squadron, Harvey and his observer were credited with twenty-six victories–eighteen with the forward-firing gun and eight with the rear-mounted guns. *Jon Guttman*

BELOW: Bristol F.2Bs of No. 1 Squadron of the Australian Flying Corps undergo maintenance at El Mejdel, Palestine, in 1918. Postwar the F.2B was used as an army fighter and trainer until 1931. *Jon Guttman*

WIND IN THE WIRES 27

FOKKER DR.I

Fokker Dr.I | National Museum of the US Air Force | Replica

It wasn't the first, but it was the most famous. Inspired by the success of the Sopwith triplane, the iconic Fokker Dr.I was introduced in 1916. The triplane concept was not a new one, but the design's performance proved superior to the Fokker and Albatros fighters in service at the time. German authorities were quick to react. The Inspectorate of Military Aviation ordered all German aircraft manufacturers to submit a triplane fighter design.

Fourteen new designs were built with the most impressive coming from the Fokker Flugzeugwerke. Eager to regain his position as chief supplier of German fighting scouts, Anthony Fokker was already busy working on a series of lightweight prototype scouts. Switching gears he ordered his chief designer to modify one of the existing prototypes into a triplane. Powered by a German copy of the French Le Rhône rotary engine and armed with two 7.92mm Maxim LMG 08/15 Spandau machine guns, the famous Fokker Dr.I triplane was born.

The first Dr.I was delivered to *Jasta* (Squadron) 15 on October 11, 1917. By month's end a series of accidents grounded the entire fleet. Quick inspection revealed poor workmanship and substandard materials in the wing construction. The problems were soon rectified, but only 31 of the 173 aircraft that had been delivered by December 1 were available. At the model's peak, 171 Dr.Is were operating on the western front in April 1918.

Made famous by Germany's great ace, Manfred von Richthofen—the "Red Baron"—the Dr.I was not an easy aircraft to fly. Its inherent instability required the pilot to be vigilant at all times. And although its three short-span wings and axle airfoil made the Dr.I supremely maneuverable, the airplane was hamstrung by the performance of its Oberursel rotary engine. At just 110 horsepower, the fighter's top speed was just 112 miles (180 kilometers) per hour. Further, the drag caused by its thick wings and questionable construction restricted the Dr.I from diving at full speed.

For almost a year the Fokker Dr.I was a much feared and deadly opponent in the skies over France and Belgium. By summer 1918, however, it was no longer a match for the RAF S.E.5, Sopwith Camel F.1, and SPAD VII and XIII. Also by this time only Jasta 19 was still fully equipped with the famous Dr.I. Even though it was considered obsolete when compared to the Fokker D.VII and the latest Allied types, the airplane was still preferred by many pilots to the second-rate Pfalz and Albatros scouts.

The last downing of a Dr.I occurred on October 3, 1918, when ace Lt. Josef Jacobs was shot down by the pilot of an S.E.5a while defending Jasta 7's airfield.

PILOT IMPRESSIONS
Andrew King, Aircraft Restorer

The Fokker triplane's top wing is mounted pretty high so you can't see over the top and that blocks out a lot of sky. The middle and bottom wings are no better and block out a lot of sky below you. The major factor when flying the triplane, though, is your forward vision. You can't see in front of you. The middle wing goes right across your horizon and blocks out the entire world. It's a big issue and learning to deal with it takes time. During World War I the aerodromes were wider, giving you lots of space, and if you swerved on landing you probably wouldn't hit anything. Once airborne your forward vision improves.

The cockpit layout could be better in terms of instrumentation, and a factory-installed altimeter would have helped. There's been some debate about where the tachometer was placed in the Dr.I. I think it was above the rudder bar down between your feet. It wouldn't be that easy to read, especially during combat. The replicas I've flown have the tachometers mounted higher up where you could see them better. Like the Camel, the gun butts are right in your face.

The cockpit is cramped, not as roomy as the Fokker D.VII, but if someone was on your tail you could easily outturn them. The designers knew that if everything was jammed together, it would make the triplane more maneuverable—its raison d'être.

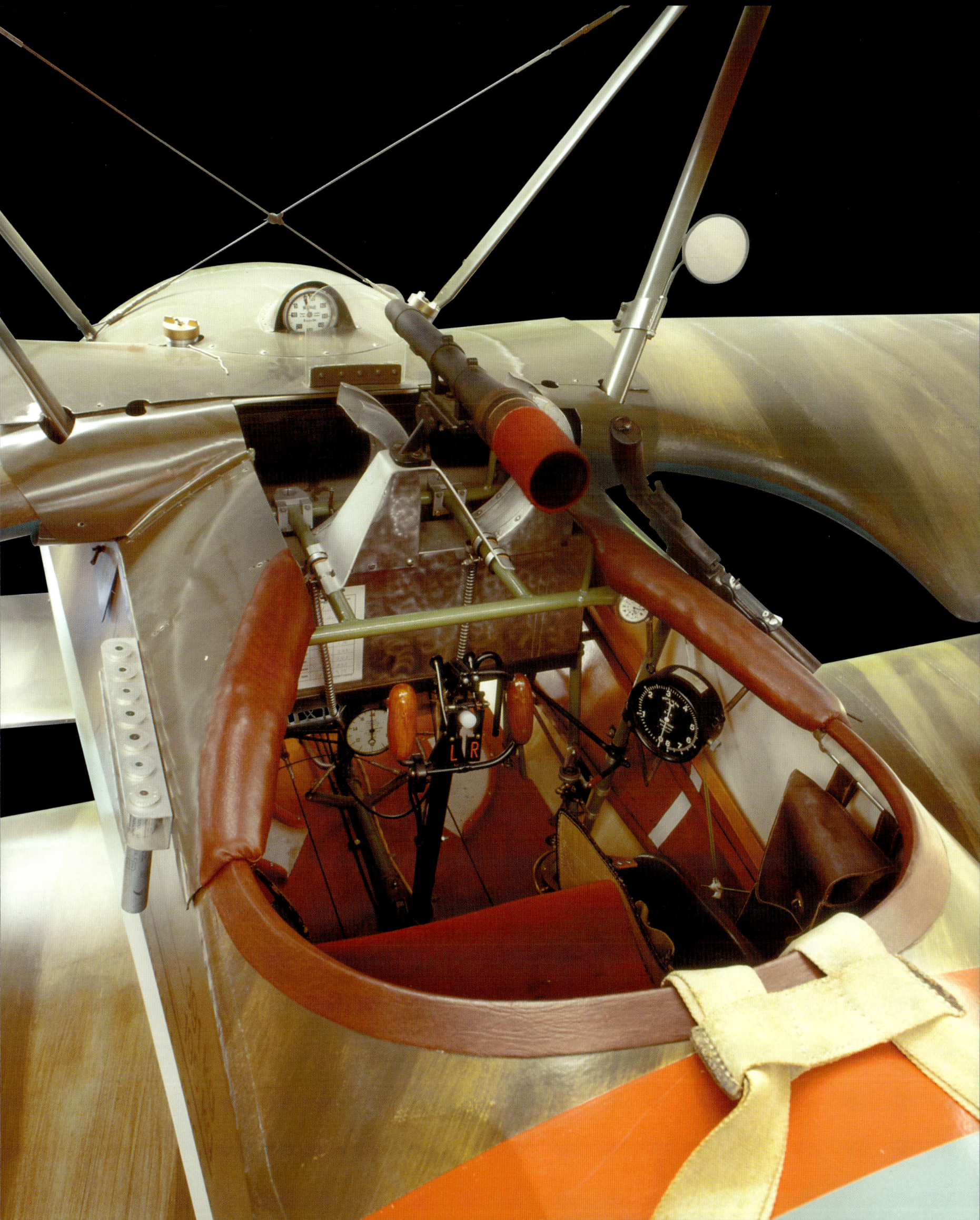

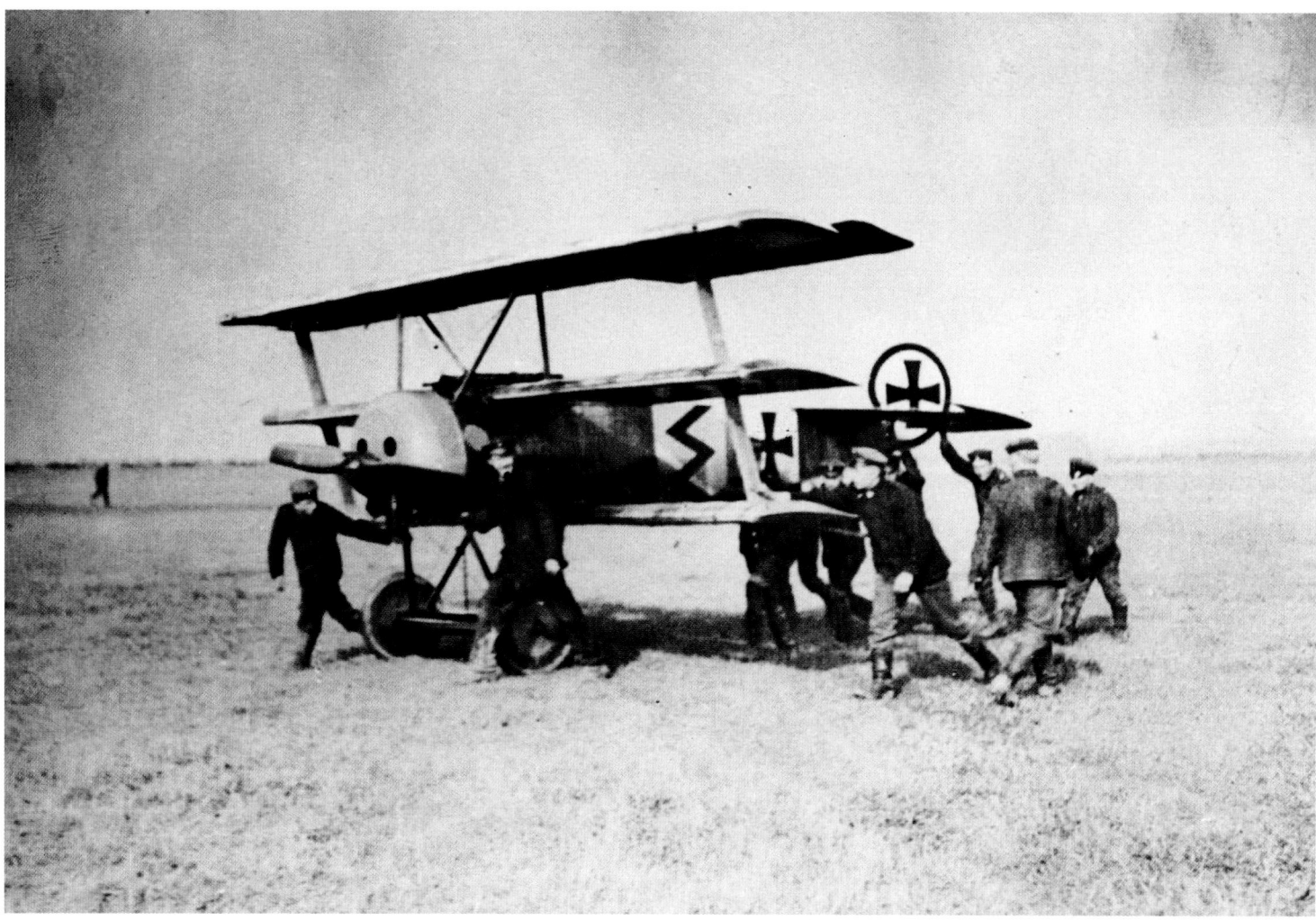

ABOVE: A 1918 hand-me-down Dr.I is manhandled by a ground crew from Jasta 54. A number of high-scoring German aces flew the Dr.I, including Manfred von Richthofen, who scored nineteen of his eighty kills with the Fokker. *Jon Guttman*

OPPOSITE PAGE: Lieutenant R. Paul Hoffmann of Jasta 12 comes in for a landing in early 1918. At the Dr.I's peak in April 1918, 171 aircraft were operational over the western front. *Jon Guttman*

Like most of the aircraft of that era, they didn't have conventional fuel pumps on the engines. They relied on air pressure in the fuel tanks. Before starting, you pumped up the pressure and once running, an air pump would keep the pressure constant. That's one thing you had to keep your eye on. If the fuel pump failed there's a bicycle hand pump on the right side of the cockpit to keep up the pressure.

With no windscreen you're fairly exposed with a lot of wind in your face. It's not the most comfortable airplane to fly. Being inherently unstable you have to fly the Dr.I all the time. I tell people I love doing it, but it's not fun. It's a more a natural experience—you're automatically compensating for the various inputs affecting the airframe.

The triplane wasn't very fast, couldn't run away from a fight, but it could outturn anything in the sky. But because it was so unstable, I've always wondered how good a gun platform it really was. Of course, I've never had the chance to prove that theory.

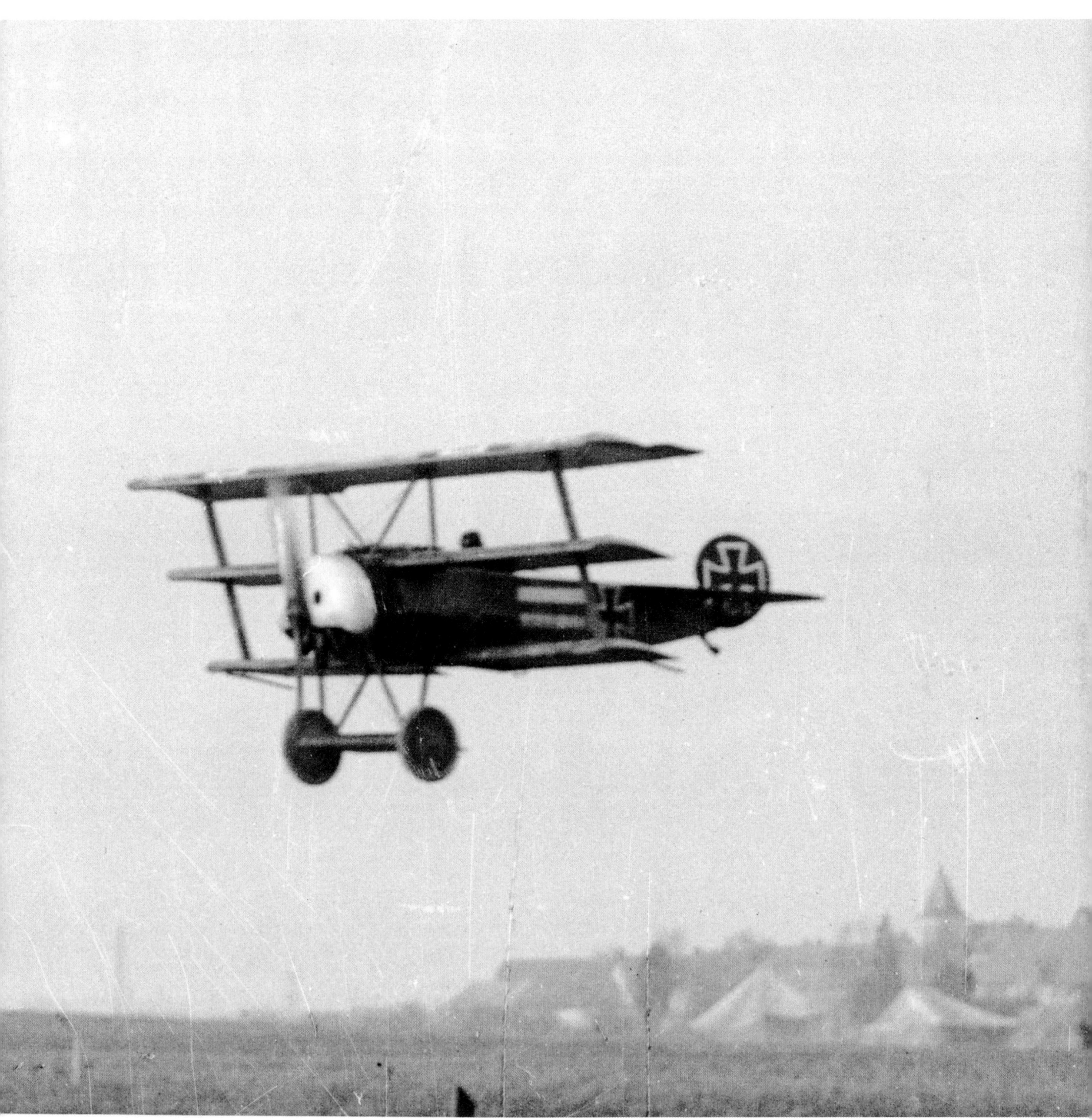

SOPWITH CAMEL

Sopwith Camel | Dr. Russ Turner, Jamestown, Ohio | Replica

It was regarded as one of the very best dogfighters of World War I. As Britain's most famous fighting scout, the Sopwith Camel was the most successful design to see service on either side. A natural outgrowth of the respected Sopwith Pup and Triplane, the Camel would claim 1,294 aircraft and three airships destroyed, the most by any type.

The first British fighter to boast two Vickers machine guns synchronized to fire through the propeller arch, the Camel gained a fearsome reputation in both combat and among those young pilots learning to fly it. For pilots moving from the Pup or Triplane, the Camel could be a nasty beast—it required a great deal of skill to master and, for novice pilots, often proved fatal. But in the hands of a skilled aviator, it was arguably the best dogfighter of World War I.

Powered by a rotary engine, the Camel had a tendency to drop its nose during a steep turn to starboard (the direction in which the rotary engine spun). In a port climbing turn, it rose alarmingly (against the direction of the engine). But for those who mastered the Camel, the massive spinning engine worked in their favor, its weight allowing a skilled pilot to put the Camel into an incredibly tight and quick right-hand turn. The Camel's rate of turn to the right was so tight many pilots wishing to turn left opted for the quicker 270-degree turn to the right.

Pup ace Lt. Arthur Gold Lee of No. 46 Squadron had high praise for the Camel. "First impressions—more room in the cockpit than the Pup, so you can take a deep breath without feeling you're going to burst the fuselage at the seams," he wrote. "Second, the exciting pull of the 130-horsepower Clerget. Third, her amazing lightness on the controls, lighter even than a Pup. She turns with lightning quickness to the right."

Sopwith built 5,500 Camels and the type remained in RAF service until 1920.

PILOT IMPRESSIONS
"Dodge" Bailey, Chief Pilot of the Shuttleworth Collection

Getting into the Camel is pretty difficult. The main problem arises from Sopwith's decision to switch the cockpit and fuel tank locations when compared to the Pup and Triplane. In the Camel, the pilot sits under the upper-wing center section, so you cannot stand upright on the seat while boarding as you can in the others.

In the cockpit everything feels pretty close in front of you. Your shins are hard against the air-intake pipes, and thick ends of two Vickers guns dominate the upper cockpit area.

The cockpit, not surprisingly, shares many characteristics with the cockpit of the Sopwith Triplane. The spade grip stick with ignition blip switch and rudder bar are well positioned, and the inclinometer for lateral level is immediately ahead of the stick. The block-tube lever (throttle) and fine adjustment (mixture control) are on the left side as you would expect, but are perhaps a little too far down. The block tube, again as with the Triplane, is mounted in a quadrant labeled from 0 to 10 and moves conventionally. The fine adjustment shares this numbered quadrant and moves forward for rich.

The fuel tank selector is on the floor beneath the engine-control quadrant. Just ahead of that is an isolated glass tube–type fuel-quantity gauge–should the glass break the fuel will not leak into the cockpit. Two magneto switches are located on the lower left of the instrument panel; on the lower right you'll find the fuel tank pressure gauge and associated Jones valve to regulate pressure. As with the Triplane, a hand pump on the right cockpit side pressurizes the main fuel tank before the Rotherham pump (mounted on the starboard center-section strut–where the pilot can see it) takes over after start. The hand pump maintains tank pressure should the Rotherham pump fail. Flight instruments are

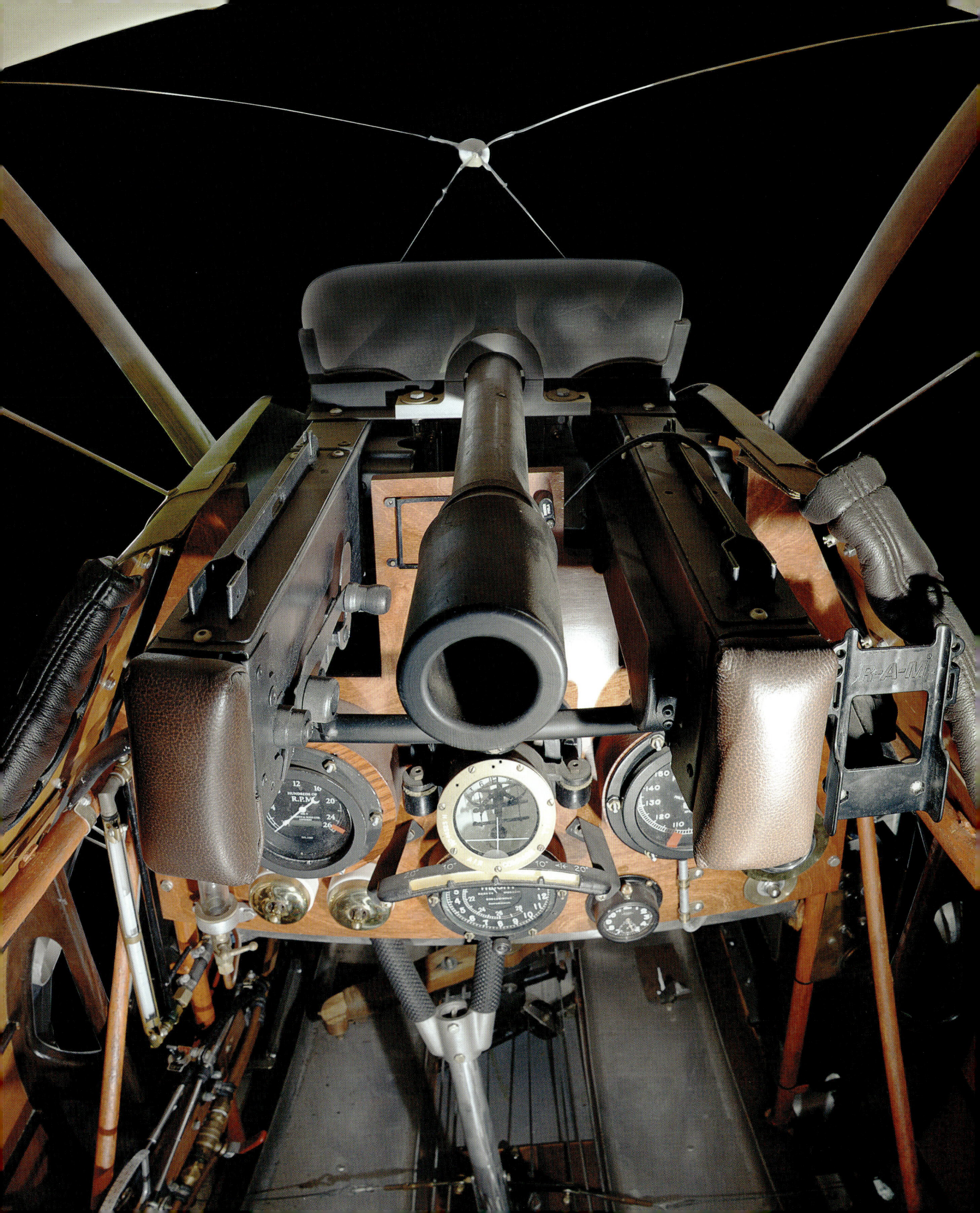

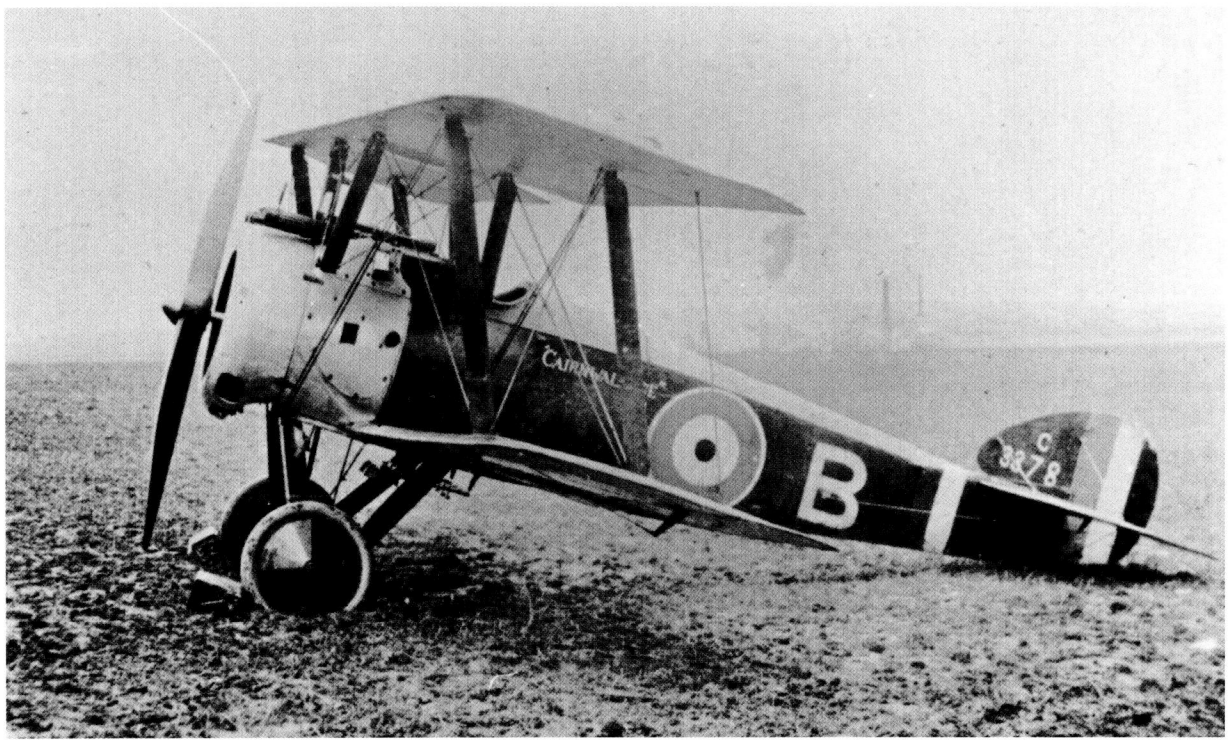

ABOVE: A Camel from No. 80 Squadron RAF. The Camel wasn't a world beater, as it's often portrayed. During the war 413 of its pilots were killed in action, 307 were taken prisoner, 189 were wounded, and 385 were killed in accidents. *Jon Guttman*

OPPOSITE PAGE: Captain Percy Wilson, No. 28 Squadron flight leader and seven-victory ace, poses by his Sopwith Camel at the end of hostilities in Italy. Camel pilots were credited with 1,294 enemy aircraft shot down between June 1917 and November 1918. *Jon Guttman*

grouped in the center of the panel, the more important instruments (i.e., rpm gauge and airspeed indicator) at the top, left and right, respectively, with a compass between. Below the compass there's a single-pointer altimeter and a stopwatch to its right measures engine-running time on the ground. A sight glass at lower left shows oil being supplied to the engine.

By placing the pilot under the center section of the top wing, the field of view is more restricted than on other biplanes. The upper wing shuts out a lot of sky, hence the need to leave open areas in the center section to give the pilots some upward view. Being a tail-dragger, the forward view is very restricted when the aircraft is on the ground.

One has to be always careful to enter and exit the cockpit without damaging the airframe. You also have to make sure that your feet are able to move the rudder over its full range without snagging anywhere—another consequence of moving the cockpit forward is that the rudder bar, and hence the pilot's feet, are farther forward in a different part of the airframe from the Pup and Triplane, and there is much less room and more bits of structure to snag on.

Overall, the cockpit instruments are well laid out, but a better windscreen would be good. Apart from entry and exit, it's a pretty good cockpit; and along with the S.E.5a, it would be considered one of the best for that era.

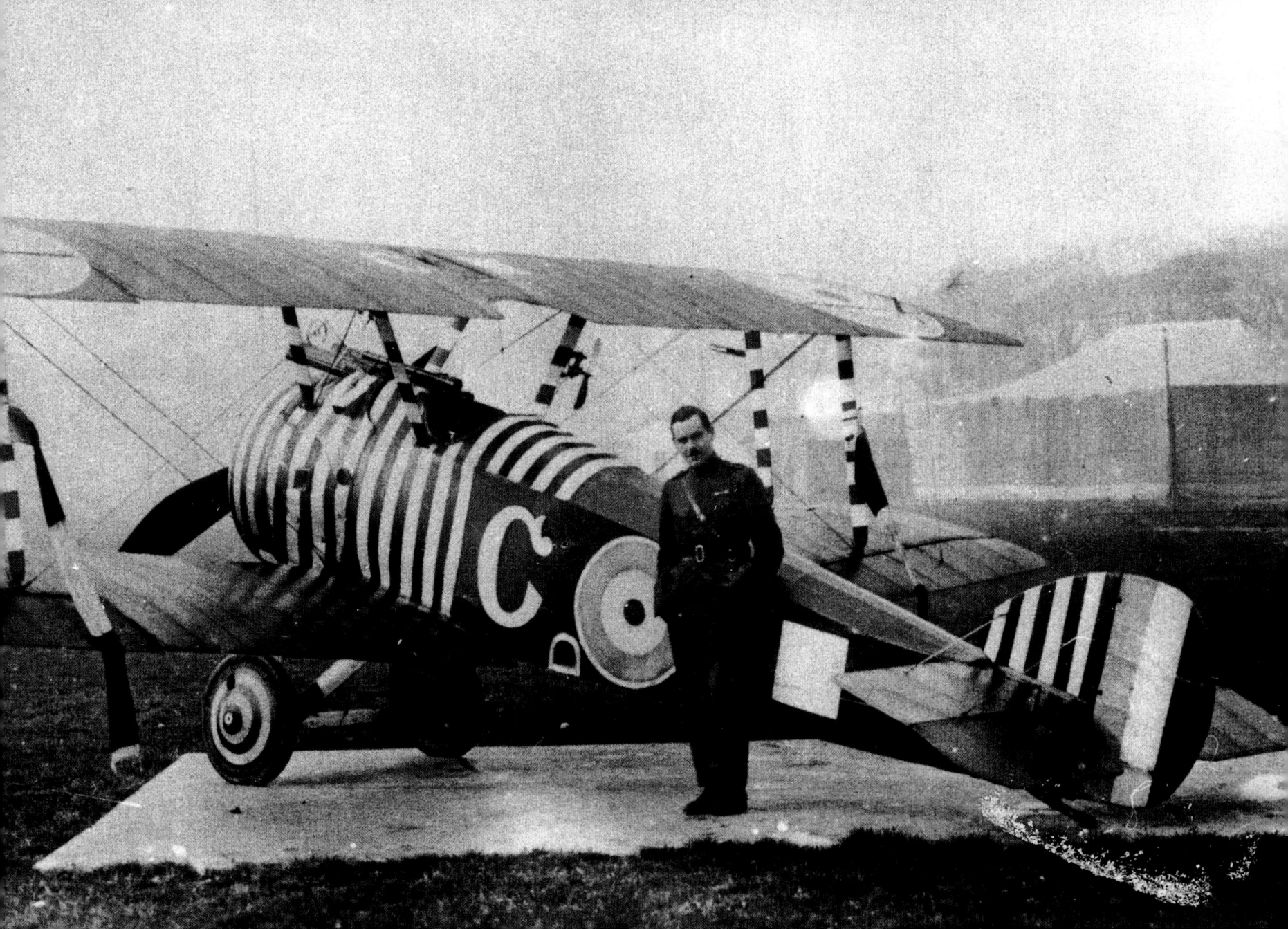

SOPWITH TRIPLANE

Sopwith Triplane | Canada Aviation and Space Museum | Airworthy replica

When the first Sopwith Triplane prototype took to the air, it didn't take long for test pilot Harry Hawker to loop it three times and dazzle those in attendance. Shortly after the Triplane was sent to France to undergo service trials with the Royal Navy Air Service (RNAS) at Furnes. It was an instant success and was reportedly scrambled for an interception just fifteen minutes after its arrival.

Ordered exclusively for the RNAS, the Royal Flying Corps was impressed by its performance and requested planes of their own. In combat, the Triplane could outclimb and out-turn the Albatros D.III and was almost 15 miles (24 kilometers) per hour faster.

For the Germans the appearance of the Triplane in February 1917 was a huge shock that sent them into a brief Triplane-making frenzy, with no fewer than thirty-four prototypes produced, including the Fokker V.4, prototype of the successful Fokker Dr.I.

The Triplane gained its greatest fame when flown by No. 10 Naval Squadron "B" Flight, better known as "Black Flight." Commanded by ace Raymond Collishaw, this all-Canadian unit was easily distinguished by their black-painted cowlings and tail fins. In just three months they were credited with shooting down eighty-seven German aircraft. Collishaw alone accounted for thirty-four of these and his eventual tally of sixty victories made him the top Triplane ace.

But the Triplane's combat career was relatively brief. Difficult to repair, it also gained a reputation for structural weakness that resulted in collapsed wings in steep dives. Only 150 were produced, but its influence on air war and aircraft design was unquestionable.

PILOT IMPRESSIONS
"Dodge" Bailey, Chief Pilot of the Shuttleworth Collection

It's comparatively easy to board the Sopwith Triplane, but there are two tips to pass on. First, a weight-bearing area is built into the left, lower wing root, but it's fabric-covered and not obvious. Second, the bracing options of a single-strut triplane are limited, particularly in the drag sense, so there are antidrag bracing wires running between the middle wing and the fuselage at about cockpit level. You have to avoid these getting in and out.

The primary flight controls, spade grip stick (with ignition blip switch) and rudder bar, are well positioned. Immediately ahead of the stick is the inclinometer (lateral level) to assist in balancing turns. Longitudinal trimming is achieved by adjusting the incidence of the tailplane using a large wheel on the right cockpit side. The block-tube lever (throttle) and fine adjustment (mixture control) are on the left side. The block-tube moves in the conventional sense and is mounted in a quadrant labeled from 0 to 10 to show where it needs to be placed for best results. The fine adjustment moves in the modern sense (forward for rich) and shares the same numbered quadrant as the block-tube lever.

The instrument panel has a simple fuel selector, and the aircraft has only one tank. To the right of the fuel cock and mounted centrally on the lower instrument panel are the fuel-tank air-pressure gauge and the associated Jones valve. The two magneto switches are above and to the left of this fuel-pressure gauge. A hand pump on the right cockpit side pressurizes the main fuel tank before the Rotherham pump (a windmill device mounted on the starboard center section strut in pilot view) takes over after start. It also maintains tank pressure should the Rotherham pump fail. A glass-tube fuel-quantity gauge is located on the right side but isolated from the rest of the cockpit. If shattered, the cockpit would be sprayed with petrol. A single-needle altimeter is at the bottom of the instrument panel, but rarely used—the scale is not accurate enough.

Being a rotary engine there is no oil-pressure gauge. Instead a sight glass shows oil being supplied to the engine. The tachometer and airspeed indicator are placed toward the top of the panel. Since engine-running time on the ground is measured in seconds,

A factory-fresh Sopwith Triplane. While highly maneuverable, the Triplane suffered from its light armament—a single .303-inch Vickers machine gun. Most German fighters at the time carried two 7.92-millimeter Spandau machine guns. *National Museum of the USAF*

a stopwatch is provided. The instruments are set low in the cockpit, making scanning the airspeed something of a challenge on the approach.

Like all biplanes the view is somewhat compromised by the wings, but the pilot's seat is placed well behind the wings. Moving your head around, you can clear most, if not all, blind spots. The wings all have the same narrow chord. The top wing doesn't obstruct as much sky as you might imagine. Being a tail dragger the view forward on the ground is restricted. In fact, the restricted forward view was the first thing to strike me about this aircraft.

Surprisingly, rotary engines are not exceptionally noisy. The engine exhaust valve opens near the bottom, well away from the pilot. However, the lubrication system is a total loss and a fair amount of castor oil is thrown out, ending up on the pilot and his goggles. In addition, the prop wash is powerful and turbulent with precious little protecting the pilot. At high power it's like a wild animal trying to wrench your helmet and goggles off. On the positive side, when the rotary engine is running smoothly there's very little engine vibration.

Your first concern flying the Triplane is getting the engine running correctly. Once airborne the aircraft is reasonably straightforward to fly. You have to monitor the engine while attempting to modulate its power and prevent it from exceeding its rpm limit.

If there's anything I would change in the cockpit it would be a better windscreen. Overall, it's very good, but not very advanced.

ABOVE: Sopwith Triplane N6295 of "B" Flight, 10 Naval Squadron, Droglandt, France, August 1917. Ace Raymond Collishaw commanded this all-Canadian flight which claimed 87 German aircraft in three months while equipped with the Triplane.

BELOW: No. 1 Naval Squadron of the Royal Navy Air Service was fully operational with the Triplane on December 1916, but didn't see action until February 1917. *National Museum of the USAF*

WIND IN THE WIRES

AEG G.IV

AEG G.IV | Canada Aviation and Space Museum | Original; only surviving World War I German bomber

Toward the end of 1916, the German High Command introduced the Allgemeine Elektricitäts-Gesellschaft Grossflugzeug (AEG) G.IV bomber. While a slight improvement of the G.III, it possessed neither the range nor lifting power necessary to be an effective bomber. In fact, why the Germans introduced the G.IV remains somewhat of a mystery.

The prototype G.IV appeared in September 1916 and was followed by the first production machines in January 1917. By the middle of that year, frontline units began receiving the new bomber in significant numbers.

Powered by two Mercedes D.IV 260-horsepower six-cylinder liquid-cooled engines, the AEG G.IV had a good top speed of 103 miles (166 kilometers) per hour. The engines were mounted on a complicated system of steel struts that tied directly to the lower wing spars and the upper-fuselage longerons. During the war the Germans favored the pusher engine arrangement for their bombers, but the G.IV was unique and easily recognizable with its tractor configuration.

The G.IV fuselage and tail assembly were made of welded steel tubing. The fuselage was welded in one complete unit and was unique to the G.IV. (Other large airframes of the period used two or three

subassemblies to complete the aircraft.) Plywood covered the nose section and fabric covered the rest of the aircraft.

Due to its small size and comparatively high structural weight, the G.IV could carry only a small bomb load of 880 pounds (399 kilograms) when fully fueled. For this reason the G.IV was used as a short-range tactical bomber striking targets behind the frontlines. Occasionally, when stripped of bombs, it was used for long-range reconnaissance and aerial photography. It saw day and night action along the western front and in Romania, Greece, and Italy.

Well liked by its crews, the AEG G.IV was considered rugged and easy to fly. Crew accommodation was sufficient for a crew of four, but most sorties were flown with a pilot, commander, and gunner. (The G.IV also carried three Parabellum machine guns, one in the front and two in the rear; the third could be fired through a trapdoor in the bottom of the fuselage.) The cockpit gunner's position and the commander's *Kanzel* (pulpit) position were interconnected, allowing the crew to change stations in flight. The commander was provided with a foldaway seat positioned to the right of the pilot for takeoff and landing, which offered protection in the event of a nose-over accident.

Though the AEG G.IV was not a star performer, a surprisingly large number, 320, were produced. Limited as a daylight bomber, it eventually was restricted to night missions raiding Allied "back areas." Night operations took a heavy toll with many aircraft lost to landing accidents. In fact, production never kept pace even though the demand for new aircraft was constant.

Late in the war a G.IV was converted into an armored antitank gunship, the G.IVk. Armed with two 20-millimeter Becker cannons, it never saw service and only one was built. By August 1918 fifty aircraft were still in use.

SPAD VII

SPAD S.VII C.1 | Canada Aviation and Space Museum | Serial No. B9913

From the beginning of World War I, Allied aircraft manufacturers were largely committed to the rotary engine for their fighting scouts. But they did possess one stationary water-cooled engine that greatly impacted the war in the air: the Hispano-Suiza 8Aa. Built largely of aluminum, this eight-cylinder had an excellent power-to-weight ratio, developing 150 horsepower, yet weighing just 442 pounds (200 kilograms)—200 pounds (91 kilograms) lighter than the straight-six 160-horsepower Breadmore and 160-horsepower Mercedes.

The first fighter to be equipped with the remarkable Hispano-Suiza was the SPAD VII designed by Louis Béchereau for Louis Blériot's Société Pour l'Aviation et ses Dérivés (SPAD). In April 1916 the first SPAD V prototype took to the air. Flight tests revealed an excellent top speed of 119 miles (192 kilometers) per hour and rate of climb (4.5 minutes to 6,500 feet, or 1,981 meters). It also had a rugged, well-engineered airframe capable of absorbing a great deal of battle damage.

In May 1916 the French Aviation Militaire ordered the SPAD VII into full production. A pugnacious and muscular fighter, the SPAD in many ways represented a change in air combat philosophy. Armed with a single .303-inch Vickers machine gun, like the SPAD V it was fast with a good rate of climb and exceptional diving characteristics. This combination gave Allied pilots the ability to engage or leave combat almost at will.

Not surprisingly, however, quite a few pilots regarded the SPAD's lack of maneuverability with suspicion and tried to keep their more nimble Nieuport 17s. But the SPAD soon proved itself and many were quick to realize its combat abilities. René Fonck, the leading Allied ace, had high praise for the SPAD, stating "it completely changed the face of aerial warfare."

But the SPAD VII was not an easy aircraft to fly. At low speed its thin airfoil cross section often resulted in unforgiving stalls. It was, however, an outstanding diver capable of speeds in excess of 249 miles (401 kilometers) per hour followed by a steep climb. Dive and zoom tactics were soon developed, giving SPAD pilots the ability to dive on their opponents, fire off a burst, and zoom climb back out of harm's way. By 1917 some five hundred SPAD VIIs were in frontline service.

Impressed by the SPAD VII's performance, many Allied nations acquired the new fighter. The first was the Royal Flying Corps with two squadrons based on the western front. British license-built SPADs were used by their training units, as well as in the Middle East. Russia received forty-three aircraft in the spring 1917 with a further one hundred built under license. Belgium equipped its 5e Escadrille with the type, and Italy used it in nine of its Squadriglia. When America entered the war in 1917 it had an air force in name only. An order for 189 SPAD VIIs was quickly placed. In February American volunteers in the French Lafayette Escadrille, who were already flying the SPAD VII, were transferred to the US Army Air Service, becoming the 103rd Aero Squadron.

After the war many SPAD VIIs found their way into the air forces of Brazil, Czechoslovakia, Finland, Greece, Japan, the Netherlands, Peru, Poland, Portugal, Romania, Siam (current day Thailand), the United States, and (the former) Yugoslavia.

HALBERSTADT CL.IV

Halberstadt CL.IV | Smithsonian National Air and Space Museum | Steven F. Udvar-Hazy Center
Serial No. 8130 | Combat veteran | Built under license by LFG Roland

During World War I the use of ground-attack aircraft by both sides proved highly effective. In March 1918 the Halberstadt CL.IV was put into service with the vastly expanded German *Schlastas* (battle squadrons) and made ready for battle. During this period the Schlastas had become highly organized formations of no fewer than four aircraft. Once airborne the four-aircraft formation was the most efficient for command and coordination, and it operated with devastating effect. Intended for use at decisive points of attack, the new Schlastas were not wasted over a wide front. Key to their success was timing. Arriving too soon they would show the enemy the point of attack; arriving too late they would expose their own troops. Detailed and precise orders were issued, with each formation flying ahead of the advancing infantry, strafing and bombing enemy troops and artillery positions.

Intended as a replacement for the CL.II, the Halberstadt CL.IV was only slightly better. Performance in terms of speed and rate of climb were generally the same but its maneuverability was much better, making it ideally suited to the low-level role for which it was designed. Powered by the same 160-horsepower Mercedes D.III engine, the airscrew spinner was discarded and new bulbous side panels were wrapped around the nose. The wooden fuselage was the same ply-skinned construction and incorporated back-to-back cockpits with the observer manning the elevated gun ring. Horizontal tail surfaces were redesigned with a greater span and higher aspect ratio than the CL.II. The wings were the same, but because the fuselage was 3 feet (1 meter) shorter, they were repositioned to keep the center of gravity around the two cockpits. After these modifications, the CL.IV made an excellent escort and ground-attack fighter.

Armament for the CL.IV consisted of two fixed forward-firing Spandau machine guns and one flexible Parabellum machine gun, as well as antipersonnel grenades and four or five 22-pound (10-kilogram) bombs. Top speed was 103 miles (166 kilometers) per hour at 16,400 feet (4,999 meters).

During the 1918 Spring Offensive, the Schlastas were at the forefront, attacking Allied troops and artillery positions with varying degrees of success. By late April, however, German resources had been exhausted and the offensive ground to a halt. The Schlasta units found themselves flying defensive support missions to help cover their own retreating infantry. The last days of the war were hectic and chaotic. Unarmored, the CL.IV had to rely on its maneuverability to survive; losses were heavy.

When not flying close ground support, CL.IV crews often flew as two-seat escort fighters. Their maneuverability and heavy armament provided a potent punch, much like the two-seat Bristol F2. The CL.IV was also employed as a night fighter and bomber. On bright, moonlit nights they attempted to intercept Allied night bombers returning to their bases and attacked Allied aerodromes, supply dumps, and troop concentrations. These raids lacked the accuracy of daylight attacks and were considered a nuisance that caused little or no damage.

FOKKER D.VII

Fokker D.VII | National Museum of the US Air Force | Replica

For German fighter pilots, spring 1917 was a time of great success. The Allies were losing fights against the Albatros D.II and D.III. By year's end, however, the Allies had introduced a number of superb aircraft that would outclass anything in the sky. German efforts to counter the new SPAD VII and XIII, the S.E.5a, Sopwith Camel and Triplane, and the Bristol F.2B fighter were met with considerably disappointment.

When Germany launched its last great offensive of the war in March 1918, the German air force's best fighter was the Fokker Dr.I triplane, of which just two hundred were on the frontline. In response, Germany announced a D-type standard fighter competition in early 1918 that attracted no fewer than thirty-one contestants. Anthony Fokker sent eight aircraft and his V11 and V18 biplane prototypes won the competition. Baron von Richthofen and his fellow pilots were particularly impressed by the V18's performance, and the new fighter was ordered into production under the military designation D.VII. By late April the first D.VIIs began arriving at Jasta 10 of *Jagdgeschwader* (fighter group) I.

When the first Fokker D.VIIs reached the frontline, the German *Jagdflieger* (fighter pilot) was fighting a desperate rearguard action. The D.VII redressed the balance, not by sheer numbers but with its fighting abilities.

The Fokker D.VII was one of the most structurally sound fighters of the war and used some of the revolutionary features first seen in the Dr.I: thick-section high-lift cantilever wings built on two wooden box spars, and a wire-braced, welded steel-tube fuselage that dispensed with the tangle of flying, landing, and incidence wires. Powered by a 180-horsepower Mercedes D.III engine, the D.VIII had a top speed of 125 miles (201 kilometers) per hour.

But the new Fokker was not without its faults. There was a tendency for the ammunition to overheat and explode. Frontline units quickly worked through the problem by cutting ventilation holes in the cowling. Improved ammunition eventually resolved the issue.

The D.VII was a great all-round fighter. It was fairly easy to fly—forgiving, yet extraordinarily responsive. Stall was straightforward and it was hard to spin. While some Allied fighters stalled and spun out during a dogfight, the D.VII remained under full control. The Fokker could also hang on its prop, giving its pilots the ability to fire from underneath with great accuracy.

In the last months of the war, quality over quantity gave the Germans the ability to remain a potent fighting force. The sight of "straight wings" approaching often struck fear and anxiety into the heart of Allied pilots who had to fight the famous D.VII. By war's end the aircraft was specifically singled out for mention in the armistice agreement, forcing the Germans to hand over all first-line D.VIIs.

Exact production figures are elusive, but it is thought 3,200 were ordered and more than 1,720 delivered.

PILOT IMPRESSIONS
Andrew King, Aircraft Restorer

For a World War I airplane, the Fokker D.VII is really kind of a modern. It's well engineered with a steel-tube fuselage construction, cantilever wings, and one of the more comfortable World War I cockpits, being fairly deep and wide, which minimizes your exposure.

The really interesting thing about the D.VII cockpit—and it applies to a lot of German airplanes—is the two-handed control stick: the throttle control on the left side, machine gun triggers in the middle, and a handle for flying inputs on the right.

Compared to earlier German fighters, the D.VII had a well-furnished instrument panel. The fuel valves, engine instruments, and pressure and temp gauges are right in front of you. The tachometer is between the guns, and when they did mount an altimeter, it was placed wherever they could find the space. At that time most German pilots wore wristwatch altimeters.

WORLD WAR I

The view from the cockpit is pretty good, but again the bottom wing blocks most of your vision down and to the side. The top wing is fairly close to the fuselage, giving good visibility forward. Because it has an inline engine, the nose is long and slender, making it one of the better World War I fighters for all-around visibility.

Powered by a six-cylinder water-cooled engine, the D.VII cockpit is definitely less noisy than the Nieuport 28. As reliable as the engine was, every so often you had to turn the greaser a couple of times to keep the water pump lubricated. A failed water pump would end your flight rather quickly.

In terms of flying characteristics, most would say the Fokker D.VII flies like a Piper Cub, but in reality it handles more like a Stearman. The D.VII's biggest advantage during the war was how easy it was to fly. You can tell just by looking at its long nose and well-proportioned fuselage. In 1918 the Germans were pushing as many pilots through the system as they could. If they had to fly the Fokker Dr.I triplane, it would have been problematic.

British cockpits gave you more information, but were cramped in comparison. The Fokker D.VII was a truly advanced design, making it one of the most deadly fighters to see service during World War I.

OPPOSITE PAGE: This impressive lineup of Fokker-built D.VIIs of Saxon Jasta 72 was based on the Bergnicourt Aerodrome near Rethel, north of Riems, in July 1918. The aircraft first in line here belonged to ace Carl Menckhoff, who had thirty-nine victories—a large number of them scored in the D.VII. *National Museum of the USAF*

BELOW: Lieutenant Josef Mai poses before his Fokker D.VII. Mai would claim thirty victories two flying the D.VII. The black and white zebra stripes were an attempt to throw off the aim of attacking pilots. *National Museum of the USAF*

WIND IN THE WIRES

CHAPTER TWO: BETWEEN THE WARS
THE RISE OF THE MONOPLANE

The first great age of aviation had come to an end, and the "war to end all wars" showed aircraft to be versatile and deadly weapons. Air forces became significant additions to many countries' armed forces (the Royal Air Force became the world's first independent air arm on April 1, 1918). For many newly formed nations and the remaining major powers, military aircraft were vital to maintaining their sovereignty.

The Martin B-10 represented one of the most significant advances in the history of military aircraft. For the first time all-metal stressed-skin construction, cantilever monoplane wings, flaps, and retractable landing gear were combined in one aircraft. Its two cockpits and rotating front turret were fully enclosed. This example is flying over Oahu, Hawaii, in 1941 with the pilot's hood slid back. *National Museum of the USAF*

By the end of World War I, five categories of offensive military aircraft were standard:

Fighters Called pursuit aircraft into the 1930s, these were mostly single-seat aircraft armed with one or two forward-firing machine guns. They were short- range planes and were often extremely agile.

Bombers These fell into two categories: light bombers with a single engine and a crew of two, and heavy bombers with two or four engines and up to seven crew members. This category also included torpedo bombers.

Ground Attack These were single-engine two-seaters with a pilot and rear gunner. The world's first, purpose-built, all-metal, ground-attack aircraft was the Junkers J.I.

Reconnaissance These were single-engine aircraft with a pilot and and observer/gunner. The most effective was the Bristol F.2.

Maritime Patrol Aircraft like the Felixstowe F.2A, in service with the RNAS, flew antisubmarine and anti-Zeppelin patrols.

Also standard, and the one constant all World War I pilots shared, was an open cockpit—all airmen flew and fought in it. And for fifteen years after the war's end, the cockpit would remain open. While the war was fertile ground for aviation research and development, the end of the conflict meant a sudden halt to new aircraft production. With budgets slashed, most nations' militaries had little incentive or financial means to build better aircraft. Technological advances that might have been made were delayed for another ten years.

Any new types of planes produced were still biplanes of wood and fabric construction, although a few had steel-tube fuselage structures. Engine power had increased to 450 horsepower, but crews still had few instruments and no capability for "blind flying" in clouds. When some aircraft designers provided cockpit enclosures, it was often discarded by pilots because they found them cumbersome and unsafe. Attitude instrument development was extremely slow and the bubble-in-glass inclinometer remained the primary attitude instrument for most aircraft for the next decade. Pilots even continued to rely on the "wind-on-the-cheek" method to indicate sideslip during a turn, and they also continued to share their forward view with the upper wing and related wires and struts. The monoplane, by contrast, gave pilots a better all-round view, but designers would continue to favor the biplane over cantilever wings well into the 1930s.

One critical area in which pilot safety improved was the introduction of the Irvin parachute. Developed by Leslie Irvin and tested in April 1919, the US Army Air Service ordered three hundred for their use. The RAF experimented with their own designs, but Irvin's was superior and was adopted by them in 1924. As altitudes increased the parachute became a vital piece of equipment.

On February 27, 1920, Maj. Randolph Schroeder of the United States became the first man to reach a height of 33,143 feet (10,102

meters) in a powered aircraft. It was a significant feat and one that would alter cockpit evolution. Schroeder's aircraft was a Packard-Le Père LUSAC-11 two-seat fighter biplane powered by an experimental turbo-supercharged engine.

The ability to fly at greater altitudes offered many advantages. While in combat seeing the enemy first was crucial, and if you could fly higher than your opponent, you had a clear edge. Height also made interception a problem. The higher one flew the longer it took for a combatant to reach the same altitude. By the time a fighter reached the desired height, the enemy would be miles away. Height could also be traded for speed.

Experimental high-altitude flights helped advance cockpit development. Flying at high altitude required reliable oxygen systems, improved navigation, and more and better instruments. (Pilots would also finally get warmer clothing.) All these improvements would eventually lead to the pressurized cabin. That, however, was still a long way off—for fighter pilots, the "all-round" view remained critical. To have a canopy with structural members only added to the forest of struts and rigging wires already in place. An enclosed cockpit also limited arm signals, which were vital for pilots passing information. They even proved to be lethal as exhaust fumes were common in most aircraft. Machismo also played a role—pilots considered an open cockpit a test of their toughness and in the small fraternity of aviators it was the only way to fly.

High-altitude flying also advanced supercharging technologies and, thus, engine power also had a direct role in modernizing the cockpit. As horsepower increased in the 1920s so, too, did the number of cockpit instruments and controls. Cockpits now had to accommodate throttles, fuel-mixture controls, oil- and fuel-pressure gauges, engine-temp gauges, fuel-system cocks and levers, and oxygen systems. Aircraft designers at this time had to solve two basic and conflicting requirements: (1) position cockpit equipment and instruments to simplify the pilot's job, and (2) arrange the mechanical linkages connected to the various aircraft systems in a logical manner.

Cockpit design up to this point was still dictated by practical considerations and compromise, with very little thought given to the human driver. Most cockpits looked as if the instruments and controls had been tossed in to land where they may, forcing pilots to reach and blindly grope for poorly placed controls. Unfortunately, this led to accidents and fatalities. Another frequent criticism by pilots of this era was the lack of space when wearing their full flying kit and parachute. At the same time, aircrews didn't have other aircraft as a direct comparison, and designers were often unaware of problems or possible solutions. Cockpits continued to be cramped, cold, and cluttered.

Even with new instruments and controls, pilots continued to rely on "seat of the pants" sensations when flying, especially while in the clouds with no visible horizon. British research in the 1920s revealed that experienced pilots, when flying into clouds or under a hooded cockpit, would last just eight minutes before going into a spin. In 1928 the Hawker Tomtit RAF trainer was equipped with an extendible hood for blind flying, and the cockpit was equipped with the Reid and Sigrist blind-flying instrument panel that included the new turn and bank indicator. Pilots could now perform perfectly co-ordinated turns while flying blind. It was a big advance, but due to financial restraints, these bank indictors were in short supply.

On September 24, 1929, Jimmy Doolittle took his Consolidated NY-2 from takeoff to touchdown on instruments alone. The cockpit included three new instruments: an accurate altimeter, directional gyro, and artificial horizon. Note the canvas hood in the down position along the cockpit's edge. *National Museum of the USAF*

In the United States cockpit development and aircraft design was also stifled by budget constraints or pressing military needs. During World War I Americans were equipped solely with French and British aircraft, some of which were built on US soil with British cockpit instruments. For the next five years, American cockpit instrument development was painfully slow. By the late 1920s, however, when the British were tackling the problem of blind flying, Americans made their own cockpit advancements. On September 24, 1929, Lt. James "Jimmy" Doolittle of the US Army Air Corps made history while flying a Consolidated NY-2 Husky trainer. The cockpit was fitted with three new experimental flight instruments: a gyroscopic compass, artificial horizon, and precision altimeter, all designed and built by Elmer Sperry Sr. and Paul Kollsman. With his cockpit completely shrouded, Doolittle took off and, after climbing out, flew a 15-mile (24-kilometer) set course, returned, and landed. It was the world's first blind-flying takeoff and landing.

At the beginning of the 1930s, the performance of fighter aircraft increased by some 30 percent. Nevertheless, the fighters and bombers in service were hardly more operationally advanced than their early 1920s counterparts. Metal replaced wood and engine power and reliability improved, but the fabric-covered biplane remained in use and operations were still dependent on good weather. But change was on the horizon. The 1930s proved to be a decade of scientific discovery—groundbreaking innovations accelerated aviation technology and development. The march to war also added a worrisome dash of anxiety as designers and air staffs scrambled to predict the future.

In June 1933 the world's first all-metal bomber was put to use by the US Army Air Forces (USAAF). The Martin B-10 was a huge leap forward in aeronautical technology and design. In a single stroke the twin-engine B-10 made all biplane bombers and fighters around the world obsolete. Using monocoque construction, the monoplane

The British were the first to put some order to the placement of flying instruments in the cockpit. The RAF's "basic six" panel (seen here in a Gloster Gladiator) was a significant step forward and became standard equipment on all British fighters and bombers. Compared to the haphazard arrangement used by other air forces, the basic six panel was logical and easy to read.

B-10 was equipped with retractable landing gear, a rotating front gun turret, internal bomb bay, full engine cowlings, and, for the first time, a fully enclosed glass cockpit. It set the standard for bomber design for decades to come.

Across the Atlantic political developments set in motion a new arms race, accelerating the development of combat aircraft. Adolf Hitler's rise to power in 1933 radically altered the military landscape—his rearmament plans forced Britain, France, and other European nations to expand their air forces. Air staffs issued new requirements for bombers and fighters: The fabric-covered biplane was no longer viable, and cockpits would be fully enclosed and equipped with myriad instruments and controls.

While planes were being upgraded, manufacturers, unfortunately, continued to ignore the needs of the pilot. British industry was unable to recognize, or chose to ignore, the benefits of standardized cockpits.

(And it wasn't just a British problem.) To add some order to the confusion, however, the British developed the "basic six" panel. Built by Reid and Sigrist, the new panel grouped together six of the most important flight instruments: altimeter, airspeed, turn and bank, vertical speed, artificial horizon, and gyro heading. The panel became standard on all British fighters and bombers. In marked contrast American cockpit instruments were arranged in no apparent order and were different in every fighter and bomber. Meanwhile, new aircraft designs of the emerging German Luftwaffe had cockpits of a very high standard. Switches, selector levers, instruments, and labels were carefully designed, but like the Allies there was no standardization.

Just as the Martin B-10 transformed bomber design, the thirty-one-month period that followed (late December 1933 to summer 1936) saw a revolution in fighter design. These new models were modern monoplane fighters with retractable landing gear, flaps, and radios—and all but three would have enclosed cockpits.

The design race started with the Polikarpov I-16. First flown in December 1933, the Russian fighter was the world's first monoplane interceptor with a retractable undercarriage and the first to see operational service. The Luftwaffe responded with the Messerschmitt Bf 109 and Heinkel He 112. Shortly thereafter Hawker and Supermarine began their designs on Britain's Hurricane and Spitfire. The French answered with a specification for the Morane-Saulnier MS 405. By the end of 1934 the Americans began design work on the Curtiss P-36, followed in 1935 by the Seversky P-35 and the Brewster XF2A-1. The Italians produced two designs: the Fiat G.50 and Macchi C.200. By July 1939 all eleven fighters were in service, and in terms of cockpit design, all shared the same fate. Except for the Brewster XF2A-1, all were small and cramped with controls that were hard to reach or operate. While the Italians clung to the open cockpit, the rest had canopies that restricted overall view, especially to the rear. Reflector gunsights mounted directly in front of the windscreen also limited a pilot's forward view. It wasn't an ideal situation, but at the time these cockpits were state of the art.

By 1939 the fighting cockpit was a compact, disordered, and in some cases, a dangerous place to be. As horsepower, speed, altitude, and weaponry increased, so too did the pilot's workload. Additional, aerodynamic advances required new, and more numerous, sets of systems and controls for the pilot to master. Aircraft were now equipped with engine superchargers, variable-pitch propellers, flaps, retractable undercarriage, and oxygen systems. Not only did pilots have to manage these systems, they had to learn how to fight in these advanced, complicated machines. Surrounded by aluminum and glass, a World War I pilot would have been overwhelmed by a forest of instruments and controls. The stick and rudder pedals would be familiar, but everything else would be a mystery. For new pilots the cockpit was a technological marvel.

As European nations prepared for war, the cockpit characteristics of each country were easily identifiable. A blindfolded pilot would not only smell the difference, he would feel it as well. When a French or Italian pilot wanted to increase power he pulled the throttle levers backward (opposite of British, American, German, and Japanese designs). American cockpits were distinguished by their large size and greater number of switches and controls (due the extensive use

of electrical motors and actuators), and were far more comfortable. Ashtrays were even common and some cockpits had sound insulation. British cockpits, by contrast, came in various shapes and sizes with little consideration for pilot comfort. The only degree of uniformity was the adoption of the RAF's basic six panel. German cockpits reflected a sharp eye for detail and finish. Instruments were mounted on carefully shaped and finished brackets and all wiring was bundled and neatly tucked away. For Capt. Eric Brown, the differences were unique. "Throughout and after World War II, I had the opportunity to fly the aircraft of many nations," he remarked. "It was very interesting to see the differentiation between them. Not only was it instrumentation, the interesting thing was they all smelled differently. German aircraft you could tell by the type of paint they used. It was very distinctive. Because of their wooden construction, Russian aircraft smelled heavily of resin, and American aircraft, I would say, were almost hygienic."

For the thousands of young pilots preparing for war, the complicated cockpits and aircraft they would fight in were, in many ways, just as lethal as air combat itself. Accident rates were high, but the majority of pilots did cope. It was a credit to the high standard of their training and the adaptability these young men showed on the verge of war.

RIGHT: When it entered service in 1937, the Seversky P-35 boasted state-of-the-art cockpit design. Flight instruments were mounted directly in front of the pilot, with engine instruments grouped together down to the pilot's right.

BELOW: The Brewster Buffalo F2A-1 was the US Navy's first modern, all-metal, stressed-skin, monocoque-construction monoplane fighter. Equipped with a fully enclosed cockpit, retractable landing gear, and tail hook, it had a top speed of 301 miles (484 kilometers) per hour. *National Archives*

THE RISE OF THE MONOPLANE 55

MARTIN MB-2

Martin MB-2 | National Museum of the US Air Force | Replica

Ordered in June 1920, the Martin NBS-1 (Night Bomber Short Range) would become the first American designed and built bomber to be produced in quantity, but not before it was redesignated the MB-2. It was introduced to replace the small number of license-built British Handley-Page 0/400 and Caproni bombers assembled at the end of World War I.

The MB-2 was derived from the earlier MB-1 biplane bomber built by the Glenn L. Martin Company, and which entered service in October 1918, too late to see action in the war. The new MB-2 was essentially a World War I bomber. While it had more powerful engines, larger wings, and fuselage than the MB-1, it was still constructed of wood and canvas. Powered by two Liberty 12-A liquid 420-horsepower V-12 engines, the MB-2 had a top speed of 99 miles (159 kilometers) per hour and range of 400 miles (644 kilometers). With an aircrew of four, the MB-2 was capable of lifting 2,000 pounds (907 kilograms) of bombs and was armed with five .30-inch Lewis machine guns.

A transcontinental flight undertaken between September and December 1923 resulted in a document by 1st Lts. John F. Whiteley and Harold B. Smith that reported in part:

> All Martin bombers should be provided with some sort of suitable wind screen, which will afford good vision at all times.
>
> It is impracticable to fly a Martin at less than 70 miles per hour in bumpy air. At lesser speeds it is impossible to get

sufficient aileron control whenever the wing goes down. This is particularly true at altitudes above 5,000 feet [1,524 meters].

The ceiling of a standard NBS-1, Curtiss Type, with 250 gallons [946 liters] gasoline, 20 gallons [76 liters] oil, 500 pounds [227 kilograms] load, and four men, is approximately 10,400 feet [3,170 meters].

The most excellent characteristics of the service Martin Type bomber is its ease of landing and handling on the ground, at sea or at altitude.

Martin built 130 MB-2s, which equipped eight US Army bombing squadrons. They remained in service until 1928.

PILOT IMPRESSIONS
Leigh Wade, Test Pilot

- Taxies very easily except in strong crosswind.
- Takes off very easily, but uses a long run.
- Controls are normal.
- Rudders are of sufficient size to fly a straight course on either engine.
- Maneuvers very easily.
- Controls answer very smoothly, having no tendency to jerk.
- Can be flown with hands and feet off the controls except in too bumpy weather.
- Pilot's visibility is very good to the right, and fair in other directions.
- The airplane is improved laterally by the engines being on the lower wing, in comparison with the original Martin Bombers.
- Controls, except for the altitude controls, which are on the extreme left side, are very accessible for the passenger by the pilot.
- The airplane is not difficult to land, but loses its flying speed very quickly, having a tendency to lose its speed so quickly that it drops out from a glide.

"Official Performance Test of Martin Bomber N.B.S.-1 Equipped with two 400 Liberty H.P. '12' Engines," *Air Service Information Circular*, No. 290, October 1, 1921.

HAWKER HIND

Hawker Hind | Canada Aviation and Space Museum | Registration No. L 7180

When the Hawker Hart two-seat light bomber entered service in 1930, it was faster than the RAF's top fighters. Its success and exceptional performance led to a number of different variants that included the Demon, Audax, Osprey, and finally the Hind.

The Hind was, in many ways, a transition aircraft, bridging the gap between the old biplane era and the modern RAF bomber force, which was equipped with the all metal Fairey Battle and Bristol Blenheim.

Powered by a single Rolls-Royce Kestrel supercharged V engine developing 640 horsepower, the Hind had a rated altitude of 26,400 feet (8,047 meters), compared to the Hart's 22,800 feet (6,949 meters). With a top speed of 186 miles (299 kilometers) per hour, it was armed with one .303-inch forward-firing machine gun and one .303-inch Lewis gun in the rear cockpit, plus up to 500 pounds (227 kilograms) of bombs. Other improvements included: cut down rear cockpit for a better field of fire, a prone bomb aiming position for the observer gunner, and a tail wheel replacing the tail skid.

Production of the Hind was quick and efficient. The prototype flew on September 12, 1934, and one year later, in September 1935, the first production aircraft took to the air. Squadron service followed in 1936, and by spring 1937, more than three hundred Hinds were delivered, equipping twenty-six RAF Bomber Command Squadrons (plus thirteen auxiliary squadrons).

But the Hind's frontline service life was short. By the end of 1937 it was already being replaced by the single engine Fairey Battle and twin engine Bristol Blenheim. Fortunately for the RAF, who were desperately short of training aircraft, 124 Hinds were converted into dual-control trainers and issued to Training Command. The Hind continued in the training role well into 1941. By 1942 they were finally withdrawn and given secondary roles as glider tugs or communications aircraft until early 1943.

The Hind saw service with the air forces of Afghanistan, Republic of Ireland, Latvia, Iran, South African, Switzerland, and (the former) Yugoslavia. Total production was 582 aircraft.

PILOT IMPRESSIONS
Rob Millinship, the Shuttleworth Collection

The Hind is a big airplane and intimidating device. It's very similar in some respects to the Hawker Hurricane. It has a big, Rolls-Royce, liquid-cooled V-12 and a big, long-engine cowl and what appears to be a tiny little windscreen.

The whole airplane says "go fast" and makes a lot of noise. Ironically, it's quite a benign airplane. But certainly the intimidation factor is high.

Interestingly enough the Hind did not have the standardized British blind-flying panel. By World War II the blind-flying panel was standard on most British aircraft. In the Spitfire and Hurricane, the instrument panel is flat along the bottom and shaped like the letter D laying on its side. The Hind instrument panel is not like that; it's like a horseshoe. The instruments are strung around in an arch. Initially, you need to look around to identify where everything is. Like all these airplanes, you're simply not going to jump in and fly away. You'll spend a day sitting in it, understanding and learning where everything is.

The big problem for me was that I had to adjust the seat to its highest position. There, I could see straight out along the engine cowl with a sensible view out of the cockpit. There was one control in particular that's a real stretch for me and it's one of the most important in the cockpit. Because you have a liquid-cooled engine, the Hind has a huge radiator that retracts in and out of the fuselage. To regulate the engine temp you simply lower it into the slipstream. To raise or lower the radiator there's a ratchet wheel on the right side of the cockpit. I don't know the weight of the radiator, but it's a big brass construction full of water. To move it I have to reach down, grab a handful of the wheel, and heave back. It's hard work especially if you're flying in formation, doing 150 miles (241 kilometers) per hour at low level. Every time you move the throttle the temp changes, so you need

A company shot of a factory-fresh Hawker Hind complete with external bomb racks. The Hind was also armed with two .303-inch machine guns and was capable of carrying 500 pounds (227 kilograms) of bombs. *The Aviation Historian*

ABOVE: Sleek in design, the Hawker Hind was powered by a Rolls-Royce Kestrel V water-cooled engine developing 640 horsepower.

OPPOSITE PAGE: Five Hawker Hinds from No. 18 Squadron RAF fly in stepped up formation in 1938. No. 18 Squadron flew the Hind from 1936 until May 1939, when they were equipped with the Bristol Blenheim. *Royal Air Force Museum/Getty Images*

to be working the radiator, sometimes quite vigorously. It can be hard work for a little guy like me. There are occasions where I've had to get right down into the cockpit to move that wheel. It's bloody heavy to work. I've seen photos of the Hind roaring past the flight line apparently without a pilot. Everyone knows it's me because I'm down inside the cockpit grabbing a handful of that radiator wheel!

The Bristol Fighter and Hind are very similar in that the top wing is very close to the fuselage. The gap between the top of the fuselage and upper wing is no more than 9 or 10 inches (23 or 25 centimeters). Looking through that little slot along that big silver bonnet is most impressive.

The cockpit is luxurious, particularly if you retract the radiator. Because you're bringing the radiator right up into the cockpit you never get cold. There's always warm air coming up past your feet. The other really impressive thing about the Hind is the startup. The Rolls-Royce Kestrel engine is like a baby Merlin. When you get a slightly wet start, the smoke and flames reach all the way back to the cockpit. Something you don't get in your average Cessna 150!

The windscreen design is pretty good and the cockpit is not a turbulent place to be. If I were to change anything in the cockpit it would be the position of the radiator wheel. I would move it higher in relation to the position of the seat.

BETWEEN THE WARS

FIAT CR.32

Fiat CR.32 | Italian Air Force Museum | Original; built under license in Spain by Hispano-Suiza

Designed by Celestino Rosatelli the CR.32 took to the air for the first time in 1933. The CR.32 was an improvement over the CR.30, which appeared in small numbers in 1932. Smaller and more compact, the handsome and highly agile CR.32, while powered by a 600-horsepower Fiat A.30 R.A.bis twelve-cylinder liquid-cooled engine, still represented World War I thinking. Constructed of steel and light alloy, the fabric-covered aircraft had an open cockpit and fixed landing gear. Regarded as one of the best biplanes ever produced, the CR.32 relied on its superlative maneuverability to win and survive. It was a combat and design philosophy the Italians preferred even with the adaption of the monoplane fighter.

The Fiat CR.32 saw combat in two wars, with its greatest success occurring during the Spanish Civil War (1936–39). In 1936 some four hundred were in service with Italy's Regia Aeronautica (RA) when Spain's Gen. Francisco Franco asked Germany and Italy for air support for his Nationalists. Just days after the military coup that started the civil war, Italy sent twenty-four CR.32s to Spanish Morocco to aid Nationalist troops. By the end of the year, some 120 CR.32s were in service, providing protection and escort for both Nationalist transports and bombers.

CR.32s encountered Spanish Republican aircraft for the first time on August 21, 1936, over the city of Cordoba in southern Spain. Three CR.32s were based in nearby Seville. On their third scramble of the day, a single CR.32 engaged two Republican Nieuport-Delage NiD 52s. The CR.32's Italian pilot succeeded in shooting down one of the fighters with 172 rounds of 7.7-millimeter ammunition. The second victory of the war occurred on the August 27 when a single CR.32 shot down a NiD 52. The CR.32 soon established its dominance over the mixed equipment of the Republican air force well into the autumn of 1936. One of the keys to the CR.32's success was its reliability as a steady gun platform. Armed with two 12.7-millimeter machine guns that later replaced the 7.7-millimeter guns, it was one of the most heavily armed biplanes of the war. By late autumn new aircraft in the form of the Polikarpov I-15 biplane and the I-16 monoplane fighter began to reach Republican units. Flown by Russian and Spanish pilots, these new fighters came as a surprise and ended the CR.32's earlier dominance of the air.

Between 1936 and 1939 the Nationalists received 730 aircraft from Italy, including 477 CR.32s. During the course of the war, Italian pilots were credited with 709 confirmed aerial victories, with an additional 320 kills claimed by Spanish and foreign pilots. Just 118 Fiat CR.32s were lost.

The RA was still equipped with 292 CR.32s at the beginning of World War II, despite the aircraft's obsolescence. When Italy declared war against England and France in the second week of 1940, the fighter arm of the RA was biplane-heavy with 200 CR.42s and 177 serviceable CR.32 biplane fighters compared with 77 operational Macchi C.200s and 88 Fiat G.50s (both monoplanes).

BOEING P-26 PEASHOOTER

Boeing P-26A Peashooter | National Museum of the US Air Force | Replica

The Boeing P-26 was in many ways highly advanced. It also was a transition aircraft, bridging the gap between the biplane era and the new, more developed, monoplane. The P-26 would lay claim to many "firsts"—and an equal number of fighter "lasts." Entering service in June 1934, the P-26 was the US Army Air Corps' (USAAC) first production all-metal monoplane fighter of semimonocoque construction. It would also be the last with an open cockpit, fixed undercarriage, and externally braced wing, as well as Boeing's last production fighter.

Design of the Boeing Model 249 (P-26) was initiated in September 1931. Progress was rapid with the first prototype taking flight on March 20, 1932. The P-26 was in many ways an experimental design and for Boeing it was a big risk. During the Great Depression aircraft orders were few and far between. To hedge their bets Boeing focused their manpower and production facilities on the P-26. Entire design and engineering teams set up their workspaces alongside the three prototypes as they were being built. It was a brilliant move. In January 1934 a contract for 111 P-26As was issued; this was later increased to 136, the largest military order since 1921 for a single aircraft type.

Powered by a Pratt & Whitney Wasp R-1340-27 radial engine rated at 500 horsepower, the P-26A had a top speed of 234 miles (377 kilometers) per hour at 6,000 feet (1,829 meters). Armament consisted of two .30-caliber machine guns or one .30-caliber and one .50-caliber machine gun.

Once it was in service, however, the USAAC was not happy with the P-26's high landing speed. The army developed experimental flaps that they fitted to one aircraft. The results were promising, reducing landing speed from 82.5 miles per hour to 73 miles per hour (133 to 117 kilometers per hour). Soon the flaps were fitted to all P-26As in service and to those P-26Bs and Cs on the production line.

The P-26 had the honor of being the first American-built fighter to do battle with the Japanese before the attack on Pearl Harbor. It was also ordered by the Chinese in 1934, who equipped one squadron and saw constant action with it before being forced out of service due to a lack of spares. Additionally, the P-26 saw combat during the Spanish Civil War, with a single example flying on the Republican side.

The last production P-26C left Boeing in 1936. The P-26 would serve in twenty-two USAAC squadrons and remained in frontline service with the Philippine Army Air Corps until December 1941. Soon after the attack on Pearl Harbor, Philippine P-26s of the 6th Pursuit Squadron claimed one Mitsubishi G3M Type 96 bomber and two or three A6M2 Zero fighters. Clearly obsolete, the last Philippine P-26s were burned by their crews in late December.

Considered radical at the time of its introduction, the P-26 was out of date within three years. Boeing responded with a new version called the P-29. Featuring a fully cantilevered wing, retractable landing gear, and fully enclosed cockpit, the new P-29 proved just 16 miles (26 kilometers) per hour faster than the P-26 and was soon canceled. In total 151 "Peashooters" were built with a unit cost of $14,009 each.

CURTISS F9C SPARROWHAWK

Curtiss F9C-2 Sparrowhawk | Smithsonian National Air and Space Museum, Steven F. Udvar-Hazy Center
Original; only known example in existence

The Curtiss F9C Sparrowhawk has to be one of the most unusual and unique fighter aircraft ever built. Known as a "parasite" fighter, the Sparrowhawk was neither land- nor carrier-based—it was an airship reconnaissance fighter. Designed for the two largest airships at the time—the USS *Akron* and USS *Macon*—the F9C was air launched. Its job was to provide the airships with long-range reconnaissance capability and protection against aerial attack.

The concept of an air-launched fighter was not new. In 1918 the Royal Flying Corps successfully launched a Sopwith Camel from HM Airship 23. Delivered in March 1931 the first XF9C-1 had a monocoque metal fuselage, metal wings with fabric covering, and an aerial hook located directly in front of the cockpit. After several hook-on tests in October 1931, the new prototype left a lot to be desired. A second prototype (XF9C-2) was produced with a more powerful engine, a pronounced upper gullwing, single-strut landing gear, and a new tailplane. After trials, six new F9C-2s were ordered, bringing the number to seven, including the second prototype; in June 1932 the first successful hook-on took place aboard the USS *Akron*. On April 4, 1933, the *Akron* was lost at sea (without any aircraft aboard) and all F9C-2s were transferred to the USS *Macon*, which could accommodate four Sparrowhawks. During operations the landing gear was removed, and a fuel tank added for improved range and performance.

Unfortunately, on February 12, 1935, the *Macon* was hit by a hurricane and lost at sea with all four fighters aboard. The three surviving F9C-2s had their hooks removed and were placed in navy reserve.

PILOT IMPRESSIONS
Lew "Woody" Williamson, USN

It was the most enjoyable airplane I've ever flown and I've flown a whole lot of them.

I had just finished a flight when right across the taxiway I saw a new aircraft sitting on the ramp. I said to myself, "Another oddball." I walked into the operations room and checked myself in. I was told to go out, look at that airplane, and give them an estimate. I went out to the Sparrowhawk, checked it over, and realized it was in fairly good shape.

The cockpit was real small. You could hardly get a parachute in it. One interesting thing about the Sparrowhawk cockpit was the placement of the compass. It's on the outside left wing. Interference from the metal hook caused them to move it outside of the cockpit.

At the time of my inspection, I wasn't allowed to fly the Sparrowhawk. My commander said everything we had on the ramp had to have a pilot's handbook. If I wanted to fly the Sparrowhawk, I first had to fly up to Lakehurst, New Jersey, and go through a pile of boxes in the hope of finding a handbook. I went through half a dozen before I finally found three copies. I read those things cover to cover and took an oral test. I knew the airplane fairly well after that.

Because it was a single-seat cockpit, there was no way for me to be checked out on the airplane. At first I just taxied up and

The world's first operational "parasite" fighter, the F9C-2 was considered very capable. Once on board the airship, its landing gear was removed, allowing for improved performance and range. *National Naval Aviation Museum*

down the ramp. A half hour later, and feeling more comfortable, I took it out to the strip and turned into the wind. I fireballed that thing and went forward on the stick. The tail came up. I didn't go more than 200 feet (61 meters) before it bounced off the runway straight into a climb. I said, "Man, I'm not going to deviate from this climb at all." I climbed up to about 2,000 feet (610 meters) and leveled off. I went on up to 4,000 feet (1,219 meters) and started working with it. Just shallow banks at first. I did a head-on climbing stall. Spun it about three times. All the recoveries were fine.

I then went up to 8,000 feet (2,438 meters) to give it a real workout. The first thing I tried was a hammerhead, but something happened between the time I started my turn and the airplane stalling. I was doing about 90 knots but I was going too fast for an actual stall. The Sparrowhawk stalls at 58 knots. So I kicked it over and suddenly it snap-rolled, followed by another, and went straight up. I don't know what the airplane was doing but it turned me every way but loose. Finally, I put the airplane into spin and recovered at about 2,000 feet (610 meters). I was so damn sick when I brought the airplane back to Norfolk. I had cuts in my shoulders caused by my parachute straps. When I finally taxied up to the ramp the ground crew said, "Man, what happened to you? You look white as a sheet." I went to sickbay and stayed there for three days.

The Sparrowhawk was a truly unique fighter. When aboard the airship, all engine starts were done outside on the trapeze. It was a fire hazard. All aircraft were lowered away from the airship, but not all the way. Just before the maximum extension, a little cord was passed down to the airplane. The pilot would then plug it into a little receptacle in the cockpit, just like a cigarette lighter. That provided power for the starter.

The airships were usually equipped with three or four fighters, but they couldn't take off with them onboard—the Sparrowhawks had to go onboard in the air. Once onboard the landing gear were removed, which reduced drag and improved airspeed.

I can fairly say of all the things I've flown, and I've flown some airplanes, the Sparrowhawk has to be the finest I ever sat in. It was so agile. You could hold your hand out in the slipstream and it would start a bank. But you had to be very careful with it because it would over-control very easily. Come back on that stick just a bit, and you'd go straight up in the air. It was a good airplane and a good fighter. In its day it was the best flying airplane in the world.

Capturing the trapeze aboard the USS *Macon* in 1933. Designed as a pursuit fighter, the F9C's primary role was reconnaissance. Visibility from the cockpit was ideal for launching and retrieval, but downward vision was restricted. *Author collection*

VOUGHT SB2U VINDICATOR

Vought SB2U-2 Vindicator | National Naval Aviation Museum | Original; only known example in existence

In many ways the SB2U Vindicator was more a transitional aircraft than a transformational one. When it was first flown on January 4, 1936, it was considered a modern break from the biplane era. Even though it was a cantilever monoplane with retractable landing gear and a fully enclosed cockpit, the fuselage structure of steel tubes and fabric remained. By the time of its first carrier landing, it had already been overtaken by developments in light-metal, stressed-skin monocoque structures.

The US Navy (USN) and Marine Corps (USMC) ordered 169 SB2U-1s, -2s, and -3s. The French Navy ordered ninety examples based on the SB2U-2, designating them V-156-Fs. Forty more saw action with Escadrilles AB-1 and AB-3 during the Battle of France in May 1940.

In June 1942 the Marine Corps' SB2U-3 Vindicators from VMSB-241 participated in the Battle of Midway. Operating from Midway Island, the Vindicators didn't score any hits on the Japanese fleet and suffered heavy losses. It was the Vindicators' last combat mission.

Following the Japanese defeat, all Vindicators were transferred to training units throughout the United States, with the largest concentration of SB2Us located at the naval air station in Jacksonville, Florida.

PILOT IMPRESSIONS
Captain Eric Brown, RN (Ret.)

It was not that the Chesapeake, the RAF's name for the Vindicator, was a bad aircraft; it simply was outmoded.

The cockpit was situated almost level with the wing leading edge and proved roomy in the usual American style, although . . . even with the adjustable seat in its lowest position, [someone 6 feet tall (183 centimeters)] must have found the sloping sides of the aft-sliding canopy pressing in on his ears. Visibility was good in all directions except downward, which was precisely where it was needed the most if an aircraft is intended to fulfill the dive-bombing role . . . [and] the framing of the small clear-vision panel irritatingly detracted from forward view.

The instruments were quite neatly arranged, but the layout of the panels would have been considered somewhat illogical in later years, and the control column was awkwardly far forward.

The [Vindicator] proved to be stable about all axes but was sensitive to loading . . . for example, if the contents of the wing-center section tank were exhausted and full ammunition happened to be carried for the aft-firing gun, it became markedly unstable longitudinally, while with full fuel and ammunition but without bombs, it was necessary to remove the aft floor and bulkhead armor, the arrester hook, and the landing flares in order to keep [it] within the aft limit.

The [Vindicator] was steady enough in a dive, but even with the undercarriage extended, the dive angle had to be limited to about 60 degrees. Another limiting factor was, of course, the poor aileron control, which greatly affected bombing accuracy as aileron turns onto the target are the only means for correcting misalignment once committed in the dive. In short, as a dive-bomber, the [Vindicator] could be considered as one of the also-rans.

WESTLAND LYSANDER

Westland Lysander Mk III | Canada Aviation and Space Museum
Constructed from parts of three surviving aircraft | Registration No. R9003

The Westland Lysander was one of more unusual-looking aircraft of World War II. Its high, bent seagull wing with two "V" struts and enormous fixed landing gear made it look ungainly and slow. But looks can be deceiving. The Lysander was indeed capable of flying very slow, but it was a well-balanced aircraft with remarkable short takeoff and landing capabilities.

When the British Air Ministry issued Specification A.39/34 calling for a two-seat army cooperation aircraft to replace the Hawker Hector, Westland Aircraft Limited put forth the well-thought-out Lysander. Determined not to repeat mistakes made on an earlier fighter interceptor proposal, Westland's technical designer, Edward Petter, interviewed RAF pilots directly and asked what they required in a new army cooperation aircraft. The consensus revealed that good visibility, exceptional takeoff and landing capabilities (especially from small, unprepared fields), and excellent low-speed handling characteristics were vital.

To address visibility, Westland designer Arthur Davenport put the wing at the top of the canopy, bracing it with two sturdy struts. To boost the aircraft's low-speed handling, the unique wing structure was thickest at mid-span, shrinking to nearly half that at the wing roots. The Lysander was also the first British aircraft equipped with leading-edge slats and trailing-edge flaps. These devices operated automatically, giving the Lysander its phenomenal low speed flying capabilities.

The first prototype flew on June 15, 1936, with an order for 144 following in September. At the outbreak of World War II, 66 Lysander Mk Is in seven RAF squadrons were operational.

The German invasion of the Netherlands, Belgium, and France in May 1940 saw the RAF's Advanced Air Striking Force equipped with four Lysander squadrons. The aircraft did not fare well during the furious onslaught, even with Hurricane fighter escorts. One hundred and eighteen Lysanders were lost during the Battle of Belgium and the Battle of France. But it wasn't all one sided—Lysander crews were credited with the destruction of one Messerschmitt Bf 110, one Henschel Hs 126, and one Junkers Ju 87

The fall of France revealed the Lysander's extreme vulnerability to fighter attack, but its unique flying characteristics made it desirable for other vital roles. While overseas squadrons, especially in the Middle East, continued to use the Lysander in the reconnaissance and ground attack role, it was quickly reassigned as a target tug, trainer, air-sea rescue aircraft, and courier with the Special Operations Executive. In its most famous role, specially modified Lysander Mk IIIs of No. 138 (Special Duties) squadron flew agents and supplies in and out of occupied France well into 1944.

In total, 1,786 Lysanders were built, including 225 under license in Canada.

PILOT IMPRESSIONS
John Aitkens, Display Pilot, Vintage Wings of Canada

I joined the RCAF in 1960 via the Regular Officer Training Plan and completed pilot training in the spring of 1965. I was then posted to Bagotville for five years, flying the CF-101 Voodoo. In January 1971 I was posted to Edwards Air Force Base for the USAF Test Pilot School Course and spent the next eight or nine years in military flight test. I left the RCAF in 1982 for the National Research Council of Canada's Flight Research Laboratory, retiring in 2007 as chief pilot. Shortly after, I began flying with Vintage Wings of Canada.

BELOW: A Lysander Mk III of No. 4 Squadron poses for the camera in 1941. The stub wings, attached to the undercarriage fairing, were capable of carrying light bombs, giving the Lysander a limited ground attack capability.

OPPOSITE PAGE: A Mk I Lysander from No. 4 Squadron picks up a message during a training flight in mid-1939. The message was attached to a rope between two poles. A hook attached to the top of the main undercarriage leg would snag the rope and the message then retrieved by the observer.

74　BETWEEN THE WARS

The Lysander is a strange airplane. Compared to the Spitfire or Mustang it's a big aircraft, with a wingspan of about 50 feet. Designed for short takeoffs and landings from rough, unprepared airfields, the Lysander's role was to provide the army with reconnaissance, artillery-spotting, and general communications capability.

The cockpit sits high off the ground. The view down and forward is very good. You have about a 90-degree field of view to the left and right, but the vision over the engine while on the ground is poor. One of the first things you notice is that there's no cockpit floor—drop anything and you won't be able to retrieve it until you land. The cockpit layout is typically British, with the center blind flying panel. All controls are easy to hand. The seat position and rudder bar are adjustable. Because the engine oil tank is just forward of the instrument panel and the oil coolers are located just outboard of your left and right legs, the cockpit tends to get uncomfortably warm.

Taxiing the aircraft can be tricky. The Lysander is equipped with pneumatic brakes, which work to a modest degree but are definitely weak. The aircraft is not fitted with a steerable tail wheel, so taxiing requires the use of differential braking. The large vertical tail and fuselage side area aft of the main wheels results in the Lysander's acting much like a weather vane while taxiing in winds above 10 to 12 miles per hour. The combination of weak brakes and the "weather vane" effect limit the pilot's ability to control the aircraft on the ground.

The Lysander's takeoff and landing speeds are low; liftoff happens at around 50 miles per hour. Immediately after takeoff the aircraft has a "mushy" or "wallowing" feel, but as speed increases, control tightens to a more normal feel.

Rudder trim is not provided—not a problem, as rudder forces tend to be light even up to cruising speed. Trim is provided only in the pitch axis and is affected by changing the angle of the horizontal tail. Elevator control is directly affected by trim position airspeed and prop wash. More power means enhanced elevator control. The pilot must be aware of pitch control available to him, especially in low-speed and low-power conditions. With the wrong pitch-trim setting, the pilot can lose pitch control at speeds as high as 65 miles per hour. Pitch trim is changed by rotating a wheel to the left of the pilot's seat and takes from fifteen to twenty seconds to execute.

Unique to the Lysander the full-span leading-edge slats, which are connected to the flaps. The pilot has no control over either; as the angle of attack increases, the slats pull out along with the flaps. The slower you fly straight and level, the farther the slats come out. The slats were designed to control the airflow over the top of the wing and delay separation. You literally can't stall the airplane.

If I could change anything in the Lysander cockpit it would be more ventilation, better steering, and a more responsive pitch-trim control mechanism.

THE RISE OF THE MONOPLANE

PZL P.11

PZL P.11c | Polish Aviation Museum | Serial No. 863; 121st Flight of the 2nd Air Regiment, September 1939

Before World War II began, Poland boasted a well-developed aircraft industry and some good designs, including a modern, twin-engined light bomber, the PZL P.37. What it lacked, however, was a high-performance fighter. On the eve of the war, a dozen squadrons were equipped with the Bristol Mercury–powered PZL P.11c.

The PZL P.11 was a gullwing, all-metal fighter with a conventional layout, fixed landing gear, and an open-cockpit design. It was powered by a 565-horsepower engine, giving it a top speed of 242 miles (389 kilometers) per hour. Armament consisted of two (and later four) 7.92-millimeter machine guns.

When the P.11 entered service in 1934, it was arguably the most advanced fighter in the world. Slightly superior to the British Gloster Gladiator and German Heinkel He 51 biplane, it was nevertheless obsolete by 1935/36 with the introductions of the Messerschmitt Bf 109, Hawker Hurricane, and Supermarine Spitfire monoplane fighters.

When Germany invaded Poland on September 1, 1939, the Polish Air Force had the PZL P.11c (109 units), P.11a (20 units), and P.7a (30 units) ready for battle. The Luftwaffe committed more than 1,500 first-line aircraft to the attack, including roughly 360 Bf 109s. In anticipation of hostilities the Poles dispersed their fighters to remote airfields. Up against the Luftwaffe's latest Bf 109Es and Me 110Cs, the brave Polish fighters were hard pressed. Both German fighters were faster by up to 100 miles (161 kilometers) per hour and their armament was far heavier. German bombers were also hard to shoot down with the P.11's weak armament. In their attempt to save their air force from destruction on the ground, the Poles never had the chance to concentrate their fighters and blunt the German attack in the first days of the war.

Advantages the P.11 did have were its maneuverability, good rate of climb, better all-round view from the cockpit, and short-airfield performance. The P.11 may have not been the best fighter, but it would record the Allies' first and second air-to-air victories of the war. On the morning of September 1, a PZL P.11c flown by Władysław Gnyś shot down two Dornier Do 17Es returning from an early morning raid on Krakow.

Despite the Luftwaffe's vast superiority, the P.11 put up a reasonably good fight. Without early-warning radar or a well-developed ground-to-air radio network, the Poles fought courageously. In just more than four weeks, Polish fighters put 564 German aircraft out of commission, of which 285 were destroyed. At least 110 were credited to pilots flying the P.11, who lost 100 of their own.

Eventually defeated by both Germany and Russia, the Polish armed forces would fight on until the end of World War II, with 84,500 Polish soldiers, sailors, and airmen battling with the Allies in France, Britain, Norway, Italy, Normandy, and Syria from 1939 until 1945. During the Battle of Britain, two full squadrons (Nos. 300 and 301) of Polish fighter pilots flew with the RAF, with many more participating in other RAF squadrons (141 pilots fought, with 29 killed). By D-Day four Polish Spitfire and one Polish Mosquito IV squadrons were assigned to the British Second Tactical Air Force.

CHAPTER THREE: WORLD WAR II
DEATH AT 30,000 FEET

At 0234 hours on September 1, 1939, the first bombs of World War II fell. Shortly after that the first air-to-air victory of the war was recorded.

After honing their skills and tactics during the Spanish Civil War, German Luftwaffe pilots unleashed a well-planned aerial campaign against Polish air and ground forces. Leading the attack was the famous Junkers Ju 87 dive-bomber. Designed in 1935 the Ju 87 was a single-engine, low-wing monoplane with fixed landing gear and a crew of two sitting back-to-back under a large glazed canopy. On September 1, the Luftwaffe had approximately 331 Ju 87s ready for combat. Not only did the Ju 87 drop the first bombs of the war, it also claimed the first Allied aircraft shot down. While returning to their base on the first day of the war, elements of the *Sturzkampfgeschwader* 2 flew over a Polish airfield just as a pair of PZL P.11c fighters were scrambling. In sharp contrast to the Ju 87, the PZL P.11c was an open-cockpit fighter with a high-mounted gullwing. As they clawed for altitude intent on the Ju 87s in front of them, the Polish pilots failed to notice a trio of Ju 87s closing in behind them. It was over in a matter of seconds. Lining up his target Lt. Frank Neubert fired a short burst, hitting one of PZLs' cockpit and causing the aircraft to "suddenly explode in midair."

Neubert's shot provided a symbolic end to the era of the open cockpit. Cockpit deficiencies, both in equipment and pilot usage, would also come to the forefront during the war. The Fairey Battle was a single-engine British monoplane bomber with a crew of three. Just prior to the war, in 1938, a prototype was written off after a forced landing. The pilot mistakenly moved the fuel selector lever to the right believing it would connect with the right tank. Unfortunately, the cockpit designers (who had not consulted with the pilots) had arranged the fuel selector lever for the right tank to move to the left, and the left tank to the right.

Lack of standardization in combat cockpits meant important equipment located on one side in one type of aircraft would be situated on the opposite side of a different plane. Difficult-to-reach items were the norm, forcing pilots to reach awkwardly. In some aircraft takeoffs and landings required pilots to switch hands in flight in order to operate flaps or the undercarriage. It was not a perfect situation, yet most of the same equipment could be found in British, German, French, Dutch, Belgium, Russian, Italian, Japanese, and American fighters and bombers. A single-seat fighter like the German Bf 109, for example, was comparable to the Curtiss P-40 or Spitfire. Each was a monoplane powered by a single, liquid-cooled engine developing just over 1,000 horsepower. Not only was performance similar, each had a good deal of apparatus in common.

One glaring error in the early days of the war was the lack of armor plate for pilots and aircrew (the first fighter equipped with armor plate was the Polikarpov I-16 in 1936). The Supermarine Spitfire, Hawker Hurricane, and Messerschmitt Bf 109 all entered service without armor plate. British fighters, however, were modified before the Battle of Britain. For the Spitfire this included a bolted-on armor glass windscreen and 72 pounds (33 kilograms) of armor plate. Remarkably, the Bf 109E wasn't equipped with armor until the E-4 version appeared at the height of the Battle of Britain in August 1940.

As reports of combat experiences reached the United States, modifications to US fighters soon followed. The Bell P-39 and Curtiss P-40 were retrofitted with armor plate and self-sealing fuel tanks. The navy followed suit in 1941, fitting 149 pounds (68 kilograms) of armor plate to their Grumman F4F Wildcats. Its main opponent, the faster and more maneuverable Mitsubishi A6M Zero-sen, had no armor plate or self-sealing fuel tanks. (The first version of the A6M to carry armor behind the pilot's seat was the A6M5c Model 52c, which didn't enter service until autumn 1944.) The Italians, on the other hand, went one step further. "The pilot is well protected by armor plate from astern and, in fact, to about 40 degrees off dead astern," a British Air enemy aircraft report noted. "He is provided with a bucket seat entirely constructed from a single piece of 8-millimeter amour, which stretches

TYPICAL COCKPIT EQUIPMENT
CIRCA 1939

By 1939 most cockpits of both Allied and Axis powers shared similar equipment and systems, including the following:

- Reflector gunsight
- Multiple rifle-caliber machine guns or a combination of heavy machine guns and/or 20-millimeter cannon, including arming circuits and ammunition magazines
- Radio for both air-to-air and air-to-ground communications
- Oxygen system
- Hydraulic system
- Electrical generator and circuits for radio, IFF (identification friend or foe), and other equipment
- Undercarriage controls

Early-war bombers like the Vickers Wellington and Heinkel He 111 were similarly equipped but with additional items for self-defense, navigation, and bomb aiming. Each had the following:

- Handheld rifle-caliber machine guns on movable mounts or in powered enclosed turrets
- Space for a navigator and radio operator and his specialized equipment
- Bombardier's position with bombsight and associated arming and release circuits

from his shoulders almost to his knees and comes well round the sides of his body. The armor plate seems to be handmade."

Armor plate thickness varied from 8 to about 13 millimeters and was face-hardened of good quality. The armor was effective against rifle-caliber machine guns, but as the war progressed these weapons were replaced by far more powerful weapons like the .50-caliber machine gun and 20-millimeter cannon, both of which could easily penetrate 8 millimeters of armor plate.

Success and survival in aerial combat often came down to the simple act of spotting the enemy first—a major advantage. According to a tactics report written by Lt. Col. Mark Hubbard, ninety percent of all fighters shot down never saw the pilot who hit them. With the enemy spotted, a pilot could assess the situation and decide on an appropriate course of action. All this, of course, depended on the view from the cockpit and the pilot's eyesight.

> **"Probably the biggest thing to a fighter pilot is being able to see things—not only to see them, but to interpret them. When he sees fighters too far away to recognize, he should have a fairly good idea whether they are friendly or not by the way they act."**
>
> —Captain D. W. Beeson, 334th Fighter Squadron, USAF

Most World War II fighters were equipped with fully enclosed cockpits (exceptions being the Polikarpov I-153 and I-16, the Fiat CR.42 and G.50, and the Macchi C.200), which restricted a pilot's view, especially to the rear. Most canopies, like those on the Hurricane Mk I and F4F Wildcat, were constructed using square metal framing. These strips blocked the pilot's view, which in combat could prove fatal. The Spitfire Mk I, however, was equipped with a slightly bulged clear canopy hood by the time the Battle of Britain started. The view directly astern was still nonexistent, but the RAF did add small mirrors on the top of the canopy to give their pilots some rearward vision. The German Bf 109E-3, on the other hand, with its heavy square bracing and cramped headroom, had the worst canopy construction and all-round view. Günther Rall, who served with III/JG 52 during the Battle of Britain, commented, "In contrast our Bf 109s had shortcomings. I didn't like the slats and our cockpits were very narrow, with restricted rear visibility. Fighter pilots need a good all-round field of vision and we didn't have it."

By 1943 the Bf 109's canopy issues were addressed with the introduction of the Erla Haube hood. The clear canopy offered a greatly improved field of vision, though to be fair, the view astern from most, if not all, World War II fighters was poor. It wasn't until the introduction of the Focke-Wulf Fw 190A in 1941 that the issue was successfully addressed.

The Fw 190 was in many was a revolutionary fighter. The Focke-Wulf team concentrated on reducing the pilot's workload by designing one of the first examples of an ergonomic cockpit. It broke new ground in terms of pilot comfort, ease of use, and versatility. The most noticeable innovation was the introduction of the "bubble canopy." The introduction of vacuum forming gave the Fw 190 a clear, self-supporting canopy that offered greatly improved all-round views. The pilot sat in a semireclining seat, which was ideally suited for high-G maneuvers, but the most innovative feature was the ingenious *Kommandogerät*—a "brain box." When the pilot moved the throttle forward or back, it automatically adjusted the mixture, propeller pitch, boost, and rpm. It also cut in the second stage of the supercharger at the correct level.

In 1942 the British Air Fighting Development Unit fully evaluated a captured Fw 190A-3, offering high praise for the cockpit:

> The cockpit is fully enclosed and although rather narrow is otherwise extremely comfortable. The pilot's position is excellent and as his feet are level with the seat, it enables him to withstand high acceleration forces without "blacking-out." The positioning of instruments is excellent and all controls fall easily to the pilot's hand, the absence of unnecessary levers and gadgets being particularly noticeable. The front panel is in two pieces, the top containing the primary flying and engine instruments, and the lower panel the secondary instruments. Cut-out switches for the electrical circuits are housed in hinged flaps on the starboard side.
>
> The switches and indicators for the operation of the undercarriage, flaps and tail incidence, are situated on the port side. The control column is the standard German fighter type with a selector switch and firing button for guns, and a send/receive button for the wireless.
>
> The cockpit canopy, which is made of molded Plexiglas, is well shaped and extends far back along the fuselage. The bulletproof windscreen has a pronounced slope, which is unusual. The canopy can be slid back for entry and exit and for taxiing, operation being by means of a crank handle similar to that in the Westland Whirlwind. The enclosure can be jettisoned in an emergency by pressing a red lever on the starboard side; this unlocks the hood and detonates a cartridge, which breaks the runners and blows the canopy off. Heating for the cockpit appears efficient, and cooling is effected by a small flap on the port side and seems quite sufficient for the pilot's comfort.
>
> The view for search from the Fw 190 is the best that has yet been seen by this Unit. The cockpit hood is of molded Plexiglas and offers an unrestricted view all round. No rear view mirror is fitted and it is considered unnecessary as the backward view is so good.

The Allies finally addressed the problem of all-round cockpit vision with the introduction of teardrop bubble canopies on the P-51D, P-47D, and Spitfire Mk XVI in 1944.

> **"The pilot who sees the other first already had half the victory."**
>
> —Hauptmann Erich Hartmann, German ace

This view illustrates the square metal framing of the F4F Wildcat's canopy. In combat a thin strip of metal could easily block the pilot's view of an approaching fighter. Also, without a rearview mirror, this pilot's vision to the aft is extremely restricted. *Author collection*

Long before the bubble canopy became standard on aircraft, the view from the cockpit was greatly improved with new tactics and electronics.

During the Spanish Civil War, German fighter pilots learned the best way to achieve a victory was to abandon the standard three "vic" formation in favor of the two-aircraft *Rotte* (pair). As a fighting pair, the *Rottenführer* (pair leader) did all the shooting. His wingman (the *Katschmarek*) had one job: protect his leader. With his tailed covered, the attacking leader could concentrate on his target and not the airspace around him. Two *Rotten* would combine to form a *Schwarm* (flight), flying some 300 yards (274 meters) apart in a line abreast. This loose formation allowed each pilot to concentrate on a selected patch of sky instead of the aircraft flying around him. The views offered by the *Schwarm* greatly increased combat effectiveness, and it was adapted by every air force, in some form or another, during World War II. American ace Capt. Robert S. Johnson of the 56th Fighter Group knew the power of the fighting pair: "Any time you lose your wingman or leader, you've lost 75 percent of your eyes and fighting strength. Jerries will shoot at anyone."

New electronics in the cockpits would also increase all-round vision, and was made possible by the invention of radar and reliable air-to-air and air-to-ground radios. Radar let ground controllers see hundreds of miles or kilometers into enemy territory. Approaching aircraft could be detected early, giving intercepting forces the time required to scramble quickly into a favorable attack position. Radar also alerted patrolling fighters of advancing enemy aircraft. With air-to-air communication, pilots were warned of unseen attacking fighters. The cry of "Messerschmitts! BREAK! BREAK!" was guaranteed to send whole formations scattering. The view from the cockpit was also now measured in miles no matter the type of canopy. Starting in 1941 night fighters were fitted with top-secret airborne intercept radar (AI), giving them the ability to see in the dark.

By the end of 1941, the world was fully engulfed in war, with America, Japan, and Russia as full participants. America introduced a number of new aircraft, including the four-engined Boeing B-17 and Consolidated B-24 heavy bombers. New fighters included the Lockheed P-38, Bell P-39, Curtiss P-40, and Republic P-47. Japan would shock the world with their nimble and deadly Mitsubishi A6M2 Zero-sen and Nakajima Ki-43 Hayabusa fighters. The Russian air force, considered the world's largest, was equipped mostly with obsolete open-cockpit fighters. New fighters like the MiG-3, Yak-1, and LaGG-3 with enclosed cockpits were just reaching frontline units at the time of the German invasion in June 1941.

For Americans the B-17 and B-24 formed the backbone of their strategic bombing force. Both the RAF and USAAF had embraced the idea of strategic bombing as a means to win the war and believed that large formations of Lancasters, Halifaxes, B-17s, and B-24s would do the job. In terms of performance all four bombers were roughly the same. It was in the cockpit where they differed. The British had taken the single-pilot approach for both their four- and twin-engined bombers. American flight decks often reflected a civil aviation cockpit arrangement with a pilot and copilot sitting side by side, the Douglas A-20 being the exception. By contrast, the pilot of the British Avro Lancaster was responsible for flying the aircraft while the flight engineer took care of the engines and throttles. An American Army Air Forces Materiel Command report dated December 6, 1943, had high praise for the Lancaster cockpit:

> The cockpit compartment, like earlier British heavy bombers, is arranged for a single pilot and a flight engineer, the engineer's position being directly behind the pilot while the usual co-pilot is primarily a passageway to the bomb aimer's "greenhouse" in the nose but is provided with a folding jump seat. The layout has been carefully planned for arrangement and simplification that is so desirable for night operations. All the controls fall readily to hand and are easily identified. The trim controls operate in the correct plane and are conveniently located. Many automatic features add to the simplicity of operations of the Lancaster. Cockpit comfort was considered highly satisfactory.
>
> The vision was found to be exceptionally good. This quality had been more carefully designed for by the British in their heavy bombers than by our designers.
>
> The Lancaster is one of those rare airplanes in which the pilot feels at home immediately. This feature makes transitioning a pleasure by inspiring confidence.

The Consolidated B-24 represented the best of early 1940s American aviation technology. The flight deck was highly advanced and considered one of the finest. Flight instruments were concentrated in front of the captain's seat, and engine instruments were placed directly in front of the copilot, allowing the pilot to concentrate on flying with fewer distractions. The cockpit was large, comfortable, and lined with sound insulation. The well-padded seats were adjustable and equipped with ashtrays.

By contrast, German bombers like the Junkers Ju 88, Dornier Do 17, and Heinkel He 111 had single pilots with the remaining crewmembers (bombardier, radio operator, flight engineer) grouped closely together in a well-fenestrated nose and cockpit. According to British propaganda this design was intended to bolster morale, but was in fact cramped and inefficient. Confined as the Ju 88 A-4 was, it was well armored; its cockpit armor consisted of a back plate, sidepieces, a head plate and under-seat slats for the pilot, an armored floor for the lower rear gunner, and a folding plate to protect the radio operator's chest.

In sharp contrast, the Mitsubishi G4M Type 1 "Betty" bomber of the Imperial Japanese Navy Air Force had no cockpit armor plate whatsoever. Japanese insistence on maximum range excluded armor or self-sealing fuel tanks, making the G4M extremely vulnerable to both air and ground fire. It quickly earned the nicknames "Type 1 Lighter" and "Flying Cigar."

(Ironically, one of the most heavily armored Japanese aircraft was the Ohka Model 11 "Cherry Blossom," a piloted suicide rocket bomb. This small monoplane had a narrow round fuselage, long prominent nose, and stubby wings. Packing a 1,200-pound [544-kilogram] warhead, the Ohka was air-launched from a G4M2E bomber. To protect the kamikaze pilot, the Ohka was equipped with 50.5 pounds [22.9 kilograms] of armor plate.)

Since World War I pilots knew that as they climbed above 10,000 feet (3,048 meters) their level of discomfort increased just as their effectiveness decreased. By World War II a regulated supply of oxygen and, in most cases, heated cockpits were standard. Bulky clothing, however, was still necessary and some airmen wore electrically heated suits. As long as pilots did not have to exert themselves too much, combat at 30,000 feet (9,144 meters) was now possible.

And altitude in combat always gave the advantage. Aircraft cruising at 40,000 feet (12,192 meters) were extremely difficult to intercept, but getting an aircraft to that height required not just oxygen and heat, it required cabins and cockpits to be pressurized. In 1942 the Luftwaffe introduced the Junkers Ju 86P photo-reconnaissance aircraft. Situated in a two-man pressurized cabin, the cockpit could maintain a cabin pressure of 9,840 feet (2,999 meters) while flying above 35,000 feet (10,668 meters). Immune to RAF fighter interception, the Ju 86P began flying reconnaissance missions over Britain in the summer of 1940. Captain Eric Brown test flew the Ju 86P after the war, later noting, "It wasn't a very impressive aircraft to fly, apart from the fact that it had pressurization and the engines to get you up to high altitude. 'Lumbering' would be the right word to describe how it felt in the controls. But in the end it would get up to at least 35,000 feet [10,668 meters]."

The British developed their own high-altitude reconnaissance aircraft, the Vickers Wellington Mk VI, but only five were built with little real success. It wasn't until the introduction of the Boeing B-29 Superfortress in 1944 that the world's first pressurized strategic bomber was ready for combat. Crews could now operate in a virtual short-sleeved environment, except when over the target or under fighter attack. The pressurized portions of the B-29's fuselage consisted of three sections: (1) The cockpit area, which contained the pilots, navigator, bombardier, flight engineer, and radio operator; (2) the center section, which was connected to the cockpit by a tunnel over the bomb bay and held the gunner's stations and rest area; and (3) a separate pressurized compartment, which was for the tail gunner. The B-29 cockpit was a revelation for pilots. "The wonderful glass nose so much more open and the visibility was exceptional," Eric Brown commented. "The cockpit in the B-29 was very comfortable and well designed."

As advanced as the B-29 cockpit was, it was the exception rather than the rule. During World War II few, if any, aircraft manufacturers had the resources or time to allow for in-depth cockpit studies, so ergonomics never really entered the picture. Most advances were too small or too late. The Martin-Baker MB 5 single-seat fighter, for example, was considered the most advanced of its type, but it was developed too late to see action. From the outset its cockpit was designed with the pilot in mind. Captain Brown recalls: "It was really the first British ergonomic cockpit I had ever been in. . . . It made you feel like you could bond with the airplane because you seemed to be at home. It flew very well. It could've had better lateral control, but the cockpit was the classic design. . . . It had all the modern innovations: clear view canopy, neatly cowled engine. You could run your hand down the fuselage and not feel anything amiss, smooth in every sense of the word."

Despite the pressures of war, there were some modest advances in cockpit design. New instruments and controls were introduced and the human factor was studied for the first time. Even so, a USAAF study on dealing with pilot performance and actions in the cockpit concluded that of 460 accidents and incidents classified as "pilot error," 50 percent were attributed to confusing one control with another; 18 percent to operating a control incorrectly; 18 percent to failure to check, unlock, or operate a control; 11 percent from adjustment errors; and 3 percent because the pilot could not reach a control.

SUPERMARINE SPITFIRE

Supermarine Spitfire Mk Vc | National Museum of the US Air Force | Original; combat veteran; Royal Australian Air Force, 1943

The Supermarine Spitfire is regarded by many as the finest single-seat fighter of World War II. Immortalized during the Battle of Britain and well known for its defense of Malta during 1942, the Spitfire saw action on every British front during the war. Originally designed as a short-range interceptor, the Spitfire was one of the best, but as the war changed, more demands were made of this elegant airframe.

As a fighter the Spitfire was renowned for its speed and maneuverability. Its greatest attribute, however, had nothing to do with its exceptional performance. Reflected in R. J. Mitchell's brilliant design was the capacity for continued development. What set the Spitfire apart from the Hawker Hurricane and the muscle-bound Typhoon was its ability to take on more horsepower without degrading its performance. Indeed, almost every new Spitfire mark was essentially a simple increase in horsepower. The Spitfire Mk V was a Mk I with the more powerful Merlin 45 engine, and the Mk IX was a Mk V with the new Merlin 61. Fortunately for the British the Spitfire's ability to accommodate the more potent engines meant the RAF had a fighter capable of taking on the Luftwaffe's latest Bf 109s and Fw 190s. One can only imagine what might have happened if the Spitfire's development ended with the Mk I or Mk V.

Like many combat aircraft of World War II, the Spitfire was modified to perform a number of roles for which it was never intended. Starting out as an interceptor, the Spitfire was soon turned into a long-range escort fighter (60 Mk IIA long-range fighters were built with a 40-gallon, 151-liter, fixed tank under the port wing; a photo-reconnaissance aircraft; an air superiority fighter; a dive-bomber; and a carrier-borne fighter (Seafire). The last twelve months of the war saw the introduction of the Griffon-engine Mk XIV and Mk 21. Powerful and lethal, they were last versions of the famous Spitfire to see combat during the war.

After the war the Spitfire continued in production with the Mk 19, Mk 21, Mk 24, and the Seafire Mk XVII, Mk 45, 46, and 47. The last operational sortie flown by an RAF Spitfire (a photo-reconnaissance Mk 19) occurred on April 1, 1954. In total, 22,685 Spitfire/Seafires were built.

PILOT IMPRESSIONS
Rob Erdos, Vintage Wings of Canada

The Spitfire cockpit was clearly designed with performance in mind. There's no wasted space and pilot comfort is secondary. It's very utilitarian and what strikes you when you first get in is how little you can see. It's blind by the standards of the old tail-draggers.

The cockpit betrays a 1930s design vintage. The instruments were generally put where most convenient. At the same time, the flight controls do fall to hand. Drop your left hand and there's the throttle. When you're operating the airplane, stick- and rudder-wise, it's well laid out. But it doesn't have modern ergonomics in any sense. It doesn't have a floor, vent, or heater. The undercarriage selector lever is on the right side of the cockpit. Meaning just after takeoff you have to let go of the throttle, change hands on the stick, reach down with your right hand, and operate the gear. Most would consider that a dumb design, but there's a good reason for it. The hydraulic pump on the Merlin is on the aft upper right side of the engine. Run the hydraulic lines straight back and they end up on the right side of the cockpit. The design has the least weight, number of parts, and potential for battle damage. It's not convenient for the pilot, but it's actually a brilliant design.

The field of view on the Mk XVI with the bubble canopy is pretty good, but it does suffer in a couple of distinct ways. There's not a lot of room to swing your head around. The windscreen is short, and that's about minimizing drag. The view through the small windscreen means you can't effectively look down over the nose. Any type of deflection shot would be very difficult. The gunsight is also right in your face. The view aft is pretty good in a Mk XVI compared to high-back Mk Vs and Mk IXs. On the ground the view is terrible. The Spitfire is nose heavy. Bump into anything with your undercarriage and it will probably tip over onto its propeller. Every Spitfire still flying has been on its nose a few times.

ABOVE: This American Spitfire Mk Vb of the 7th Photo Reconnaissance Group was photographed at Mount Farm, Oxfordshire, England, in 1944. Identified as "war weary" by the two W's on the tail, this aircraft was being used as a squadron "hack." *Andrew Thomas*

OPPOSITE: This Spitfire Mk Vb was flown by Squadron Leader R. Milne on May 4, 1942. The Spitfire's clear canopy offered a good all-round view. Pilots demanded that their canopies and windscreen be absolutely clean and transparent. It often meant the difference between life and death. *Andrew Thomas*

Once you have the airplane moving, it's relatively simple to operate. That's the big secret of World War II fighters. They're hard to fight, but there's not a lot in the cockpit that you have to attend to and that's intentional. Once the airplane's in motion, the radiator flaps are thermostatic, there's only one fuel tank to worry about, and there's no mixture, carb heat, or cowl flap controls. The Spitfire is a very simple stick-and-rudder airplane.

When I first flew the Spitfire, the combination of noise, vibration, and acceleration put me on the threshold of fear. Those three elements are the symptoms of something going very wrong, but once you get used to it, it's not scary anymore. The noise is extremely loud. The Merlin is smooth but it feels like you have the back of the crankshaft attached to your chest.

The airplane on the ground is ungainly and out of its element. Once you get it airborne there's a personality change. The airplane immediately becomes pleasant, precise, and predictable, just like a Stradivarius.

DEATH AT 30,000 FEET 87

MESSERSCHMITT Bf 109

Messerschmitt Bf 109F-4 | Canada Aviation and Space Museum
Werk Nummer 10132; combat veteran; JG 5, Russia, May–June 1942

In April 1937 the Messerschmitt Bf 109 became to the world's first single-seat cantilever, stressed-skin monocoque monoplane fighter with an enclosed cockpit and retractable landing gear to claim an air-to-air victory. On April 6, during the Spanish Civil War, two Bf 109s from the Condor Legion's 2. *Staffel*, *Jagdgruppe* 88 (2.J/88), shot down a Republican Polikapov I-15 over Ochandiano, Spain.

The Spanish Civil War offered the Luftwaffe the perfect opportunity to test their new fighter in operational conditions, and the Bf 109 (B, C, D, and E versions) did not disappoint. By the end of the Spanish conflict,, twenty-nine German pilots, the vast majority flying the Bf 109, accounted for more than 150 confirmed Republican aircraft shot down. Many of the top Luftwaffe aces of World War II received their baptism of fire in the Bf 109. They also devised superior tactics that would prove effective during the war.

At beginning World War II the Luftwaffe assigned 496 Bf 109Es and a smaller number of Ds for the invasion of Poland. Arguably the best fighter in the world at the time, the Bf 109 proved superior to anything the Allies had. It wasn't until the Battle of France that the Bf 109 met its match in the Supermarine Spitfire.

The Bf 109 was improved throughout the war. The E, or "Emil," variant was followed by the "Friedrich" (F), "Gustav" (G), and "Kurfust" (K). More powerful engines and heavier armament were added. Unfortunately, as engine power increased, flight characteristics of the aircraft suffered. By the time the G-6 series entered service in 1944, the Bf 109 was no longer a great fighter-versus-fighter aircraft. When it was flown by a competent pilot, however, it was still a deadly weapon. Its final version, the Bf 109K-14, was powered by a 2,000-horsepower engine, giving it a top speed of 450 miles (724 kilometers) per hour at 37,000 feet (11,278 meters).

By September 1944 production reached its all-time peak when 1,605 fighters were delivered. The Bf 109 was produced in greater numbers than any other fighter aircraft in history (more than 30,000). It served with the Finnish air force until 1948 and was built under license by the Czechs (G-12s designated the S 199 and powered by a Jumo 211 engine) and Spanish (G-2 designated HA-1112 and powered by the Hispano-Suiza engine) in the postwar years. The Hispano-Suiza version proved disappointing and in 1953 it was re-engined with a 1,600-horsepower Rolls-Royce Merlin. Ironically it would remain in Spanish service until 1967, more than thirty years after the Bf 109 first flew over that country.

ALLIED IMPRESSIONS OF THE 109

This aircraft is a development of the 109F-4, from which it is indistinguishable in the air. The main difference lies in the engine, that of the 109F-4 being a D.B.601E, while the 109G-2 has a D.B.605A. . . .

Cockpit

The fuselage is clearly designed to be as small as possible to give maximum performance, and consequently the cockpit is rather cramped for anyone over 6 ft. [183 centimeters] tall. The controls are laid out so that the ordinary ancillary controls are worked with the left hand, the right side of the cockpit having only switch controls. This layout, combined with automatic pitch control and automatic control of oil and water coolant flaps, simplifies the task of the pilot.

The rudder pedals are level with the seat, so that the pilot is in a good position to resist acceleration. All ancillary controls are convenient to reach and use.

Owing to the inverted engine, the top of the front cowling is narrow and the view forward on each side is reasonably good.

Several nations flew the Bf 109 during World War II, including the Finns, Romanians, Bulgarians, Hungarians, and Italians. This Bf 109G-6 trop belonged to the 365th Squadriglia, 150th Gruppo of the Regia Aeronautica just before the Italian capitulation on September 8, 1943. *Author collection*

Two Bf 109G-2 trops (tropicalized fighters) left behind by JG 53 at Comiso, Sicily, 1943. Technical trails by the British revealed the Bf 109G-2 to have a maximum true air speed of 322 miles per hour at 5,000 feet (518 kilometers per hour at 1,524 meters), 385 miles per hour at 25,000 feet (620 kilometers per hour at 7,620 meters), and 373 miles per hour at 30,000 feet (600 kilometers per house at 9.144 meters). *Author collection*

The hood is small and has no curved surfaces. The thick plexi-glass [sic] panels are flat and allow a good view through them. A sliding panel on the top and each side allows a clear view in bad weather. The hood is jettisonable by a red lever on the left side.

Armor
Consists of one curved 10 m.m. plate protecting the back and top of the pilot's head. Three plates, the top one 8 m.m. and the lower 2.4 m.m., protect the pilot's back; and a 63 m.m. bullet proof glass shield is set 13 m.m. behind the plexiglass [sic] windshield . . .

"Air Intelligence Summary of Technical Trials Carried out in Middle East. M.E. 109G-2"

Cockpit control arrangements
General.—The cockpit is far too cramped for comfort. It is too narrow, has insufficient head-room and a tiring seating position. The cramped position seriously restricts the force which the pilot can exert on the control column, particularly in the lateral direction for aileron operation.

Flying controls.—The control column, with its offset grip, is well positioned, but the absence of fore-and-aft adjustment for the rudder pedals is a bad feature. . . .

Instrument panel.—The instruments are well grouped, with flying instruments on the left and engine ones on the right. . . .

View.—During flight the view is similar to our own fighter aircraft, but due to the cramped seating position, the tail plane can only be seen with an effort.

The cockpit hood hinges along the starboard side and so cannot be opened in flight. The arrangements for jettisoning this hood are outstanding, the hood being spring-loaded so as to be flung clear, together with the wireless mast, when the jettison lever is operated.

"Royal Aircraft Establishment–Enemy Aircraft–Messerschmitt Me 109"

PILOT IMPRESSIONS
Captain Eric Brown, RN (Ret.)

I would describe the Bf 109 cockpit as claustrophobic. If it had been the era of flight helmets, you wouldn't have been able to turn your head! It was as tight as that. I disliked it very much. There were a tremendous amount of frames in the cockpit canopy.

I wouldn't criticize the cockpit instrument layout. For its time it was well laid out . . . with the engine instruments to starboard and functional levers to port.

The view from the cockpit, however, was dreadful. The view behind you, without a mirror, was pretty well nonexistent. In my mind, the Bf 109 always had this considerable drawback, which made for a very an unpleasant cockpit.

DEATH AT 30,000 FEET 91

REPUBLIC P-47 THUNDERBOLT

Republic P-47D | National Museum of the US Air Force
Original; painted to appear as the P-47 Col. Neal E. Kearby flew on his last mission

Many of World War II's great fighters have been characterized by their sleek, fast lines. Always overshadowed by the slender P-51 Mustang, and to a lesser extent by the twin-boom P-38 Lightning, the P-47 was a leviathan when compared to its liquid-cooled inline-engine cousins. The P-47's empty weight was nearly twice that of a fully loaded Spitfire Mk IX, Bf 109G-6, or A6M5 Zero, and one-third more than a combat-ready P-51D. The truth is, however, the mighty Thunderbolt was in many ways better than the P-51. Often referred to as "the Jug," a nickname of postwar origin and supposedly a contraction of "juggernaut," the P-47 was referred to by pilots and crews simply as the "Bolt" or "T-Bolt."

The first Eighth Air Force P-47Cs arrived in England in December 1942. By January 1943 three fighter groups—the 4th, 56th, and 78th—began receiving their new fighters. On April 15, 1943, the 4th Fighter Group drew first blood when future ace Maj. Don Blakeslee, commander of the 335th Fighter Squadron, shot down an Fw 190 near Ostend, Belgium. From that point, P-47s and their pilots would leave their mark in the skies over Europe.

> **"If it can be said that the P-38s struck the Luftwaffe in its vitals and the P-51s [gave] the coup de grace, it was the Thunderbolt that broke its back."**
> —*William E. Kemper, Commander,*
> *Eighth Air Force Fighter Command*

Equipped with long-range drop tanks, the P-47 was the USAAF's first single-engine long-range escort fighter long before the appearance of the P-51 Mustang. In the Ninth and Fifteenth Air Forces, it proved itself a lethal ground-attack aircraft. In the Pacific, as well as in China and Burma, the heavy P-47 flew against the more nimble Japanese A6M Zero and Nakijima Ki-43 with great success.

By war's end the 56th Fighter Group was the most successful in the entire European theater. Two of its pilots, Francis Gabreski and Robert Johnson (with twenty-eight and twenty-seven air-to-air victories, respectively), were the top-scoring USAAF aces in Europe. All told, the 56th destroyed 674 aircraft in air-to-air combat, including a number of Me 262 and Ar 234 jets. In fact, the P-47 destroyed more enemy aircraft than the celebrated P-51 Mustang.

PILOT IMPRESSIONS
Captain Eric Brown, RN (Ret.)

I first flew the P-47 in 1944. My impression of the cockpit was if you got tired of flying you could go for a walk around the stick. I'm small in stature, 5 feet 7 inches [170 centimeters]. For a single-seat fighter it was gigantic. I always wondered why they needed so much airplane to make an effective fighter. I've seen other airplanes more streamlined with just as much horsepower.

The view from the cockpit was beautiful. The cockpit layout was okay—a bit untidy, but generally acceptable. The great thing about flying a fighter is the bonding you feel with it. Bond with your aircraft and you can fight anything. You can bond in the Spitfire, but I never got that feeling in the P-47 or F4U Corsair. They were just too big.

The P-47 was a big, fast, heavily armed fighter, but when it came to Europe it found its Achilles' heel. Its performance in the transonic region was very poor. In a dive its critical Mach number was 0.71. For the Mustang it was 0.78. For the Bf 109 and Fw 190 it was 0.75

This new P-47D is yet to be assigned to a fighter squadron. The bubble canopy proved critical in air-to-air combat. This P-47 is also equipped with three 110-gallon (416-liter) drop tanks for long-range escort duties. *Author collection*

PILOT IMPRESSIONS

Bud Granley, Flying Heritage Collection

The P-47 is a big, complicated cockpit. Compared to simple cockpits like the Bf 109 and Fw 190, the P-47 has a lot going on.

It's a big cockpit but everything is within reach. The instrument panel is a standard layout, but compared to other fighters I've flown, it has more switches. There's more going on, but it's all straightforward once you learn the systems. The cowl flaps are controlled by a knob that you pull and not a switch. It's possible to interconnect the propeller and mixture controls, so the throttle will pick them up and move them if you've forgotten to. The P-47 has a turbo supercharger, but I've never used the controls; I've never flown it that high.

The view from the cockpit is good. The canopy is electrically operated rather than the pull type. On the ground the view over the nose is normal for a tail-dragger—nonexistent—so you have to zigzag. After landing I usually undo my straps and stand up in the cockpit while taxiing.

Cockpit noise is low. Most fighters start with a "bang, bang, bang," and the exhaust stubs are right there in front of you. With the P-47 the exhaust gases travel underneath the cockpit toward the turbo supercharger behind the pilot.

The workload in the P-47 is no big deal. Once you get airborne, adjust the cowl flaps, check the temperatures, turn the boost pump off, and you're ready to fly. On my first flight I was surprised at how long it took for the gear to come down. In the Zero it's about two seconds, in the P-47 its almost twenty-five! The rudder pedals are adjustable. On long flights you can actually fold them down and stretch your legs.

ABOVE: The P-47 not only saw combat with the US Army Air Forces, but a large number were used by the Soviet Union (200), RAF (830), Brazil (48), and Mexico (25). This lineup shows four brand-new P-47s with RAF, Mexican, Russian, and American markings. *National Museum of the USAF*

BELOW: According to pilot reports, most pilots shot down during World War II never saw the aircraft responsible for their demise. This US Army Air Force Training Aid Division poster featuring the P-47 highlights the fact that eyesight wasn't the only sense required to stay alive. *Author collection*

NORTH AMERICAN P-51 MUSTANG

North American P-51C | Dan Friedkin, Houston, Texas | Serial No. 43-25147

Built to a British specification in the United States, the P-51 Mustang has to be considered the best American fighter of World War II. With its exceptional aerodynamic qualities and powered by a Rolls-Royce Merlin, it gave the Allies the long-range escort fighter they so desperately needed.

By April 1940 Britain had been at war with Germany for seven months. Eager to obtain more fighters, the British Purchasing Commission approached North American Aviation (NAA) in the last quarter of 1939, and suggested the NAA produce the Curtiss P-40 under license.

NAA designers Raymond Rice and Edgar Schmued, however, saw this as an opportunity to build an entirely new fighter. The British agreed and on May 23, 1940, the NA-73X prototype contract was signed. For years many myths surrounding the birth of the Mustang persisted: Due to NAA's lack of experience, the British stipulated the company purchase P-40 wind tunnel data from Curtiss; Ed Schmued was a German who had worked for Messerschmitt and based the P-51 on the Bf 109; the British insisted the NA-73X be built in 120 days.

Started in 1939 the NA-73X was a completely new design, and by May 1940 was in a highly advanced state. Incredibly, it emerged from the NAA's Inglewood plant after only 102 days (without an engine and with wheels from an AT-6). On October 26, 1940, the first test flight was made. After forty-five flights the British placed an order for 320 Mustangs.

The Allison-powered Mustang I entered RAF service in January 1942 and was 25 to 45 miles per hour (40 to 72 kilometers per hour) faster than the Spitfire Mk V below 15,000 feet (4,572 meters). As good as the Mustang was, its performance above this altitude fell off rapidly (the Allison had a single-stage supercharger). The British realized they had a great fighter but with the Rolls-Royce Merlin they knew it would be even better. So on October 13, 1942, the first Merlin-powered P-51 took to the air. The increase in high-altitude speed was dramatic—the new P-51B/C powered by a Packard Merlin recorded a top speed of 421 miles (678 kilometers) per hour at 35,000 feet (10,668 meters).

The first USAAF squadron to be equipped with the P-51 was the 154th Observation Squadron, based in French Morocco in April 1943. But the airplane would gain much greater fame in the skies over Europe. Throughout 1943 the US Eighth Air Force's attempts to bomb targets deep in Germany were met with horrendous losses. Escorts provided by the P-47 and longer-range P-38 were limited. Reaching more distant targets required a new escort fighter. Fortunately for the Allies the P-51B and C variants proved ideal. When modified with a 75-gallon (284-liter) rear-fuselage tank and two 108-gallon (409-liter) drop tanks, along with its two 90-gallon (341-liter) wing tanks, the Mustang could reach Berlin and beyond.

The Mustang D was introduced in 1944. With its distinctive bubble canopy and powered by the 1,590-horsepower Packard Merlin, the P-51D dominated the skies over Germany.

By war's end, the P-51 equipped forty USAAF fighter groups and thirty-one RAF and Royal Canadian Air Force (RCAF) squadrons in Europe, China, Burma, and the Pacific.

PILOT IMPRESSIONS
Captain Eric Brown, RN (Ret.)

The P-51 was originally built to a British specification. When tested with the Allison engine it wasn't very good above 25,000 feet (7,620 meters) and by that time we were fighting at 30,000 feet (9,144 meters). The early models didn't have the clear canopy

Minus its drop tanks, this 356th Fighter Group P-51D has just completed another long-range escort mission in April 1945. The group consisted of the 359th, 360th, and 361st Fighter Squadrons. Even with the bubble canopy, this Mustang still has a rearview mirror attached on the top of the forward canopy bow. *Author collection*

and were equipped with the birdcage hood. The instrument layout was a bit messy. They tried to base it on the standard basic six flying panel, with some success.

The Allison- and Merlin-powered Mustang were extensively tested by the British. Excerpts describing the cockpit of the Mustang I and Mk III (P-51B/C) were produced by the Aeroplane and Armament Experimental Establishment and Air Fighting Development Unit:

Mustang I

The head room provided is inadequate. Even with the seat fully down, an average-sized pilot feels very cramped. No undue noise or vibration was experienced under any conditions of flight.

The view for a single-engine fighter is good, especially to the front over either side of the fuselage. This is due to the narrowness of the nose compared with other fighters such as the Spitfire. No forward clear-view panels are fitted but each side panel is fitted with a sliding window.

Mustang III/P-51B/C

[. . .]

3. The pilot's cockpit is similar to the Mustang 1. It has been "cleaned up" considerably. Of particular note are:

(i) The only undercarriage-warning device is a red light by the gun site [*sic*], which lights when the wheels are unlocked.

(There is no light when the wheels are locked up or down.)

(ii) The cockpit, and in particular the instruments, are of American design and consequently seem oddly placed to a British pilot.

(iii) When the engine is started and the mixture lever placed in "Normal", the locking unit must be tightened, otherwise the pitch control may creep back on take-off.

(iv) The tail wheel only becomes castoring when the stick is pushed right forward.

(v) It should be impossible to retract the undercarriage when the weight of the aircraft is on the wheels.

(vi) There are three trimming wheels for all control surfaces [. . .].

4. The control column is well placed and of the stick variety. It is pivoted in both directions at its base.

5. No "misting up" was encountered during the trails, including flying at and diving from heights up to 35,000 feet [. . .].

6. The Mustang III is very similar to fly and land as the Mustang 1. It is therefore delightfully easy to handle. It is as easy to fly as a Spitfire IX with the exception that the rudder is needed whenever changing bank (in order to prevent skid, and to prevent the sight from swinging off). This soon becomes automatic. The engine feels very smooth.

P-51 ace Col. Donald J. Blakeslee in the cockpit of his P-51D. The P-51D's large bubble canopy gave pilots exceptional all-round vision. The large K-14A gyro gunsight dominates the front windscreen. A major step forward in air-to-air gunnery, this sight gave the average fighter pilot a much better chance of scoring hits. *Author collection*

HANDLEY PAGE HALIFAX

Handley Page Halifax Mk VII | National Air Force Museum of Canada
Serial No. NA377; No. 644 Squadron RAF, shot down April 23, 1945

The Handley Page Halifax was constantly overshadowed by the famous Avro Lancaster—it was never able to lift the same bomb load as the Lancaster or fly as far. The Halifax, however, was far better than its critics claimed. Indeed, other than the Lancaster, the Halifax made a bigger contribution to the RAF Bomber Command's war effort than any other aircraft, dropping more bombs (224,207 tons [203,397 metric tons] in 36,995 sorties) than the Battle, Blenheim, Boston, Fortress, Hampden, Manchester, Mitchell, Mosquito, Whitely, Stirling, Ventura, and Wellington combined.

The Halifax was often derided and faced harsh criticism. There is no doubt that the early Merlin-engined Halifaxes (Mk I and II) were underpowered and, in comparison to the Lancaster Mk I, were slower, could not fly as far or high. Bomber Command Air Chief Marshal Arthur Harris didn't hold back in December 1943: "I will state categorically that one Lancaster is preferred to four Halifaxes. Halifaxes are an embarrassment now, and will be useless for the bomber offensive in six months, if not before. The Halifax suffers about four times the casualties for a given bomb tonnage when compared to the Lancaster. Low ceiling and short range make it an embarrassment when planning attacks with Lancasters."

In reality, while the Lancaster got all the glory, both aircraft had their design faults. Early on the Halifax suffered from poorly designed fins and was underpowered, while the Lancaster was plagued by structural weakness in the wings and tail. Fortunately for Halifax crews, the new Hercules-powered Mk III was in service by the time of Harris's comments, with more on the way. The Hercules transformed the Halifax, making it equal to, and in some categories better than, the Lancaster, with a similar range/bomb-load capability.

One of the persistent myths regarding the Halifax was its higher loss rate compared to the Lancaster. Although this was true, its crews' survival rate was much better. Only 11 percent of Lancaster crew survived being shot down, compared to 29 percent of Halifax crewmen. The Halifax's fuselage was more spacious, making movement easier, especially when it came time to bail out. Also, early on the Halifax was used in a number of poorly planned daylight operations, contributing to its heavy losses. But as the Mk III and Mk VI entered service, the loss rate at the end of the war for the two heavy bombers was remarkably similar: 2.20 percent for the Lancaster, 2.28 percent for the Halifax.

In addition to comprising a large part of the RAF's bomber force, the Halifax excelled in a number of roles unsuitable for other types. The Halifax was one of the first four-engine heavies modified for use by the Special Operations Executive. Its commodious fuselage, long range, and large payload made it ideal for dropping agents and supplies deep in occupied Europe. In the countermeasures role, special-equipped Halifaxes from No. 100 Group jammed radio and radars during the nightly raids on Germany. In the airborne transport role, the Halifax excelled being the only transport cleared to tow the massive Hamilcar glider. On D-day Halifaxes from Nos. 298 and 644 Squadrons towed more than sixty Hamilcar and Horsa gliders. Airborne operations Market Garden and Varsity followed, with Halifaxes towing thirty and forty-eight Hamilcars respectively. As part of Coastal Command, Halifaxes flew antishipping and U-boat patrols, though with limited success (just seven U-boats sunk between 1943 and 1945). In one of the least glamorous roles, the Halifax was issued to five Meteorology Squadrons. Accurate weather was vital to many wartime operations. These sorties were flown every day and night, sometimes in atrocious weather, and were so long and arduous that two pilots and two navigators were often carried to share the load.

The Halifax proved a rugged and dependable bomber, capable of soaking up a lot of damage and still making it home. While it

When compared to the Lancaster, the Halifax had a larger, more spacious fuselage. In case of an emergency, movement in the aircraft was easier, making the Halifax a much safer aircraft. Author collection

demanded slightly better flying skills than the Lancaster, improved training quickly addressed the issue.

At its peak the Halifax force comprised thirty-five squadrons, equipped with 1,500 aircraft. On April 19, 1945, just a few short weeks before Germany's surrender, the number of fully equipped Halifax squadrons assigned to Bomber Command were as follows: thirteen in No. 4 Group, six in No. 6 Group (RCAF), and four in No. 100 Group. In total, 6,176 Halifaxes were built. During the war they completed 82,773 sorties for a loss of 1,884 aircraft.

PILOT IMPRESSIONS

This is a single-pilot airplane just as the other RAF four-engine bombers are. A flight engineer's panel is installed behind the pilot. Duties seem to be very cleverly divided between the two in that the pilot is solely concerned with flying the airplane, which is as it should be for night missions and details such as starting, stopping, fuel system operation, engine functioning; and coolant and cowl flap operation and emergency system operation have been left to the flight engineer. The blower shift controls have been simplified by using just two blower controls for the four engines, one control serving the inboard and the other the outboards. The throttles were found to be very stiff.

The pilot's comfort was satisfactory although an armrest would be desirable. Vision was very good in both clear weather and rain. The high windscreen and vertical seat adjustment contribute towards this.

The Halifax has been a very useful night bomber although its mediocre performance limit it somewhat, high speed and operating altitude being on the low side.

"Handley Page Halifax–Army Air Force Material Command Report," December 1943. Pilot's comments on Halifax, Halifax Mk II–JD-304 with Merlin XXX engines, and Halifax III HX-227 with Hercules engines.

102 WORLD WAR II

The second British four-engine bomber to enter service, the Halifax flew its first mission in March 1941. After a number of teething problems, the bomber found its stride with the Hercules-powered Mk III and VII. *Author collection*

VICKERS WELLINGTON

Vickers Wellington B Mark X | RAF Museum | Serial No. MF628

Known as the "cloth bomber" by the US Army Air Forces, the Vickers Wellington was built in greater numbers than any other British bomber. In many ways the Wellington was an anachronism, being fabric-covered at a time when stressed-metal skin and monocoque construction techniques were the accepted methods for new fighters and bombers. What made the Wellington unique, though, was its "geodetic" airframe construction—an all-metal "basketweave" technique making for a light but incredibly strong airframe.

First flown on June 15, 1936, the Wellington prototype was a success. Two months later, a production order was issued for 180 aircraft. At the outbreak of World War II six Bomber Command squadrons were equipped with the Wellington Mk I.

The Wellington quickly endeared itself to its crews, who generally considered it a safe, spacious, and comfortable aircraft with a good view from the cockpit (though service pilots who had spent most of their careers in an open cockpit could find an enclosed cockpit somewhat claustrophobic). Pilots also regarded the aircraft as easy to fly, describing it as "docile," "viceless," and "good-natured." The Wellington was not without is flaws, however. Performance of the Pegasus engine was highly criticized and interior heating was never very good, even when it did work. Don Bruce of IX (B) Squadron recalled, "The close proximity of the flap undercarriage levers to each other resulted in some very unpleasant incidents at 20 Operational Training Units (OTU) when 'circuits and bumps' pupil pilots made errors on overshoots, retracting flaps instead of the undercarriage as they opened up for another circuit."

> **"I remember a very uneasy feeling I had when I made my first flight in a Wellington, looking out and watching the port wing flex and twist, something I was to become accustomed to; also the general twitching of the tail."**
>
> —*Don Bruce, IX (B) Squadron, RAF*

Wing Commander Jack Hoskins, who had a long tour with 221 Squadron, both in the United Kingdom and in the Mediterranean, recalled:

> I must admit on the Mk. VIII we suffered from the lack of power given the Pegasus engines. The extra drag of the "stickleback" aerials, heavy fuel loads for ten-plus-hour sorties, and operating low down in hot conditions, caused many anxious moments. It was a constant concern to keep cylinder-head temperatures down. Operating the cooling gills meant more drag and loss of speed, and produced a vicious circle. We were lucky to make much more than 100 knots for the first hour or so.
>
> Due to engine overhaul problems, the limitation on engine oil consumption was raised to 3 gallons [11 liters] per hour—one always checked the F700 (aircraft servicing record) before the flight to see the consumption figures. On a ten-hour trip, some 50 to 60 gallons [189 to 227 liters] of oil could be consumed, so we were obliged to carry five or six 4-gallon [15-liter] jerry cans of oil to top up the fuselage oil reserve stock (15 gallons [27 liters]).
>
> One crewmember was kept busy pumping oil at forty-five strokes per gallon [3.8 liters] on a semi-rotary pump and emptying the jerry cans to replace the losses.
>
> The wonderful geodetic construction was certainly strong. One of our aircraft hit the sea and bounced back into the air again, minus the bottom of the fuselage from the bomb bay to the rear turret. The rear gunner got a wet shirt and was obliged to stay put.

As the war progressed Wellington production increased rapidly. The most significant modification was the replacement of the Pegasus engine with more powerful Merlin and Hercules power plants. By April 1941 the Wellington was operating almost entirely at night. By May there were twenty-one squadrons in Bomber Command. As numbers increased, the Wellington contributed 599 of their number to the famous "thousand bomber" night raid on Cologne on May 30–31, 1942.

Eleven Royal Canadian Air Force (RCAF) squadrons used the Wellington from 1941 to 1944, and two more were assigned to Coastal Command. The forward crew positions on the Mk III consisted of the pilot, flight engineer (starboard) sitting on a folding seat, front turret gunner, and bombardier. *Author collection*

The Vickers Wellington Mk III from No. 419 Squadron RCAF. Powered by two Hercules 14-cylinder twin-row radial engines with 1,500 horsepower each, the Wellington had a top speed of 261 miles (420 kilometers) per hour at 12,500 feet (3,810 meters). *Author collection*

The Wellington had proven its usefulness, but its days in Bomber Command were numbered. New four-engined "heavies" like the Stirling, Halifax, and Lancaster were replacing the faithful "Wimpy."

In Bomber Command, Wellingtons served with Nos. 1, 3, 4, 6, and 8 (Pathfinder) Groups. All told seventy-six squadrons used the Wellington at one time or another. In addition to Bomber Command, the Wellington flew with Coastal Command, Transport, and Training Command. Retired from Bomber Command in October 1943, the Wellington continued combat operations with Coastal Command. Twenty-two squadrons in Britain, Iceland, and the Middle East hunted U-boats, flew antishipping strikes, and escorted convoys.

Many considered the Wellington the best British bomber of the war. Versatile, strong, and easy to fly, Wellingtons flew 47,409 sorties with Bomber Command, including 6,022 by OTUs. They dropped nearly 142,000 tons of bombs in all theaters of war. Coastal Command Wellingtons were credited with sinking twenty-eight U-boats. But the cost was high: Bomber Command lost 1,332 of these bombers on operations and a further 337 in accidents.

FOCKE-WULF Fw 190 WÜRGER

Focke-Wulf Fw 190 F-8/R1 | Smithsonian National Air and Space Museum, Steven F. Udvar-Hazy Center

Werk Nummer 931884; SG 2, Eastern Front, late 1944

The introduction of designer's Kurt Tank's Fw 190 in mid-1941 came as a severe shock to RAF Fighter Command. The Fw 190A-2 outperformed the Spitfire Mk V in almost every category. It was 25 to 30 miles per hour (40 to 48 kilometers per hour) faster at most altitudes and it outclimbed, outdove, and outrolled the British fighter. The Spitfire V's only advantage over the Fw 190 was its tighter turning circle, but most experienced pilots knew turning doesn't win battles.

The Fw 190 has to be regarded as one of the best single-seat fighters of the war. Its combat performance, adaptability to a variety of operational scenarios, and ease of handling and maintenance made it a true fighter, earning the nickname Würger—Butcher Bird.

But like all fighters, the Fw 190 wasn't perfect. Its harsh stalling characteristics limited its maneuver margins, and in a tight turn, the pilot would find it hard to follow a well-flown Spitfire.

Overall, however, the Fw 190 was a great success, leading to a proliferation of variants serving a number of different roles. In March 1942 the Fw 190A-4 ground-attack version appeared, followed by a night fighter, heavy-bomber destroyer, and finally the long-nose Fw 190D-9 Dora, which entered service in August 1944. The Fw 190D-9 was the best piston-engine Luftwaffe fighter of the war; seven hundred Fw 109Ds were produced, but few entered combat service during the last eight months of the war.

Approximately 19,500 Fw 190s were produced across all variants during World War II.

PILOT IMPRESSIONS
Captain Eric Brown, RN (Ret.)

The Focke Wulf Fw 190 was an outstanding German aircraft. In fact, when it appeared it was superior to our Spitfire Mk V and caused a great deal of consternation in the Air Ministry. We were so desperate to get our hands on one we were actually planning a commando raid to steal one from a Luftwaffe fighter base. Fortunately for us, on June 23, 1942, one Oberluetnant Arnim Faber landed his Fw 190 on what he thought was a Luftwaffe base, but was in fact an RAF field.

What we found was a shock. Here was a fighter aircraft full of innovations. We prided ourselves on the superb harmony of control found in our Spitfire Mk IX. But here we had an aircraft with controls almost as good if not better than the Spitfire's, particularly—and this is vital in a fighter—in lateral control. The rate of roll of the Fw 190 was superb. It had a very reliable radial engine. Despite the fact it was quite hefty, the view over the nose was much better than from the Spitfire, particularly when taxiing.

The cockpit was narrow, but I was pleasantly surprised to find the forward view better than that from the Bf 109, Mustang, or Spitfire. The controls were easy to hand and the general cockpit layout was good (though the layout of the flight instruments was not as good as in the Bf 109).

The really interesting thing in the Fw 190 was the ingenious *Kommandogerät* (command device) that relieved the pilot of having to control the airscrew, pitch, mixture, boost, and rpm when moving the throttle forward or back. This cut the pilot's workload considerably and was a great asset, especially in combat. It also had a water-methanol injection system for the engine. This meant you would get a sudden boost of power that gave you as much as 30 miles (48 kilometers) per hour increase in speed.

Flying a Spitfire Mk IX over France, I encountered what I believed to be an Fw 190A-4. By that time I had flown the Fw 190 quite a bit and so I wasn't too frightened. I reckoned I knew what the Fw 190 could do. I also knew what my Spit could do so I thought, "I can handle this guy." I was hoping for a pilot just out of training school. Unfortunately, I picked somebody who really knew what he was up to. We really had a go at each other, but after three or four minutes neither of us could draw a bead on the other. Both of us soon realized we were running out of fuel. With the waggle of our wings we departed and I realized that the Fw 190 was a top-notch fighter and could, like the Spitfire, be developed into something really awesome.

The Focke-Wulf Fw 190 canopy represented a major step forward in cockpit design. The clear hood gave the pilot superb all-round vision, especially to the rear. *National Museum of the USAF*

The Fw 190G-3 fighter-bomber was capable of carrying a 3,968-pound (1,800-kilogram) load. For the ground-attack role, additional armor plating was added to the cockpit sides and directly behind the pilot. *Author collection*

110 WORLD WAR II

PILOT IMPRESSIONS

The instrument panel is quite untidy as there are several decks of gages [sic] and also the gas tank selector control, emergency gear control, and windscreen cleaner control and cowl flap hand crank protrude through the center portion of the panel.

The engine control (combined propeller, mixture and throttle and idle cut out) is very large and course [sic] to operate with no friction adjustment provided. Toe brakes are provided and are easy to reach in all positions. Rudder pedal adjustment was very difficult to operate. All flight controls were light and free on the ground. The pilot position, which necessitates extending the legs almost straight out, seems quite suitable for pursuit work. The shoulder room and headroom are extremely limited and are the main objections to the cockpit arrangement. The pilot is bound to feel like a "rat in a trap" when the canopy is closed.

Vision on the ground is very poor because of the limited headroom, relatively high angle of inclination of the fuselage with the ground and the radial engine installation. A tail wheel of the P-51B type incorporated in the stick and good brakes make ground handling pleasant.

While this airplane has some good fighter features such as a high rate of roll and good climb, these are offset by such undesirable characteristics as poor radius of turn, bad stall, poor landing qualities, and insufficient head and shoulder room in the cockpit.

US Army Air Force Test Pilot Report, December 1943

During World War II Air Intelligence 2(G) had the job of creating drawings of captured German aircraft and equipment. They also produced drawings of German aircraft that had yet to enter service. This drawing, dated December 1943, shows the evolution of the Fw 190 from the A version to the D-9. The Fw 190D-9 did not enter service until August 1944. *National Museum of the USAF*

DEATH AT 30,000 FEET 111

FAIREY FIREFLY

Fairey Firefly F Mk I | Fleet Air Arm Museum | Serial No. VH127

In 1939 the British Air Ministry issued a specification for a new two-seat, cannon-armed fighter for the Fleet Air Arm. Bearing a superficial resemblance to Fairey's earlier Fulmar, the Firefly was designed from the outset as a multirole aircraft with the hard-hitting capabilities of a fighter.

The first Firefly (Z1826) took to the air on December 22, 1941. Three additional prototypes flew from March through September 1942. No major problems were encountered and full-scale production began shortly after with an order for five hundred Mk Is. Powered by a Rolls-Royce Griffon IIB engine developing 1,735 horsepower at sea level, the Firefly Mk I had a top speed of 316 miles (509 kilometers) per hour at 14,000 feet (4,267 meters); range was 774 miles (1,246 kilometers), and it was armed with four 20-millimeter Hispano cannon. Between 1941 and 1955, 1,702 Fireflies were delivered.

The first unit to receive the Firefly was No. 1770 Squadron in October 1943. Embarking aboard the HMS *Indefatigable* the squadron made its operational debut attacking the German battleship *Tirpitz* in Norwegian waters in July 1944. The second Firefly squadron, No. 1771, made its operational debut in February 1944. Flying off the HMS *Implacable*, they attacked airfields, seaplane bases, and shipping along the Norwegian coast. These operations were minor, however, when compared to what lay ahead.

In November 1944 the British Pacific Fleet was formed. It was a formidable force based from four fleet carriers: HMS *Illustrious*, *Victorious*, *Indomitable*, and *Indefatigable*. On January 4, 1945, flying from *Indefatigable*, the Fireflies from No. 1770 took part in Operation Lentil, a successful attack on the Pangkalan Brandan oil facilities in Sumatra. During the attack the Firefly achieved its first air-to-air kill when Lt. Dennis Levitt shot down a Nakajima Ki-43 Oscar. A second Ki-43 was shared by Sub. Lts. Redding and J. P. Stott, the latter of whom would become the Fleet Air Arm's only Firefly ace of the war with five victories. On January 24 No. 1770 claimed two more Oscars during the first of two strikes against the Palembang refineries.

In March 1945 these fighters took part in Operation Iceberg, the invasion of Okinawa. The British were given the job of neutralizing airfields on the Sakishima-Gunto archipelago and prevent Japanese aircraft from reaching Okinawa. On July 17, 1945, the Fireflies of No. 1772 became the first British aircraft to fly over Japan.

Postwar the Firefly Mk V entered service and saw combat during the Korean War. Other air forces looking to reequip their air and naval arms chose the Firefly for its strike, reconnaissance, and antisubmarine capabilities. Canada, Australia, Sweden, Denmark, Holland, Thailand, India, and Ethiopia all purchased various versions. The Fleet Air Arm would use the Firefly Mk VI in the antisubmarine role until 1956, when it was replaced by the Fairey Gannet.

The Firefly was well loved by pilots. Its outstanding versatility, reliability, handling characteristics, and performance made it one of the best carrier aircraft ever built.

PILOT IMPRESSIONS
James Bradley, Canadian Warplane Heritage Museum

My nickname for the Firefly is "the beast." It's a big, heavy aircraft built like a tank. All the engine cowlings are ⅛-inch-thick (3.18-millimeter) steel. Because of the structural support they give, we won't run the engine up without them.

While it's bigger than the Spitfire or Mustang, the visibility from the cockpit forward and behind is fairly good. I was surprised, given the large Griffon engine. The pilot sits quite a bit forward compared to normal fighters, and when you look down, the leading edge of the wing is close to the cockpit.

Compared to the Mustang or Corsair, the Firefly cockpit is wider and more comfortable, but with less legroom. I'm 6 feet (183 centimeters) tall and with the rudder pedals all the way forward it's a very tight fit. The seat doesn't move straight up and down. If you have a taller body length and want to drop the seat down, it slides forward on an angle. If you have the seat all the way up it gives you better legroom; slide it down and you lose it. The Firefly, being a reconnaissance antisubmarine aircraft, requires cockpit room for your arms in order to use the map board and to navigate.

The noise level in the cockpit is considerably louder than the Corsair or Mustang. In the Corsair all the exhaust ducting comes

Firefly Mk I DV126/4-C of No. 1770 Naval Air Squadron, Royal Navy Fleet Air Arm unfolds its wings in preparation for the first strike on the Japanese-held oil refineries in Sumatra on January 4, 1945. *Andrew Thomas*

out the bottom of the engine with very little engine noise. In the Mustang the exhaust has a more popping sound. The "beast" sounds like a shotgun.

All the controls are easy to hand and accessible. The workload is not as high as in some warbirds, but that's because it's fuel-injected. That eliminates one of the controls and the requirement to monitor enrichment. It's all automatic (I just worry about the throttle and a propeller control). It's very easy and user-friendly. The landing-gear handle is conveniently located on the dashboard right in front of the throttle and right beside the tailhook handle. So right after takeoff it's hand off the throttle right to the dashboard, gear up, and back into your power reduction.

When trimmed, you can fly the Firefly hands-off. It's fairly responsive in the roll regime, especially without the wing fuel tanks. At takeoff the engine thrust is very responsive. There's lots of power in that propeller and the torque is astronomical—more so than other fighters I've flown.

A Firefly of No. 1771 Naval Air Squadron from HMS Implacable is on its way to attack targets in Japan in July 1945. *Andrew Thomas*

114 WORLD WAR II

With tailhook and flaps down, a Firefly Mk I comes in for an arrested landing aboard the HMS *Indefatigable*. The Firefly made its combat debut during Operation Mascot–air strikes against the German battleship *Tirpitz* in July 1944. *Andrew Thomas*

FIAT CR.42

Fiat CR.42 (designated J 11) | Swedish Air Force Museum | Serial No. NC.2453 (the Swedes designated the CR.42 as the J 11)

In 1939 the Regia Aeronautica (RA) began to modernize its fighter force, introducing three new fighters: the Fiat CR.42 and G.50, and the Macchi C.200—all powered by the 870-horsepower Fiat A.74 RC.38 radial engine. (This engine was, at the time, the only one in Italy suitable for fighter installation. Although it was a magnificent power plant, its lack of horsepower stopped Italian fighter development in its tracks.) When Italy entered the war on June 10, 1940, the fighter arm of the Italian air force was predominantly equipped with the Fiat CR.42 biplane. Although the new, all-metal monoplanes—the Macchi C.200 and Fiat G.50 —were far superior to the biplane, most frontline pilots disliked them.

While they were able to produce impressive fighter designs, the Italians never implemented the proper techniques of mass production. This, and the fact that their frontline fighter units failed to employ their aircraft effectively throughout the war, meant their impact at the front was marginal. On the day Italy declared war, there were twenty-four *stormi* (groups) of bombers in the RA and only eight with fighters. This was a direct result of Benito Mussolini's vision of a blitzkrieg victory, in which bombers were more important than fighters.

The Fiat CR.42 Falco (Falcon) is considered by many to be the last, best biplane fighter ever built. When it was first introduced, it achieved a maximum speed of 274 miles (411 kilometers) per hour at 20,000 feet (6,096 meters). Its robust structure allowed for every conceivable maneuver, a quality preferred by most Italian fighter pilots. Simple construction methods made for quick and easy production of the CR.42, and the familiarity with the biplane configuration enabled frontline squadrons to work up their efficiency in a short period of time.

The CR.42's armament consisted of one 7.7-millimeter and one 12.7-millimeter Breda-SAFAT machine guns installed in the upper fuselage in front of the pilot and firing through the airscrew. Like German fighters the Italians installed round-counters on the cockpit instrument panel. When the war began a total of 330 Falcos were on strength, of which 290 were ready for combat. The first CR.42s to see action belonged to the 23rd Gruppo and 151st Gruppo. During the fourteen-day campaign over southern France, losses suffered by both fighter and bomber units were light. This only reinforced the idea that the RA was unbeatable and clearly on the winning side of the war. Italian commanders then sent an expeditionary force—Corpo Aereo Italiano (CAI), with CR.42s, G.50 fighters, and BR.20 bombers—to join the Luftwaffe during the Battle of Britain in September 1940.

The campaign did not go well. The weather in northern France was far different from the sunny clear skies of the Mediterranean. The CR.42 was not equipped with radios and didn't stand a chance against the RAF's sophisticated air-defense system. By the end of operations in April 1941, the CAI had flown just 137 bomber sorties and 590 fighter sorties. The Italians claimed nine enemy aircraft shot down, plus six probables (in actuality, the RAF suffered no losses).

The CR.42 would be most widely used in North Africa. Initially deployed as an interceptor, the Falco soon proved no match for the RAF Hurricanes and P-40 Tomahawks and it was quickly regulated to a ground-attack role. Designated as the CR.42AS, the Falco could carry two 220-pound bombs. By January 1942 most fighter units in Africa were equipped with the G.50 monoplane fighter, but attrition and Italy's inability to produce large numbers of MC.200 and G.50 monoplane fighters meant that the demand for the Falco remained insatiable. From June 1940 to February 1941, CR.42 units flew a total of 11,286 hours with an average of thirty-six aircraft engaged per day. For 157 victories, only forty-one CR.42s were lost.

If there was one victory the Italians could have achieved during World War II it should have been the capture of Malta. With the declaration of war, few Italians believed that the twin islands could survive against the might of the RA. Sensing a quick victory, Mussolini ordered the 2nd Squadra Aerea to begin bombing raids against the tiny islands. On the morning of June 11, 1940, thirty-three SM.79s, escorted by eighteen CR.42 fighters, attacked Valletta harbor. Malta's defense, at this time, consisted of just four obsolete Gloster Sea Gladiator biplanes, but on June 21, eight Hawker Hurricanes were flown in via France. The CR.42 biplane fighters assigned as escort for the SM.79s were found wanting against the faster and more heavily armed Hurricanes. As losses began to mount, the Italians were obliged to strip their force and send valuable aircraft to other parts of the Mediterranean.

In the rearmament period before the outbreak of war, many air forces looked for modern aircraft. Choices were limited, with the major powers holding onto their monoplanes. The Hungarian air force was the first to order the Falco, purchasing fifty in late 1940. In September 1939 the Belgian government ordered thirty-four CR.42s, and during the German invasion in May 1940, thirteen of them were destroyed by Luftwaffe Ju 87s with the remaining playing little part in the rest of the campaign. Sweden purchased the largest number of CR.42s—seventy-two delivered between February 1940 and September 1941.

Saddled with the dubious distinction of being the last single-seat fighter biplane produced by any of the warring nations, an incredible 1,781 CR.42s were built, making it the most widely produced Italian aircraft of the war.

ILYUSHIN IL-2 ŠTURMOVÍK

Ilyushin Il-2M3 | Smithsonian National Air and Space Museum, Steven F. Udvar-Hazy Center | Original

Heavily armed and armored, the Ilyushin Il-2 Šturmovík was one of the most feared ground-attack aircraft of World War II, and it was produced in larger numbers than any single type of aircraft in history. It was also one of the most effective ground-attack aircraft ever conceived. During most of the war, Russia pumped out an average of 1,200 aircraft per month for a grand total of 35,952 Il-2s.

The Il-2 was the Russian air force's most effective and celebrated aircraft. The world knew it as the Šturmovík, but Russians on the eastern front called it the Ilyusha, and their German enemies referred to it as the Schwarze Tod (Black Death).

In the 1930s the Soviet air force saw their aviation assets as a tactical force that would support their army exclusively. This called for self-sufficient, fast, and rugged ground-attack aircraft capable of destroying tanks, fortifications, and infantry. Several designs were submitted, but it was the CKB-37, designed by Sergei V. Ilyushin, that won the day and was ordered into production as the Il-2.

The original Il-2 was a single-seater, but early encounters with German fighters showed it to be extremely vulnerable. In 1941 the Soviet High Command was reluctant to admit the high attrition rate suffered by the Il-2, which lacked sufficient punch to defeat enemy armor. A redesign was ordered and the already impressive armored area that covered the pilot's cockpit (between 5 and 12 millimeters thick) was extended to accommodate a rear gunner. A heavy 12.7-millimeter BS or Berezin UBT machine gun was fitted to cover the upper rear area, and two high-velocity 23-millimeter cannon replaced the original 20-millimeter wing-mounted cannon. The new two-seater entered service in August 1942. Some success was achieved against German fighter pilots who assumed they were attacking the regular single-seat version. This misperception did not last long, however, and Russian losses again began to mount.

By late 1943 the Soviet air force was better trained and equipped. Their combat techniques had improved as well, but the cost was enormous. For all its losses the Il-2 still proved to be a very effective ground-attack aircraft—T-34 tanks, supported by regiments of Šturmovík, ravaged German tank and infantry formations. No matter how many tanks or Il-2s the Germans destroyed, new regiments appeared.

When the Ilyushin Il-10 came into service in 1944, it was more streamlined and powered by a 2,000-horsepower engine. The final iteration of the Il-2 to fly in World War II appeared over the Eastern Front in February 1945.

PILOT IMPRESSIONS
Ross Granley, Flying Heritage Collection

Getting up close to the Šturmovík you realize how big the aircraft really is. The whole nose and cockpit section is covered in armor plate. The cockpit is big and roomy with lots of space. The spade grip is a huge oval shape and sits up real high, not like in US aircraft. It's utilitarian with a lot of big levers and buttons for the rockets, bombs, and guns.

Once in the cockpit you sit quite a ways back. With half of the canopy being armored plate, you can't see anything directly to your left or right unless you lean forward a good 8 to 10 inches (20 to 25 centimeters). For the size of the cockpit, it can feel claustrophobic. On the front armored windscreen is an etched pattern—a square on its corner that was used to set up their dive attack angles.

The controls are close to hand and the instrument layout is pretty good. It's comfortable except for the primer, which is in a really awkward position, forward and down. I can't reach it

Smithsonian National Air and Space Museum

The Il-2 Šturmovík was the most-produced ground-attack aircraft of World War II. Armed with two 23-millimeter cannon, it could also carry up to 1,320 pounds (599 kilograms) of bombs and rockets. *Author collection*

with my shoulder straps on, so I have to drop my straps to get a hand on it.

Compressed air drives the landing gear, flaps, and breaks. Before takeoff you have to fill the smaller brake, flap, and landing gear bottles from the master air bottle. After startup, with the smaller bottles filled, the master bottle is topped up.

The throttle quadrant is comfortable, with an intercom button on the end. There's a tension knob right there so you can tighten or loosen it. Compared to US and British cockpits it sits relatively high in the cockpit.

As a tail-dragger the nose sits high up. You can't see much out front when you're taxiing, but once in the air the visibility isn't that bad.

Noise while flying is very loud. I actually put extra padding behind my ear cups. At cruising speed I can talk and hear fine, but up toward 400 kilometers (249 miles) per hour it becomes very loud and I have a hard time picking up voice transmissions over the radio.

Workload in the cockpit is very low, but you always have to pay attention to your power settings, the prop control, and both the radiator and oiler coolers. Overboosting the engine could cause something to break. Whenever I change speed or power, my right hand goes back and forth between the radiator and oil coolers.

It's a very simple and effective cockpit layout. I've never used the weapons systems, of course, but looking at them, selecting and utilizing the switches would be simple enough.

In terms of cockpit design and finish I would compare the Il-2 to an early Curtiss P-40.

RIGHT: The Il-2 was well armed and armored. But even with the 12.5-millimeter rear-mounted machine gun, gunners were killed seven times more often than their pilots.

BELOW: The Il-2 Šturmovík cockpit was a clean, well-laid-out design. It was also the most heavily armored cockpit of any World War II aircraft. A one-piece case-hardened armored tub surrounded the pilot. The back of the tub was sealed off by a 13-millimeter-thick piece of armor plate. The pilot also had the benefit of an armored-glass canopy and a 65-millimeter-thick windscreen. *Author collection*

ОБЩИЙ ВИД КАБИНЫ САМОЛЕТА Ил-2

1 — указатель наддува.
2 — счетчик оборотов.
3 — термометр воды.
4 — термометр входящего масла.
5 — трехстрелочный индикатор.
6 — бензиномер.
7 — указатель скорости.
8 — компас.
9 — вариометр.
10 — высотомер.
11 — „Пионер".
12 — авиагоризонт.
13 — переключатель магнето.
14 — кнопка вибратора.
15 — выключатель фары.
16 — выключатель хвостового огня.
17 — выключатель аккумулятора.
18 — выключатель АНОН.
19 — выключатель АНО.
20 — вольтметр.
21 — часы.
22 — розетка включения подсвета ПБП-1.
23 — сигнальные лампочки шасси.
24 — сигнализация сброса бомб.
25 — кнопка сигнализации сброса бомб.
26 — выключатель термометров.
27 — выключатель обогрева трубки Пито.
28 — выключатель рации.
29 — выключатель сигнализации шасси.
30 — выключатель обогрева сбрасывателя.
31 — выключатель вибратора.
32 — выключатель освещения приборной доски.
33 — выключатель освещения кабины.
34 — радиоприемник.
35 — переключатель бензиномеров.
36 — рукоятка пожарного крана.
37 — манометр баллона запуска.
38 — прицел ПБП-1.
39 — катушка триммера.
40 — рукоятка нормального газа.
41 — рукоятка высотного корректора.
42 — соединительный кран.
43 — тормозной кран.
44 — рукоятка крана шасси.
45 — гашетка крана щитков.
46 — дополнительный кран.
47 — манометр перезарядки.
48 — манометр заполнения.
49 — манометр перезарядки.
50 — специальный кран.
51 — штурвальчик шторки водорадиатора.
52 — запорный кран.
53 — манометр бортового баллона.
54 — манометр тормозов.
55 — манометр воздушной сети.
56 — штурвальчик управления шагом винта.
57 — педаль левая.
58 — кнопка бомбосбрасывания.
59 — гашетка для стрельбы из пушек.
60 — гашетка для стрельбы из пулеметов.
61 — предохранитель гашеток.
62 — тормозной рычаг.
63 — кнопка для стрельбы снарядами.
64 — педаль правая.
65 — рукоятка аварийного сбрасывателя.
66 — сигнальная лампочка.
67 — краник системы запуска.
68 — распределительный кран.
69 — плунжер бензонасоса.
70 — воздушный кран.
71 — рукоятка лебедки аварийного выпуска шасси.
72 — рычаги перезарядки пушек и пулеметов.
73 — рукоятка предохранителя пневмоперезарядки.
74 — рукоятка управления шторкам маслорадиатора.
75 — микротелефонный щиток.
76 — рукоятка стопора костыля.
77 — рефлектор кабинной лампочки.
78 — ЭСБР-3П бомб.
79 — ЭСБР-3П снарядов.

HEINKEL He 219 UHU

Heinkel He 219 A-2/R4 | Smithsonian National Air and Space Museum, Steven F. Udvar-Hazy Center | Werk Nummer 290202

The He 219 was one of World War II's more controversial aircraft. Originally proposed as a versatile multirole combat aircraft, it was finally developed into one of the war's more outstanding night fighters. Taking flight for the first time on November 15, 1942, the He 219 Uhu (Owl) represented a very advanced design for a specialized night fighter. Its purposeful lines incorporated a number of novel features, including ejector seats, tricycle landing gear, an all-round vision canopy, and interchangeable armament combinations.

With initial flight trials behind it, the He 219 still wasn't accepted into squadron service. Production proved to be a protracted and tortuous affair. Political rivalries between Kurt Tank of Focke-Wulf, Josef Kammhuber, commander of the Luftwaffe night-fighter force, and Erhard Milch of the German Ministry of Aviation (RLM) kept Ernst Heinkel's fighter in limited production.

Milch was the He 219's harshest critic. Despite his continual animosity, Heinkel initiated production of the Uhu on his own. Initial deliveries went to I/*Nachtjagdgeschwader* 1 at Venlo in the Netherlands in June 1943. With just three He 219A-0s on strength, the unit was credited with shooting down twenty RAF bombers, including six Mosquitoes, in just ten days.

By mid-1944 RLM officials had realized their mistake, but it was too late. In November 1944, Albert Speer, a war minister, virtually halted all aircraft production except for jets and single-seat fighters. In January 1945 I/*Nachtjagdgeschwader* 1, the only unit to be fully equipped with the He 219, had only sixty-four on hand with forty listed as operational.

The He 219's contribution to the night air war over Germany was small, but not insignificant. The core aircraft used by the *Nachtjagd* (night fighters) included the able Ju 88 and Me 110. Both were adaptations of designs originally intended for other roles while the He 219 was one of only two aircraft to be produced from the outset as a night fighter. In total just 288 He 219s were produced, but it was responsible for the majority of the eighty-four Mosquito night fighters lost over Germany during the war.

PILOT IMPRESSIONS
Captain Eric Brown, RN (Ret.)

When I flew the German Heinkel 219A-2, I was impressed. It had so much innovation. The ergonomic cockpit drew your attention straightaway. It was like walking into a hospital operating theater, all bright and clean, not a sign of dust or muck anywhere. The pilot and radar operator were seated back-to-back and both were equipped with every conceivable device tailored for a successful nocturnal interception. From a pilot's point of view the cockpit layout was beautiful and the layout of the instruments was logical and well positioned. Blind-flying instruments were dead ahead and laid out in that six-instrument pattern.

When you entered the cockpit you felt extremely comfortable. As a night fighter there wasn't too much to criticize apart from its lack of speed. It wasn't as fast as I had hoped for, and not nearly as fast as the Mosquito. It was underpowered, and for a twin-engined aircraft that was significant. This defect makes takeoff a critical maneuver in the event of an engine failure. It was, however, a very stable airplane, which is what you want at night with firepower galore. Apart from that, it was a very effective night fighter.

You've got to realize that when you take off at night you're holding the stick with your right hand, your throttles with your left. All the functional things like the flaps, undercarriage, and propeller controls should be on the left side because that's your free hand. In the He 219 they were beautifully positioned. The cabin heating and de-icing systems were very good and the autopilot was easy to operate, all critical for an all-weather airplane.

It gave you the feeling the designer was really in charge. It was a remarkable aircraft with a number of innovations. Not only was it one of the first aircraft to have an ergonomic cockpit it was also the first production aircraft with ejection seats for both crew. They worked beautifully. The Germans operated on a different system from the later Martin Baker seats. Martin Baker opted for

a cordite explosion whereas the Germans used compressed air. The record speaks for itself. During the operational history of the He 219 there were twelve successful ejections for both crews.

The other innovation was not directly related to the cockpit, but it did revolutionize night fighting. It was called *Schräge Musik* (a German colloquialism for jazz music). This consisted of two 30-millimeter cannon mounted in the fuselage that were angled upward at 60 degrees. Instead of attacking a bomber directly from the rear, the He 219 could approach unseen from underneath and fire upward. British crews never knew what hit them. Indeed, on the He 219's first operational mission it was credited with shooting down five four-engined RAF bombers.

LEFT: This three-view, aircraft-recognition profile of the He 219 Uhu was produced by Air Intelligence 2(g). The He 219 was a very advanced night fighter with a number of novel features, including interchangeable weapons pack, all-round vision canopy, and ejector seats for the crew. *National Museum of the USAF*

OPPOSITE: At the time of the Heinkel He 219's introduction, the Allies were aware of the aircraft, but they didn't have an oblique photo of it. This blurred gun-camera image was their first glimpse of the He 219—and it caused considerable interest in early 1945. *National Museum of the USAF*

BELOW: The early He 219V series prototypes were equipped with four-bladed propellers. First flight of the He 219V1 took place on November 15, 1942, powered by two 1,750-horsepower DB 603A engines.

KAWASAKI Ki-45 TORYU

Kawasaki Ki 45 Kai Hei (Mod. C) Type 2 | Smithsonian National Air and Space Museum, Steven F. Udva[...]

Design work on the Kawasaki Ki-45 Toryū (Dragon Slayer) began in January 1938, but the first production examples did not enter combat until the fall 1942. The development period was the longest of any Japanese World War II–combat aircraft. Conceived in the style of the Messerschmitt Me 110, the Ki-45's specification called for a two-seat long-range escort fighter with a top speed of 336 miles (541 kilometers) per hour, an operating altitude of 16,405 feet (5,000 meters), and endurance of more than five hours.

In January 1939 the first prototype, powered by two Ha.20B engines (Bristol Mercury engines built under license), developing 820 horsepower each failed to impress. Too slow, the Ki-45 suffered from a number of mechanical problems, including issues with the landing gear and engines. The second prototype was another disappointment with the top speed lower than expected. The frustrated Imperial Japanese Army put the project on hold.

In April 1940 Kawasaki adapted the Ha.25 engines, with 1,000 horsepower each on takeoff, and produced eight prototypes. Powered by the new engines the Ki-45 "Nick" attained a top speed of 323 miles (520 kilometers) per hour. With the Japanese army finally satisfied, the Ki-45-KAIa Toryū Type 2 Heavy Fighter Model A entered production in September 1941. Forward armament consisted of one 20-millimeter Ho-3 cannon, two 12.7-millimeter Type 1 (Ho-103) machine guns, and a single 7.92-millimeter flexible gun for the observer. In addition, two 550-pound (449-kilogram) bombs could be carried between the engine nacelles and fuselage.

The Ki-45 first saw combat with the 21st Sentai in Burma in October 1942. Like the Me 110, the Ki-45 did not perform well against single-engine fighters like the Curtiss P-40. As a long-range escort it was also a failure, but as a heavy-bomber destroyer, antishipping plane, and ground-attack aircraft the Ki-45 was a great success and well-liked by its crews. Unlike Japanese naval aircraft, the Ki-45 featured self-sealing fuel tanks. When armed with a single 37-millimeter cannon it became a potent antishipping aircraft, attacking American PT boats and Allied [...] and the Solomon Islands.

The Ki-45's greatest virtue w[...] it was Japan's most successful de[...] 20-millimeter cannon, Ki-45 pi[...] ground searchlights to shoot up i[...] effective when it worked, the stra[...] the defense of the Japanese hom[...] sively as a day and night intercep[...]

On August 20, 1944, a Ki-45 [...] twin-engine fighter to down a B-[...] astating but effective. In Novem[...] formed using stripped-down Ka[...] ramming attack by a Japanese fig[...] a B-29 was destroyed over Haku[...]

Shortly thereafter, Japanese [...] disappeared. The sky now belong[...] react against the massive formati[...] told to keep its remaining aircraf[...]

PILOT IM[...]
Captain Eric [...]

The Nick's design was a fine ef[...] behind the West in technology, [...] slightly superior to the Me 110 [...] and ability to absorb punishme[...] could still give a good accoun[...] the high-performance Allied fig[...]

Hellcat II versus Nick 2 [...] speed advantage over the twi[...] with superior climb and maneuv[...] advantage in every phase of co[...]

A Kawasaki Ki-45 Kai Hei of the 3rd Chūtai, 53rd Sentai, patrols for high-flying B-29s. This Ki-45 has a pair of obliquely mounted (at an angle of 70 degrees) Ho-5 20-millimeter cannon in place of the 59-imperial-gallon (268-liter) upper-fuselage tank. *National Museum of the USAF*

An abandoned Ki-45 Toryū ("Nick") of the 71st Dokuritsu Hikō Chūtai is examined by a RAF officer. The aircraft was found at Kallang Airfield, Singapore, in September 1945. *National Museum of the USAF*

its attack skillfully, keeping out of the Nick's forward and rear fields of fire. The Hellcat's optimum approach was diving from the forward quarter to get at the unprotected fuel tanks, then breaking away under the Nick. *Verdict*: The Hellcat should never really be ousted by the Nick unless its pilot got overconfident and made a careless attack, exposing himself to the enemy's rear gunner.

Corsair III versus Nick 2 This situation should be similar to the Hellcat-Nick encounter, but with the Corsair having a slightly better speed advantage and more of a maneuver disadvantage. *Verdict*: The Corsair would have as much success as the Hellcat against the Nick, provided it use the same tactic for the attack.

Firefly I versus Nick 2 Outperformed by the Nick, the Firefly could not hold the initiative in an attack, but once combat was engaged it could outmaneuver the Japanese fighter and bring its powerful forward armament to bear. The Nick's best chance of success against the undefended rear of the Firefly would be a hit-and-run attack. *Verdict*: The Firefly would only have a chance of success if the Nick could be lured into a dogfight, and the Nick would probably not get a kill from anything but a well-judged hit-and-run attack. This combat situation was really a well-balanced stalemate.

TBF Avenger versus Nick 2 The Avenger's best chance of survival would be to keep at low altitude, forcing the Japanese fighter to come in from above, and then to bring its turret guns to bear against the attacker. The Nick would be lethal, however, if it made a frontal attack against the bomber. *Verdict*: The Avenger's prospects of survival against the Japanese twin fighter would not be high, and its chances of a kill would be low.

Source: Brown, Eric M. *Duels in the Sky: World War II Naval Aircraft in Combat.* Shrewsbury, UK: Airlife Publishing, 1989.

CURTISS SB2C HELLDIVER

Curtiss SB2C-5 Helldiver | National Naval Aviation Museum | Registration No. 83479

As the Allies' most-produced dive-bomber (more than seven thousand built) the Curtiss Helldiver endured one of the longest gestation periods of any combat aircraft during World War II. It wasn't the best dive-bomber of the war or even the most liked, but it was responsible for the destruction of more Japanese targets than any other aircraft.

In 1938 the US Navy issued a request for a new carrier-based scout dive-bomber to replace the Douglas SBD Dauntless. A half dozen companies responded, with Curtiss winning the contract. Even before the first prototype was built, the navy ordered 370 SB2C-1s. The order of so many aircraft before a prototype had yet to fly was extraordinary and, predictably, problems soon followed. On December 13, 1940, XSB2C-1 was rolled out and flown for the first time. In February the prototype's engine failed on finals causing a crash landing.

> **"The SB2C offered little improvement on the SBD . . . the SBD would be my choice!"**
>
> —*Lieutenant Commander James E. Vose, USN*

For eight months the Helldiver program proceeded without the benefit of a flying aircraft. Initial flight testing revealed that the design was clearly not ready for mass production. The Helldiver's stalling characteristics were bad and low-speed handling was marginal at best. As the Curtiss team tried to cope with the design changes demanded by the US Navy's Bureau of Aeronautics, production of the new Helldiver moved ahead despite the known problems.

When the first production SB2C-1 took flight in June 1942, it revealed even more problems. Between this first production test and November 1943, no fewer than 899 major design changes were made.

The Curtiss Helldiver SB2C-1 finally entered combat with VB-17 on November 11, 1943, flying a strike against the Japanese base at Rabaul. From 1943 to 1945 thirty navy squadrons deployed the SB2C. At first greeted with a great deal of enthusiasm, the Helldiver soon earned the nickname "the Beast." For many the aircraft was a clear step backward. During twenty-two months of combat in the Pacific, the Helldiver logged 18,808 combat sorties. Because of its poor landing characteristics, however, more SB2Cs were lost in deck-landing accidents than to enemy action. (During 1944 to 1945 alone, 1,103 Helldivers were lost to all causes.) Curtiss built total of 7,140 Helldivers, while in Canada, Fairchild Aircraft and Canadian Car and Foundry added 300 and 894 units, respectively.

After World War II, Greece, Italy, France, Portugal, and Thailand flew the Helldiver.

PILOT IMPRESSIONS
Ed Vesely, Commemorative Air Force

The Helldiver is a very large single-engine airplane weighing in at approximately 15,000 pounds (6,804 kilograms). The cockpit is roomy. The ergonomics of the Dash 5 (i.e., SB2C-5) are very good. Compared to the Dash 4 it has a much better cockpit flow. The flow is circular starting from your lower left working your way in a clockwise fashion. The throttle quadrant is on the left side; all the hydraulics, cowl flap, oil cooler, bomb bay, and flaps and landing gear handle are conveniently located below that. Apparently in the Dash 4, the landing gear handle was on the right side, which meant you had to switch hands. That could lead to throttle rollback—not what you want just after a carrier takeoff.

ABOVE: An SB2C-5 Helldiver of Attack Squadron (VA) 9A is pictured in the aircraft carrier elevator of the USS *Philippine Sea* during operations in 1946. *Author collection*

OPPOSITE PAGE: An SB2C-3 Helldiver of VB-7 from the USS *Hancock* drops a 1,000-pound bomb on a Japanese convoy off the coast of French Indochina on January 12, 1945.

Like any large tail-dragger, ground visibility on the over the nose is zero. Being a turtle-backed airplane, visibility to your six o'clock and side is restricted to 30 degrees on either side of the tail. I can't imagine landing one of these things on a straight-deck aircraft carrier.

My first takeoff was similar to what I experienced in the TBM Avenger and F6F Hellcat. Once airborne the most surprising thing was how light the Helldiver's ailerons were. For its size it also has a moderately quick rate of roll.

Noise level without a headset or helmet is a roar. Unfortunately we don't have an autopilot; hand flying a 15,000-pound airplane over a three-hour-plus cross-country is work, but other than that it's a very comfortable.

Other than monitoring engine instruments, flying the Helldiver is straightforward. The workload for takeoff is what you'd expect for airplane this size. It's also absolutely important to set the trim before takeoff. We take off with eight degrees right rudder trim.

While extremely rugged the Helldiver wasn't well liked due to its higher approach speed. Compared to the Avenger and Hellcat's approach speed of 80 knots, the Helldiver needs 100. Both the SB2C-5 and Avenger had similar operating weights, but the Helldiver's wing was shorter with higher wing loading. It's like a P-40 wing on steroids! It's a high-speed airfoil, and for deck landings that's not a positive thing. For the guys who transitioned from the Douglas SBD Dauntless it was very intimidating. The Helldiver is also a handful to fly when you find yourself on a short final, down-and-dirty go-around. On this aircraft the flaps and landing gear act as drag devices. When you add power for the go-around there's no time to trim the aircraft. To keep it from torque rolling you have to jam your right foot right up against the firewall. While going around, gear up immediately and slowly milk the flaps up. Once you hit 100 knots, only then will it begin a positive rate of climb.

If I could change anything in the cockpit it would be the emergency hydraulic pump handle. It's too short. Other than that they definitely got the cockpit right in the SB2C-5.

WORLD WAR II

The P-61 was a large aircraft. Its broad wing was extremely strong and stressed for high g loads. At 662.36 square feet (201.89 square meters) it was bigger than today's massive F-15 Eagle.
National Museum of the USAF

P-61A-1 of the 6th Night Fighter Squadron prepares for another nocturnal mission. By 1945 night engagements with Japanese aircraft were sporadic, with several P-61 squadrons recording no kills at all. *National Museum of the USAF*

scope. U.V. lighting poor for night adaptation. Flaps hard to operate. Could simplify starting procedure.

Power Plant Operation Prop and throttle controls should be together. Prop feathering switches awkwardly placed. No prop vernier control. Supercharger control too far from quadrant.

Combat Qualities Poor, inasmuch as it lacks necessary speed and rate of climb. The cockpit is too complicated. Visibility is not good. Should have a stick instead of a wheel. Excellent night-fighter against large bombers or non maneuvering targets. The instrument lights are too bright. Not enough performance for a night-fighter. Needs more range, better climb, air brakes, better cockpit in both arrangement and lighting. Just too damn big for a night-fighter. This aircraft is simple and quite pleasant to fly, except for the infernal wobble, which only detracts from its gun-platform qualities. This airplane is a useful combat machine, but can stand much improvement in speed and cockpit.

Maneuverability Its maneuverability is god [*sic*] for such a large airplane, but it may find it hard to stay behind a Jap night bomber. The P-61 is not easily controlled in the clean condition below 110 miles [177 kilometers] per hour. The Japs sometimes fly this slow just to bitch up night-fighters. Turning radius is excellent considering wing loading. Acceleration too slow. Not enough power.

In October 1944 the Joint Fighter Conference was held at the US Navy's Patuxent River test center. The latest fighters were tested by pilots from the army and navy/Marine Corps, the RAF, the National Advisory Committee for Aeronautics (NACA), and manufacturers.

DEATH AT 30,000 FEET 137

BOEING B-17 FLYING FORTRESS

Boeing B-17G | National Museum of the US Air Force | Original, restored; 24 missions with 91st Bomber Group

The Boeing B-17 is arguably the most famous American bomber of World War II. Featured in such film classics as *Twelve O'Clock High* and *The War Lover*, the B-17 often overshadowed the more prolific Consolidated B-24. When it was first conceived, the B-17 was not considered for the role of a strategic bomber, but instead as a defensive weapon designed to sink ships off the coast of the United States. When the USAAC issued a requirement for a new multiengine bomber in 1934, Boeing took the term "multiengine" to mean four. In June 1934 work on the Model 299 began and the prototype first flew on July 28, 1935. A local paper nicknamed the new bomber the "Flying Fortress" and it stuck.

When the B-17B entered service, it was the fastest, highest flying bomber in the world. At the same time the USAAC was developing its long-range strategic-bombing program, believing that massed formations of self-defending B-17s would make it to the target without suffering heavy losses.

The B-17 first saw combat with the RAF beginning in July 1941. Its defensive armament, however, could not be described as fortress-like. The B-17C was armed with two handheld .50-caliber guns in the dorsal position, two in the ventral position, one .303-caliber flexible gun in the nose, and two .50-caliber guns in the waist positions. The RAF wanted to use the B-17 as a high-altitude bomber in the hopes of avoiding enemy fighters, but the results were not good. The guns had a tendency to freeze at high altitudes and the Norden bombsight did not live up to expectations. Losses to fighters and accidents steadily grew until just four of the original twenty B-17s remained.

An extensive redesign was ordered and the first, truly combat-ready B-17 was the E model, equipped with a Sperry top and remote lower turret (soon replaced by the Sperry ball turret), tail turret, two guns in the waist, and two in the nose. The next variant to enter service, the B-17F, incorporated hundreds of changes, including new fuel tanks and more armor. The B-17F also bore the brunt of early deep-penetration raids into Germany. Against stiffening fighter resistance, aircraft losses frequently rose above 10 percent. It also became clear that the B-17s, like the B-24s, were vulnerable to head-on attacks. The B-17G attempted to solve that problem with the addition of the Bendix chin turret operated by the bombardier. In the end the introduction of long-range escorts enabled the Eighth and Fifteenth Air Forces to continue using this aircraft for the daylight bombing of Germany.

PILOT IMPRESSIONS
Rey Fowler, Current B-17 Pilot

The B-17 cockpit is incredibly unique. A lot of cockpits look similar, but the B-17 is totally different. No other airplane that flies today has that throttle quadrant. Every other airplane has a throttle you grab at the top. In the B-17 you handle the throttles from underneath, using your underhand. Grasp the top rung and engines one and four will respond, while the bottom rungs give you two and three. The split middle rung gives all four at once and is therefore used the most. It takes a while for new B-17 pilots to remember to turn their hands.

The other thing you have to be aware of is the mixture controls. In most aircraft, to increase fuel mixture, you push the control forward; to increase power in the B-17 you move the throttles forward and the mixture controls back. It's counterintuitive. You could easily shut off all four engines if you're not paying attention.

The view from the cockpit is very good. I've got limited time in the B-24 but in comparison, the B-17 is much better. You have a low wing behind you and the cockpit sits past the leading edge. The only obstruction is over the nose. The celestial navigation dome can block your view, but otherwise visibility is outstanding.

The cockpit noise level is comfortable. Compared to the B-25, which is the loudest aircraft I've ever flown, the B-17 is very good. When it comes to overall comfort, however, it's not great. We don't fly the B-17 at 20,000 or 30,000 feet (6,096 or 9,144 meters)–6,000, 7,000, or 8,000 feet (1,829 to 2,438 meters) is the norm, and after flying for two or three hours, it gets pretty

This fully armed B-17F was designated "war weary" in late 1943. Many worn-out airframes were quickly used as VIP transports or whiskey haulers. Pilots often found them a challenge to fly, with their stretched control cables and tired engines. *Author collection*

darn cold. It's the coldest I've ever been. It gives you a lot more respect for the guys wearing the heated suits flying around at 30, 40 below zero (−1 to −4 degrees Celsius) at 30,000 feet.

The B-17 is a two-pilot airplane. The workload in the cockpit is relatively straightforward. The pilot in command does most of the work with the copilot checking the gauges to make sure everything is within limits. The controls are heavy. There's no boost, just cables and pulleys. It will wear you out. At the same time the B-17 was comfortable and easy to fly, that's why they gave it to nineteen-years-olds with just one hundred hours. You have to respect those young men flying formation for hours while dodging German flak and fighters. The B-17 does not have a mean bone in its body. It will embarrass you, however, especially when you bounce it on the runway for the first time.

When the war started the B-17 was somewhat obsolete. Built with 1930s technology, the cockpit was still very useful. The wartime instrument-panel configuration was very good. It's logical, easy to read; I wouldn't change a thing. If it wasn't for a bullet, bomb, or gas they didn't leave a lot of room for comfort. It was one of the best military aircraft ever built. I love every part of flying the B-17. It was put together right.

ABOVE: The lead bombardier of the 390th Bomb Group has just released his smoke markers, the signal for the other B-17s in the group to drop their bombs. The large astrodome obviously obscures the pilot's forward vision. *Author collection*

BELOW: Easily the most famous American bomber of World War II, the B-17 featured in such films as *Twelve O'Clock High* and *The War Lover* and often overshadowed the more prolific Consolidated B-24. *Voyageur Press collection*

BOEING B-29 SUPERFORTRESS

Boeing B-29A | New England Air Museum | Serial No. 44-61975

When it was first produced, the Boeing B-29 was an inspiring sight. With a wingspan of 141 feet (43 meters) and length of 90 feet (27 meters), it dwarfed both the B-17 and B-24. With a gross weight of nearly 70 tons it was double that of the B-17 Flying Fortress. In terms of wartime projects, the B-29 was the most expensive weapons system designed and built in America. It cost $3 billion to develop and manufacture, which was almost $1 billion more than the top-secret atomic bomb project.

In many ways the B-29 was a technical marvel—it was the first bomber to be pressurized. It was also powered by the largest piston engines at the time, had the most sophisticated radar, and was equipped with the world's most advanced remote-controlled turret fire–control system.

Despite its technical prowess and commendable history, when the B-29 flew for the first time, it was far from being combat ready. Even when it entered service, those who flew it had to live with its many faults: explosive decompression at altitude, inexplicable engine fires, and the notorious unreliability of the Wright Cyclone Duplex R-3350 engine.

From their bases in India, China, and the Pacific, B-29 crews flew the longest combat missions of the war. In the fourteen months of combat, starting on June 5, 1944, and ending on August 15, 1945, the B-29 dropped 170,000 tons of bombs and 12,000 aerial mines. The toll on the aircraft during this period was heavy: 414 planes were lost, with 147 of that number shot down in combat. Unfortunately, more B-29s were destroyed to mechanical failure and unknown causes than were lost in actual combat. When compared to the 4,600 B-17s lost in Europe, the crews who flew the B-29 were, in some ways, more fortunate.

The B-29, while never perfect, was a devastating bomber. After its conventional bombing runs over Japan, it helped win the war by delivering the world's first two atomic bombs in August 1945.

PILOT IMPRESSIONS
David Oliver, Director of Operations, B-29/B-24 Squadron Commemorative Air Force

The B-29 cockpit is big and impressive. It's like sitting in your living-room lounge chair. The adjustable seats are nice and comfortable; it feels like you're commanding a big ship.

Compared to the B-17 and B-24 there are no engine instruments on either the pilot's or copilot's instrument panel except for manifold and rpm gauges. All the other engine and propeller instruments and controls can be found on the flight engineer's panel. All the pilot has are the primary flight and navigational instruments. It's an interesting layout because you have to rely on the engineer to be your systems operator.

The view through the big round bubble nose is terrible. The windows are not as big as you think and there's so much metal framing it always seems as if there's a piece blocking your view. A lot of our new pilots do what we call "shadow boxing"—constantly moving their heads back and forth trying to find a better line of sight. When you look through a curved piece of glass, what you're looking at is not necessarily what you think you're looking at. It takes a little getting used to.

The B-29 is loud, but not nearly as noisy as the B-24. In the B-29 you have insulation and the engines are set farther back from the cockpit. There's not a lot of vibration, but it's still about 120 decibels on takeoff. In cruise, with the props back to 18 or 19 hundred rpm, it's actually pretty quiet. You could probably take your headset off and yell at the guy next to you, but I wouldn't recommend it.

The B-29 is a pretty straightforward airplane. There's nothing in it that demands constant attention. The workload, compared to the B-17 or B-24, is not nearly as high. The other four-engine bombers are more fun to fly because there's more stuff to do,

Two YB-29s in flight. Fourteen YB-29s were built for flight and armament testing beginning in the summer of 1943. *Universal History Archive/Getty Images*

more levers to pull. In the B-29 you just kind of sit there, call out commands and fly the airplane.

The B-29 was the first aircraft to use the term "Aircraft Commander." Its complexity required a separate flight engineer, which freed the pilot to fly the aircraft and take command of the mission.

It's a great cockpit. The truth is when it comes to a flying an airplane, instrumentation aside, the basic ergonomics make all the difference. That means the yoke in front of you is at the right height with a good feel. A seat with some adjustment, rudder pedals that are ergonomic for your feet. In the Liberator they're too far apart and travel too far, so a short guy can't reach them. The B-29 doesn't have any of that. It's well balanced with the correct throw for different body sizes. It also has a nice big old fat trim wheel sitting on the left side right by your knee. Exactly where you'd want it.

The manual flight controls are all cables and pulleys. There's no hydraulic assist. That means everything is heavy, but it's all balanced. It's also one of the most intense aircraft I've flown that requires so much rudder. For its size, the rudder is relatively light on the controls. That's because Boeing engineers built a diamond-shaped airfoil on the leading edge of the rudder flight control surface. It gives the rudder an aerodynamic boost, making it easier for the pilot. If you want to fly the B-29 working out in the gym is a good idea.

ABOVE: B-29s from the 9th Bomb Group climb for altitude in the spring 1945. The B-29 in the foreground is equipped with AN/APQ-13 ground-scanning radar located between the two bomb bays. The radar was used for high-altitude area bombing and search and navigation. *Author collection*

RIGHT: Nose art on American aircraft was ubiquitous during World War II. *Flying Stud II* was no exception, with both bombing and supply missions (camel) noted. The Japanese flags indicate four fighters shot down, with three "probables" beneath. *Author collection*

DORNIER Do 335 PFEIL

Dornier Do 335 A-0 | Smithsonian National Air and Space Museum, Steven F. Udvar-Hazy Center | Werk Nummer 240102

Throughout World War II German aircraft designers pushed aerodynamics to the limits. Aided by supersonic wind tunnels (which the Allies didn't have) the Germans were able to produce some of the world's most advanced fighters and bombers. One of the most unique and innovative was the Dornier Do 335 Pfeil (Arrow).

Since the end of World War I, Dr. Claudius Dornier had been interested in the field of centerline thrust, whereby two engines shared the same thrust line with one pushing and the other pulling. Dornier's early flying-boat designs, like the Do 18 and Do 26, gave him a wealth of knowledge in simple centerline engine configurations.

In 1942 the German Ministry of Aviation (RLM) issued a requirement for a high-speed, unarmed intruder aircraft. Dornier submitted his Projekt 231 that incorporated the tractor-pusher engine arrangement. A development contract was awarded and, as the design got underway, the RLM changed the specification and requested a multipurpose combat aircraft. This change resulted in a delay in the production of a prototype and it wasn't until the autumn 1943 that the Do 335 ready for flight.

The Do 335 was a beast of an airplane. A single-seat aircraft, its wingspan was 45 feet (14 meters) with an empty weight of 16,005 pounds (7,260 kilograms). It was powered by two Daimler-Benz DB 603A engines developing 1,750 horsepower each. The first prototype took the air on October 26, 1943. Test pilots were surprised by its speed, acceleration, and turning circle. Pilots soon nicknamed their new mount the *Ameisenbar* (anteater) because of its long nose.

Aside from its unusual engine layout, the Do 335 was a very advanced design that introduced a number of innovative features, including a de-icing system on the leading wing edge; a reversible tractor airscrew to shorten the landing run; hydraulically operated flaps; a ventral air intake for the rear engine; and a compressed-air ejection seat (only the fourth production type to feature this, after the He 219, He 162, and SAAB J21).

The fifth prototype was fully armed with two MG 151 15-millimeter cannon on the upper fuselage decking and a single MK 103 30-millimeter cannon firing through the propeller hub. In September 1944 ten Do 335A-0 preproduction fighters were assigned to the Erprobungskommando 335 for evaluation and the development of operational tactics.

By late 1944 the Do 335A-1 variant was in full production, with delivery beginning the following January. Capable of a maximum speed of 474 miles (763 kilometers) per hour at 21,375 feet (6,515 kilometers), this fighter could easily outpace any Allied piston-engine fighter it encountered. Like many of Germany's revolutionary late-war designs, the Pfeil was soon ordered as a night fighter, a reconnaissance aircraft, and a fighter-bomber. In April 1945 American forces overran the factory at Oberpfaffenhofen and found eleven Do 335A-1s and two Do 335A-12 two-seat trainers under construction. Just thirty-seven Do 335s had been completed with seventy others awaiting final assembly.

There are no reports of the Pfeil entering combat, but French ace Pierre Clostermann claims to have encountered a Do 335 in April 1945. Leading a flight of four Hawker Tempests from No. 3 Squadron RAF over northern Germany, a lone Pfeil was intercepted at treetop level. Spotting the RAF fighters the German pilot reversed course and quickly pulled away from the pursuing Tempests.

The Do 335 was a technical marvel, heavily armed with an impressive performance. It represented the pinnacle of piston-engine fighter technology just as the age of the jet fighter took hold. Possessing great potential as a combat aircraft, the Do 335 never got the chance to prove itself—German indecision in the high ranks, Allied bombing attacks, and lack of time, sealed the Do 335's fate.

Captured Dorniers are seen in the Obernfaffenhofen factory in April 1945. American troops found eleven Do 335A-1s, four A-4s, and a pair of A-12s in final assembly. *National Museum of the USAF*

The Do 335A-10 two-seat trainer prototype. The Do 335 was the most unconventional piston-engine fighter developed by any nation during the war. Its tractor-pusher configuration proved successful, though, with a maximum speed of 474 miles (763 kilometers) per hour at 21,325 feet (6,500 meters). *National Museum of the USAF*

PILOT IMPRESSIONS

Captain Eric Brown, RN (Ret.)

The Dornier 335 appeared right at the end of the war and was test-flown into production. Production hadn't reached the numbers required to make it effective enough to be a fully functional combat aircraft. The concept of having a tandem-engine layout with a pusher and a tractor propeller was extremely interesting. Because it was a fast airplane, it had a 13-degree sweepback wing for stability.

We tested a Do 335 at Farnborough. It stacked up as the fastest twin-engine in the world at that time. Its contemporaries were the De Havilland Hornet and the Twin Mustang. Interestingly enough, the Do 335 had a top speed of 472 miles per hour and the Twin Mustang 470 miles per hour (760 and 756 kilometers, respectively).

The cockpit layout, by virtue of the inclusion of an ejection seat, was slightly complicated. Instead of all your functional buttons being on the left side they had to put some on the right. They just ran out of space. The cockpit felt quite comfortable, but getting out would have been a little difficult because of the mincing machine behind you. You also had a cruciform tail, which made for a very complex structure. To get out in an emergency you had to press three buttons on the right-hand panel. The first one blew off the pusher-engine airscrew. The second one blew off the top of the cruciform tailfin rudder. The third one armed the ejection seat. The hood was then jettisoned manually and, finally, the seat was fired by squeezing a trigger on the armrest. Assuming you could do all that you could get out.

I have to say the canopy-jettison mechanism for that era wasn't cleverly designed. When fully locked there are two levers at the cockpit sill level pointed upward at 90 degrees. To jettison the hood you had to them pull both back at the same time. You really had to pull hard. It seemed to me to be a bit of a snag.

The Do 335 flew very well. It was stable and would've been a good night fighter in my opinion. Cockpit-wise I had no real problems, except for the ejection procedure, which I found a little overcomplicated.

MESSERSCHMITT Me 262 SCHWALBE

Messerschmitt Me 262 A-1a | National Museum of the US Air Force | Werk Nummer 501232

The Me 262 Schwalbe (Swallow) remains one of the great "what if" fighters of World War II. Its swept-wing design and sharklike appearance caused a great deal of anxiety in the Allied camp. Under the code names "Stormbird" and "Silver," the Me 262 represented a quantum leap in fighter technology. Luckily for the Allies the Me 262 entered the conflict too late and its impact on the air war over Germany was minimal.

In 1941 Germany was at the height of its military powers. Ideas for new fighters and revolutionary jet technology, however, were given little or no priority. Despite a lack of official interest, work on the Me 262 progressed. In April 1941 the first prototype took to the air, but it wasn't jet powered. Fitted with a 750-horsepower piston engine, the Me 262, aerodynamically superior to any fighter in existence, proved faster than the 1,000-horsepower Bf 109.

The first turbojet-powered Me 262 flight occurred on July 18, 1942. By early 1943 Luftwaffe Maj. Gen. Adolf Galland knew the Me 262 was superior to anything the Allies had and, if put into service, it would prove to be decisive. With a top speed of 540 miles (869 kilometers) per hour at 20,000 feet (6,096 meters) it was 140 miles (225 kilometers) per hour faster than the fabled P-51 and Mk XIV Spitfire. Heavily armed with four 30-millimeter cannon, the Me 262 could shred any bomber with just a short burst. Adolf Hitler, however, saw the Me 262 in a different light and ordered the first examples produced as a bomber. Then, in November 1944, Hitler rescinded his order and demanded thousands of Me 262 fighters.

In October 1944 the first all–Me 262 fighter unit was formed. Plagued by engine failures, crashes, and pilot inexperience, the original complement of thirty aircraft was reduced to just three by month's end.

The first Me 262 to be downed by gunfire occurred on October 5, 1944, when five Spitfires from No. 401 Squadron of the RCAF shared in its destruction over Nijmegen, Holland. The Me 262 did, however, enjoy some success. On March 18, 1945, the US Eighth Air Force lost twenty-four bombers to the Me 262. Then, on March 31, the RAF lost seventeen Lancasters to Me 262 cannon and missile fire.

As the war situation grew desperate for the Germans, they increased Me 262 output using large numbers of slave laborers in extensively dispersed and heavily camouflaged factories. Eventually, 1,433 Me 262s were produced, but only a hundred or so actually saw combat service.

The last Me 262 unit to see action was *Jagdverband* 44 (JV44) commanded by Galland and a cadre of elite pilots. Operating from the Munich Augsburg Autobahn, JV44 flew in the last month of the war, claiming fifty American bombers destroyed.

For many Luftwaffe pilots the Me 262 proved challenging to master. Its sensitive throttles and unreliable engines made it vulnerable during takeoff and landing. (Most Me 262s shot down were caught while landing or takeoff.) Its massive speed advantage also made aiming difficult. Even though it was the fastest fighter in the sky, it was always heavily outnumbered.

Nevertheless, the Me 262 represented the future of fighter propulsion and design. It's often claimed that if it had been available in 1943 it could have stopped the USAAF's strategic daylight bombing campaign over Germany. It may have, but just for a short time. Its unreliable engines, a shortage of fuel and safe airfields, and the lack of well-trained pilots, plus the inevitable change in Allied tactics, eventually would have rendered the Me 262 ineffective.

Me 262 *Yellow 17* of III/JG 7, along with *White 7*, were surrendered at Fassberg, Germany, on May 8, 1945.

PILOT IMPRESSIONS
Captain Eric Brown, RN (Ret.)

In my opinion the Messerschmitt Me 262 was the most formidable fighter of World War II. Because the Germans had supersonic wind tunnels for testing, the Me 262 was a highly advanced wingswept design.

When I first saw the Me 262, I knew it was a different airplane. I didn't fully realize, however, the impact its engines would have on its performance. The Germans went for the axial-flow type engine, while the British opted for the centrifugal design. I worked closely with Frank Whittle, who developed the first British jet engine. I asked him why he didn't pursue the axial-flow design. He wanted to give the RAF an engine that was simple and reliable. He was right. The German axial-flow engines had a scrap life of just twenty-five hours while the Whittle engine had an overhaul life of one hundred hours! Lacking the strategic metals to withstand the heat and compression at the time, the German engines had an extremely short lifespan. Adolf Galland, commander of JV 44, told me after the war the average engine lifespan was even worse at just twelve hours! They were also sensitive to excessive throttle movement. Move the throttle too quickly and the engine flamed out. It got so bad pilots eventually took off at full power, only to ease back to climbing power and never touching the throttles until they were ready to land.

"It was as though angels were pushing."
— *Major General Adolf Galland, Luftwaffe*

The cockpit wasn't particularly unusual. It was uncluttered with the engine instruments on the right and flight instruments on the left. The view from the cockpit was also good.

Armed with four 30-millimeter cannon, the Me 262 had huge firepower. But there was a catch—diving on a B-17 meant your closing speed was extremely high, giving you time for just a short burst of cannon fire. Opening fire at 600 yards (549 meters) gave you just two seconds before breaking away. That meant your shooting was random and inaccurate. With dive breaks you could have slowed down, giving more time to aim and adjust, increasing your chances of hitting your target.

A *Rotte* (wing) of Me 262 A-1as from III./*Ergänzungs-Jagdgeschwader* 2 taxi out for a training sortie in early November 1944. III./EJG 2 was the official training establishment for all future Me 262 fighter pilots until it was overrun by American troops in April 1945. *Author collection*

ARADO Ar 234 BLITZ

Arado Ar 234 B-2 | Smithsonian National Air and Space Museum, Steven F. Udvar-Hazy Center
Werk Nummer 140312; served with 9./KG 76

As the world's first jet bomber (and second jet aircraft to enter Luftwaffe service), the Arado Ar 234 Blitz appeared too late and in too few numbers to seriously affect the outcome of the war. As was the case with the Messerschmitt Me 262 jet fighter, the Allies had no real equivalent, frustrating many a fighter pilot assigned to intercept it.

The first operations flown by the Ar 234 were reconnaissance over the British Isles starting in July 1944. By October 1944 the Ar 234B-2 bomber version began to equip Kampfgeschwader 76 (KG 76). In December the Ar 234s from KG 76 saw action during the Ardennes counteroffensive (Battle of the Bulge), but most efforts were flown against the famous bridge at Remagen. Starting in 1945 three Ar 234B-1s provided vital reconnaissance work on the Italian front; by the end of March, all Ar 234 units virtually ceased to exist.

Total production came to just 210 examples with very few seeing combat. It was also the last Luftwaffe aircraft to fly over Britain during the war.

PILOT IMPRESSIONS
Wilhem Kriessmann, Kampfgeschwader 76

I joined KG76 in December 1944. Talking to some of the other pilots, I was curious to find out how they flew their bombing missions with the new jet. They described a couple of techniques used against the bridge at Remagen. Some used a glide-bombing method. Others flew higher up, 4,000 or 5,000 meters (13,000 or 14,000 feet), and used the Ar 234 as a horizontal bomber. As for accuracy, I had my doubts. After several failed attempts they finally managed to hit the bridge, but it was too late.

My first flight in the Ar 234 occurred on December 11 or 12, 1944. Because it was a one-seater there was no chance for a dual flight. Of course they considered me an experienced pilot and after some classroom instruction I was ready for my first flight. Before takeoff they sat you in the cockpit and told you what to do. The instrument panel was pretty simple. To save fuel they would tow the aircraft out to the runway. Starting the jet engines was a little bit unusual, but nothing out of the ordinary. After several attempts I finally lined up ready for takeoff. Before takeoff they warned us, "Watch out, don't push it like a piston-engine airplane. Be cautious, line it up properly, step on the brakes, open the throttles slowly, and then release the brakes." Because you hand no propeller to worry about you didn't have to correct your direction. When it came to landing, they said the same thing: "Slow and cautious" on the approach. If you pushed the throttles too hard and wanted to accelerate you'd turn the turbine blades into a *geschmolzene Salat* (melted salad). It was heat shock. Unfortunately the turbine blades in the engines were not made of high-temperature metals like chromium and titanium.

It was a different way of flying, the whole structure, the whole idea of a jet. The power was exhilarating! The aircraft was a dream. Aerodynamically smooth with an elegant fuselage. The vision from the cockpit was wonderful. It also sat very low to the ground. It had a clear 180-degree view forward and up but the rear vision was poor. Shortly after takeoff I went into in steep, steep climb and flew all the way up to between 8,500 and 9,000 meters (27,887 and 29,528 feet). The higher you flew the less gas you consumed. Interestingly, the fuel was of a low quality, much like diesel.

Whenever we flew we knew the Mustangs and Lightnings would be waiting. Early on we were told that our landing fields were protected by Fw 190s and Bf 109s. I personally had no bad experiences. The aircraft was very responsive and its speed was its best defense.

Many Ar 234Bs were captured fully intact by the Allies at the end of the war, and were tested extensively by Britain and the United States. Allied pilots found the Ar 234's handling characteristics very good, even if the aircraft was somewhat underpowered. *National Museum of the USAF*

This Ar 234 cutaway drawing was one of the first produced by the Allies after the war. *National Museum of the USAF*

PILOT IMPRESSIONS

The cockpit of the Arado 234 is designed to accommodate a man although it could easily be arranged to carry two. Access to the cockpit is satisfactory, and entry is facilitated by efficient recessed steps covered by spring loaded doors and hand-holds in the left side of the fuselage. The cockpit opening on the top of the fuselage is large enough for entry with winter clothing and parachute. The layout is simple and provides ample side and head space for the average pilot. The pilot sits in the nose of the fuselage in a slightly reclined position with his feet relatively high. The pilot's seat can be adjusted in only two positions and this must be accomplished on the ground. Similarly, the rudder pedals are ground adjustable only. The control column is equipped with a quick release lever which enables the pilot to throw the column forward prior to bailing out through the escape panel located immediately above the pilot's head. All controls are located on two panels or shelves at elbow height on either side of the pilot. The left side contains the engine controls, landing gear and flap controls, rudder and elevator trimming devices, and position indicator lights. The right shelf contains starter controls, fuel gauges, tail pipe and fire warning temperature gauges, fuel pressures and radio controls. Superimposed immediately in front of the pilot and slightly below eye level are the flight instruments, tachometers and oil pressure gauges. The main electrical panel with all circuit breakers is located behind the pilot's right shoulder.

Vision is distorted forward by the curved plexiglass [*sic*] enclosure and is blocked at 2 and 4 o'clock by airframe members. Rear vision is blocked completely. Overhead vision is good. Vision is satisfactory during climb although slightly restricted downward.

In general, the pilot experience[s] little discomfort with the possible exception that the fixed position of the knees due to inability to adjust the rudder pedals in flight causes cramped knees. Using a seat type parachute there is insufficient headroom for a tall pilot.

"Air Material Command Report," October 1946

CHAPTER FOUR: COLD WAR TO THE PRESENT
MUTUALLY ASSURED DESTRUCTION

By 1944 aerodynamic advances and raw horsepower had finally caught up with the single-seat fighter and multi-engine bomber of World War II. Since 1936 engine power had doubled, but the limitations of the piston engine were beginning to show.

The latest fighters, like the Hawker Tempest V, Focke-Wulf Fw 190D-9, and North American P-51H, were powered by engines producing more than 2,000 horsepower with speeds above 430 miles (692 kilometers) per hour, with the P-51H topping off at 487 miles (784 kilometers) per hour. But this is where the piston engine reached its limits of power and weight. New, larger piston engines were heavy and more complex. The added power caused the tips of the propellers to go supersonic, generating more noise than thrust. Just as the world's largest piston engines were about to be bench tested, jet engine technology altered the course of aviation.

Introduced in 1944 the Gloster Meteor Mk I and Messerschmitt Me 262 A-1a were the world's first operational jet fighters (the title of first jet fighter belonged to the Heinkel He 280, which first flew in 1942 but was never operational). The swept-wing Me 262 was a revelation. Its aerodynamic design was light years ahead of the more conventionally designed Meteor Mk I. As revolutionary as these jet-powered fighters were, however, both lacked updated cockpits. Apart from turbine temperature and rpm indicators graduated from 0 to 15,000, the general shape and cockpit layout of the new fighters remained very much the same as contemporary piston-engine aircraft.

While the Me 262 was more advanced in terms of its swept wing and aerodynamics, the Meteor Mk I did break new ground with its cockpit placement. With the jet engines mounted in the wings, the cockpit was positioned in the nose, giving the pilot a virtually unobstructed view. Engine noise was greatly reduced and the low-frequency vibrations pilots had to endure when flying the Spitfire or P-47 were gone. It was a totally improved and more comfortable cockpit environment. Nevertheless, focus on building a practical jet engine and airframe left little time or resources for cockpit design. Instrument and controls were provided from what was available, continuing a practice established in the 1930s.

Postwar, just as RAF Fighter Command equipped its frontline squadrons with the latest unswept version of the Meteor, the US Air Force (USAF) introduced the world's first Cold War game changer. The North American F-86 was a swept-wing beauty. Fast, nimble, and well armed, it was, for a short time, the world's best fighter interceptor. Designed for combat above 30,000 feet (9,144 meters), the F-86 cockpit was fully pressurized with a bubble canopy for excellent all-round vision.

> **"The F-86 had a very comfortable cockpit because you could turn the temperature down and get snow coming out of the air conditioning! You could also get heat that was comfortable."**
>
> —*Colonel Walker M. Mahurin, USAF (Ret.)*

Well equipped with an armored-glass windscreen, armor plate behind and in front of the pilot, and an ejection seat, the F-86 also had the A-1CM/APG-30 radar gunsight. During the Korean War this gunsight provided F-86 pilots with automatic ranging and proved decisive over the Soviet MiG-15's primitive ASP sight, which often failed during high-G maneuvers and was not linked to any automatic ranging device.

In terms of performance the swept-wing Soviet MiG-15 was in many ways superior to the F-86. Equal in speed, it had a higher ceiling, was more maneuverable above 30,000 feet (9,144 meters), and offered a superior rate of climb. In terms of cockpit comfort, however, the MiG-15 was severely lacking. "The environmental controls for maintaining standard atmospheric pressure did not function well," recalled Kenneth Rowe, formerly North Korean pilot Lt. No Kum-Sok who famously defected to South Korea in his MiG-15 on September 21, 1953. "The cockpit pressure at 50,000 feet [15,240 meters] was about half of the standard atmospheric pressure at sea level. The cockpit temperature was nearly freezing above 36,000 feet [10,973 meters] and about 100 degrees Fahrenheit [38 degrees Celsius] at low altitude on hot summer days."

As the Korean War came to an end in 1953, the perception of Soviet aviation and its growing capabilities worried Western leaders. As Cold War tensions grew, the Union of Soviet Socialist Republics (USSR) equipped its allies with hundreds of swept-wing fighters and light bombers. The expansion of Soviet military aviation proved a catalyst—the influence was indirect, but the evolution of Western air power was now firmly set.

The 1950s was another golden age for aviation. Spurred by Cold War fears and "mutually assured destruction," military procurement budgets expanded rapidly. Aerodynamics and engine technology were pushed to the limits, sometimes with disastrous results. As aircraft technology progressed the fighting cockpit was still playing catch-up.

The introduction of the Century Series fighters—the North American F-100, McDonnell Douglas F-101 Voodoo, Convair F-102 Dagger, Lockheed F-104 Starfighter, Republic F-105 Thunderchief, and Convair F-106 Delta—along with navy fighters (like the Douglas F4 Skyray, Grumman F11 Tigershark, and Vought F8 Crusader), ushered in the age of the supersonic fighter. The Soviets responded with the MiG-19, MiG-21, and Sukhoi Su-7. Britain contributed with the Hawker Hunter, Gloster Javelin, and English Electric Lightning. France introduced the Dassault Mystère and Mirage III.

All these fighters were capable of speeds in excess of 600 miles (966 kilometers) per hour, and many could in fact achieve Mach 1.5. These high speeds introduced a new and vital piece of equipment into the cockpit: the ejection seat. These seats were large, heavy, and commanded a great deal of space. The first successful use of an ejection seat occurred earlier on August 13, 1942, when the test pilot in a Heinkel He 280V1 prototype lost control and ejected. That seat used compressed air to eject the pilot. It was a crude beginning. Today's ejection seats are listed as "zero-zero seats," meaning they can fire upward from a stationary aircraft or low-altitude flight (zero speed, zero altitude). Previously, ejection required minimum air speeds and altitude. Before this capability ejections were restricted to minimum altitudes and speeds.

Not all Cold War aircraft, however, were fully equipped with ejection seats. To save weight and space, they were only available to the pilot and copilot of the Avro Vulcan; the navigator and electronics and radar operators had to bail out the old-fashioned way. Compared to

The HUD revolutionized cockpit efficiency. Pilots could now view vital flight and systems information projected directly in front of them. This KC-130 Hercules is seen through the HUD of an AV-8A during air-to-air refueling. *National Naval Aviation Museum*

the Vulcan the Convair B-58 Mach 2 Hustler had one of the most advanced escape systems ever devised. Each of the three crewmembers was equipped with a self-contained escape capsule. Ejecting at Mach 2 and 40,000 feet (12,192 meters) was now survivable.

By the late 1950s avionics slowly revolutionized the aircraft cockpit. Pilots, however, were reluctant to accept the way in which cockpit information was now being presented. Avionic displays, especially attack radarscopes, were often shoehorned into the cockpit at the expense of ergonomics. Instruments were pushed to the sides, adding to overall cockpit clutter.

In the F-106 cockpit two items now dominated: the large radarscope and the tactical situation display. There was also the highly advanced Hughes MA-1 navigation fire-control system. "The thing that was really impressive, initially, was the tactical situation display that sat between your legs," said Col. Don Stevlingson, USAF. "When it worked, it would show you your position on a moving map as well as your target's position. In the end it got so damn complex to maintain they started cutting those features out and the tactical situation display became a great cockpit light."

All these new navigation/radar avionics created the need for more cockpit space, especially when it came to all-weather interceptors. Designers were forced to stretch the fuselage and add a second cockpit for a weapon systems officer (WSO, pronounced "wizzo"). These longer cockpits often had a second set of flight controls, but the primary job of the WSO was to detect and target air-to-air threats. Fighters, like the all-weather F-101 Voodoo, F-4 Phantom, CF-100 Canuck, Gloster Javelin, de Havilland Sea Vixen, F-94 Starfire, F-89 Scorpion, and F-14 Tomcat, all had a backseater.

By the 1960s the cockpit arrangements of most fighters and bombers continued in a random fashion. Like their World War II brethren, designers continued to place controls and switches wherever they could. The conventional pointer-on-dial instruments were now lagging behind in terms of information efficiency. The revolutionary heads-up display (HUD), a direct descendent of the World War II gyro gunsight, would prove the game changer designers were looking for.

During World War II engineers experimented with the gyrosight in an attempt to project aiming information directly onto the windscreen surface. The results were promising but it wasn't until the advent of the airborne electronic analog computer that HUD became practicable. In 1955 the US Navy studied the use of HUDs and side-stick controllers in place of the regular control column. Unfortunately the research was never incorporated into aircraft at the time, but the rudimentary HUD mockup had all the features found in today's HUDs.

The first combat aircraft to use the HUD was the Blackburn Buccaneer, which flew for the first time in April 1958. As a fast low-level strike aircraft, the Buccaneer needed precise navigation and weapon-release information that could be easily and quickly processed by the pilot looking out of, and not into, the cockpit. Initially called "strike sights," the first HUDs were set in the pilot's forward line of sight. The HUD was a large piece of equipment. The distinguishing

MUTUALLY ASSURED DESTRUCTION 161

NORTH AMERICAN F-86 SABRE

North American F-86A | National Museum of the US Air Force | Serial No. 49-1067

The North American F-86 Sabre is regarded as one of the finest jet fighters ever built. Used by almost every Western nation, it produced a remarkable four-to-one kill ratio over the vaunted Soviet MiG-15 during the Korean War. Several versions of the F-86 were produced, including the FJ-2/3 Fury (the naval version) and the lesser-known all-weather interceptor, the F-86D Sabre Dog.

On October 1, 1947, the XP-86 prototype flew for the first time. The test-flight results were extremely positive, and in April 1948, the XP-86 broke the sound barrier in a dive, the first American fighter to achieve this.

Powered by a 5,200-pound (2,840-kilogram) General Electric J47 jet engine, armed with six .50-caliber machine guns, and equipped with a radar-ranging gunsight, the F-86A interceptor was the most potent daylight fighter in the world at the end of 1949.

PILOT IMPRESSIONS
Jack Taylor, USAF (Ret.)

The difference between the F-86 and MiG-15 was that the F-86A was a Cadillac and the MiG was an early Ford. The MiG didn't have boosted controls and it didn't have air conditioning in the cockpit.

The controls and instruments in the F-86A were close to hand and easy to reach. The instruments were all suitably placed. The visibility was good, but you couldn't see out the back end because there was armor plate right behind you and radio stuff in the back end of the canopy.

Just as the F-86A entered service North American Aviation began studies on an all-weather version of the single-seat F-86. The F-86D was not a stretched version of the F-86, but a completely new airframe. Only 25 percent of its parts were common with the Sabre. Top speed for the D model was 692 miles (1,114 kilometers) per hour at sea level. It cruised at 550 miles (885 kilometers) per hour and the climb to 40,000 feet (12,192 meters) took just 7.2 minutes. Equipped with the AN/APA-84 computer and the Hughes Aircraft Corporation EA Fire Control System, the F-86D was armed with twenty-four unguided 2.7-inch "Mighty Mouse" folding-fin aerial rockets.

Production of the F-86 reached 8,681–2,504 being F-86Ds. No fewer than twenty-six countries used the legendary Sabre.

Powered by the Orenda 14 engine, the Canadair Sabre Mk 6 was considered to be the best Sabre ever built and would serve in the RCAF and RAF.

An F-86D of the 4th Fighter All Weather Squadron off of Okinawa. The F-86D was designed as a true "interceptor," not a fighter. (The Spitfire was also designed as an interceptor but proved a good air superiority fighter too.) The F-86's only job was to find enemy bombers and shoot them down. *Warren Thompson*

Jet fighters captured the public's imagination after World War II, and the F-86 co-starred with John Wayne and Janet Leigh in the Howard Hughes-produced film, *Jet Pilot*. Although filming wrapped in 1953, the film didn't see release until 1957 due to Hughes's continued tinkering with it. *Zenith Press collection*

MUTUALLY ASSURED DESTRUCTION

BOEING B-52 STRATOFORTRESS

Boeing B-52D | National Museum of the US Air Force | Seriel No. 56-0657

Incredibly, the B-52 has been in continuous operation since 1955; first with the SAC and now with Air Combat Command and Air Force Reserve. Conceived in the waning days of World War II, the B-52 came to symbolize America's Cold War nuclear defense posture through the 1960s, 1970s, and 1980s. During its service life, the B-52 has been modified, upgraded numerous times, and has been used in several new roles for which it was never designed.

The first flight of the B-52 occurred on April 15, 1952, and it was followed by the first production model, the B-52A. Only three B-52As were built, and all were used for test and development. Next in line were fifty B models, which were delivered to the SAC's 93rd Bomb Wing at Castle Air Force Base. More models would follow with the D in 1955, the E and F in 1957, the G in 1958, and the H being the final version to leave the production line.

During the Vietnam War the B-52 was used extensively in both tactical and strategic roles. B-52Fs carrying twenty-seven 750-pound (1,650-kilogram) bombs internally, and twenty-four more on external racks, were tasked with bombing missions under the code name "Arc Light." During the conflict 126,615 B-52 sorties were flown with 2,633,035 tons of bombs dropped. In total, twenty-six B-52s, including four to collision, were lost by the end of the war.

When the first Gulf War began in 1991, the B-52 took center stage once again. Flying from bases in the Indian Ocean, the United Kingdom, Spain, and Saudi Arabia, they were used in saturation bombing runs against soft targets, particularly Republican Guard units in the desert. In all, 102 B-52Gs flew 1,625 sorties; they dispatched 25,700 tons of bombs or 31 percent of all US bombs dropped during the Gulf War.

In March 1999 B-52s were used during Operation Allied Force. Sorties were flown against the Federal Republic of Yugoslavia during the Kosovo War.

During Operation Enduring Freedom in 2001 and Operation Iraqi Freedom in 2003, B-52s again made a major contribution. Capable of loitering high above the battlefield and using precision-guided munitions, they provided close air support (CAS) for the first time. Of the 744 B-52s built, some eighty remain in service.

PILOT IMPRESSIONS
Colonel William "Bill" J. Moran Jr., USAF (Ret.)

I graduated from the University of Rhode Island in 1973 and immediately entered the USAF. I was a distinguished graduate of Officers Training School and completed USAF pilot training in 1974.

During my twenty-six-year career I flew the B-52G, T-37, FB-111A, F-111A/D/E, and B-1A/B as an aircraft commander, instructor pilot, and evaluation pilot. I flew over three hundred developmental test hours in the B-1 program at Edwards Air Force Base, California, and subsequently gained membership in the Society of Experimental Test Pilots.

Getting into the B-52 cockpit for the first time was a big, "Wow, is this me?" kind of thing. The first thing that hits you is the big maze of gauges. With eight engines, the cockpit is equipped with eight rpm gauges and eight exhaust pressure ratio gauges and many more.

During training flights my instructor pilot, Cliff Hamby, use to browbeat me constantly. Because of his heavy hand I did very well in the B-52.

The B-52G was an upgrade from the D model. Instead of alternators you had generators. Sitting in front of you were twelve fuel gauges with an equal number of flow valves. There were no computers to run the fuel system and keeping the center of

The B-52's massive internal fuel capacity is shared in the 185-foot (56-meter) wingspan and upper fuselage, giving the Stratofortress a fuel capacity of 47,975 gallons (181,605 liters). *National Museum of the USAF*

A Strategic Air Command B-52A on the line. At the height of the Cold War, B-52 crews had just fifteen minutes after the first warning to get airborne and deliver their nuclear payload. The reality was most of the bombers that did get airborne would never make it to their targets. *Author collection*

gravity in the B-52 was critical. It was the copilot's job to monitor the system, opening and closing tanks, shutting off valves, and starting the flow of fuel to the engines. That took a lot of time and was one of most challenging jobs. We always tried to land with the fuel so well balanced our tip gear hardly touched.

The instruments were easy to read. The biggest problem I had was getting my hand around the eight throttles. I don't have the biggest hand in the world so I would lay my palm sideways to get all eight throttles moving together. Once you had the throttles up to where you wanted them, you would adjust using the four and five engines. During air-to-air refueling the four and five engine were all you needed.

The view from the cockpit is fine. There's a window on your overhead hatch, which helped a little bit. You can't see behind you, obviously. The only time the view from the cockpit could be difficult was during a crosswind landing. The B-52 had a unique crosswind landing system, which kept the landing gear aligned with the runway while the aircraft was in a crab (sideways position). Sometimes a window frame would be right smack in front of you causing you to constantly move your head back and forth during landing.

Like all bomber aircraft you sat on an ejection seat or capsule. It could get really hard and tiresome after six, eight, ten hours. Fortunately for us we could stow the control column, get up, and go for a coffee.

One of the most exciting things flying the B-52 was the water-injected takeoff. Once you had the throttles set, the pilot would throw one switch and ten thousand pounds (4,535 kilograms) of water would be injected into the engines. You could feel the kick and for about two minutes the engines would belch clouds of black smoke. That was exhilarating especially when you're doing MITOs—minimal interval takeoffs.

Test pilot Shawn Roberts, a graduate of the British Test Pilot School, said the B-52 was the worst flying qualities aircraft in the world. I used to hear fighter pilots complain about how refueling was sometimes difficult. Nothing was more demanding than refueling a B-52 at night, in the clouds for thirty minutes.

For an aircraft of that vintage, I thought the cockpit layout was great. I fly a Cessna 182T Garmin G-1000 for the Civil Air Patrol and that cockpit is so much more advanced from a pilot's perspective than the B-52, it's kind of ridiculous.

GRUMMAN A-6 INTRUDER

Grumman EA-6B | Marine Corps Air Station, Yuma, Arizona

During the Korean War the USN was a force in transition. Jets had made their appearance, but their abilities were limited to strictly daylight operations. Even with the older Corsairs and Skyraiders, the navy didn't have an all-weather, carrier-launched, day-and-night strike aircraft. In 1957 the Bureau of Aeronautics issued a request for proposals for a two-seat, subsonic, all-weather attack bomber. McDonnell Douglas, Vought, Boeing, Martin, Lockheed, Bell, North American, and Grumman submitted a total of eleven designs.

From the outset the navy wanted a side-by-side seating configuration, believing it would enhance the cockpit workload. However, the Intruder's large AN/APQ-92 search radar would ultimately dictate the crew configuration. The large radar meant a pointy nose and a crew sitting in tandem was out of the question.

In 1958 Grumman won the design competition and two years later the "flying drumstick" was rolled out to a not-so-appreciative crowd. Many called it the "flying tadpole" instead, thinking the pointy end had been reversed! Considered an ugly aircraft by its critics, the A-6 soon became a thing of beauty when flown in combat.

The navy and the Marine Corps would use the A-6 during the Vietnam War. The Intruders earned an enviable reputation as a dependable strike aircraft capable of dropping bombs at night, in all weather, and on both stationary and moving targets. The key to its success was the accuracy of the digital integrated attack navigation equipment system (DIANE). Taking into account speed, rate of climb or dive speed, wind, and G-forces, the DIANE system could drop a payload accurately no matter the weather, day or night.

During combat the side-by-side crew configuration greatly improved their chances of survival. Good communication was important when dodging surface-to-air missiles (SAMs) and spotting incoming MiGs. The bombardier/navigator's second pair of eyes and the Intruder's turning abilities saved many crews, but the Vietnamese air defense system took their toll. During the conflict sixty-nine Intruders were lost in combat; thirty-six to antiaircraft fire, ten to SAMs, and just two to MiGs.

In 1991 Intruders were once again called into action. During Desert Storm they flew 4,700 sorties, dropping bombs and precision-guided munitions on both tactical and strategic targets throughout Iraq.

The A-6 Intruder was a great success and loved by those who flew it. On February 28, 1997, after thirty-four years of service, the A-6 was finally retired.

PILOT IMPRESSIONS
Captain Alan D. Armstrong, USN (VA-75 Sunday Punchers)

I flew A-6s for five years out of NAS Oceania. I was in the last A-6 Squadron, the VA- 75 "Sunday Punchers."

I wanted to fly A-6s right from the start. It was an awesome airplane. I started as a bombardier navigator (B/N). I started flying the Intruder in late 1992, as a student in VA-42. I thought it was the coolest mission out there. It was post *Top Gun* and a lot of people were all fired up about the F-14. But if you look at the historical record and the actual tangible contribution towards projecting US power, the A-6 has been the workhorse. They got it done.

The side-by-side cockpit design of the A-6 was really driven by the large Norden AN/APQ 148 multiscan radar. That's what drove the width of the cockpit. It's a radar bomber, all-terrain, all-weather radar-attack airplane. The cockpit is very roomy and the side-by-side seating was great. There was also a tremendous sense of crew coordination. When you start flying with the same guys, you develop a lot of nonverbal communication, which made for a very efficient cockpit. It was a relatively typical cockpit for the late 1960s. Compared to today's modern fighters, it was a busy cockpit. It had lots of switches, knobs, and circuit breakers along with a mix of some more modern displays. On the pilot's side you had the flight controls and instruments including the attitude directional indicator (ADI). Measuring 8 by 5 inches (20 by 13 centimeters) it was the primary flight display instrument in the cockpit. For its age the A-6 had some pretty high-tech displays

and some things I think are better than what we have in some modern combat aircraft.

The controls were easy to handle, but the way we train carrier pilots today they would struggle with the A-6 cockpit. The A-6 was an analogue scan-type airplane and in terms of ergonomics, it's not like the F-18. Things were laid out pretty logically and in terms of getting weapons off the airplane you're pretty much hands on.

Now on the right side of the cockpit you had a higher workload mission. We'd fly all weather day and night, in and out of cloud, and in those circumstances the pilot's workload was not nearly as intense as in the right seat. Because the pilot's doing the flying the B/N is actually driving the whole show. With his head under the "hood" (a conical-like cover) he's looking at the radar, the forward-looking infrared (FLIR), the INS (inertial navigation system), and keeping the system tight. To keep his head under the hood, many of the switches and knobs he needed to operate had very unique shapes giving them a distinguishable tactile feel.

The A-6 cockpit was extremely well designed for the technology at the time. It could do things that we still can't in the F-18. The older systems made for a high workload particularly for the B/N. If the B/N's not on the ball, the airplane was almost useless.

Compared to the new electric jets—F-16, F-18 and F-35—the A-6 is harder and some ways much more enjoyable to fly. The actual stick-and-rudder flying in the new fighters is ridiculously easy. The F-18 will trim itself and if you let go of the controls it stays where you left it. In the A-6 you had to fly the airplane. Let go of the controls without trim and it's going to go where it's going to go. The connection to the airplane was much stronger in the A-6.

The A-6 was an extremely complex, high workload kind of airplane. It was, however, very effective.

An A-6 Intruder releases a string of Mk-82 Snakeye bombs. The Mk-82 was equipped with a tail retarding device that allowed for low-level release.

Never described as sleek and fast, the A-6 Intruder was an extremely effective all-weather bomber. Here two A6s from VA-65 fly in formation.

174 COLD WAR TO THE PRESENT

MUTUALLY ASSURED DESTRUCTION

GENERAL DYNAMICS F-111 AARDVARK

General Dynamics F-111F | National Museum of the US Air Force | Serial No. 70-2390; combat veteran

As the world's first production variable-geometry combat aircraft, the pioneering F-111 became the most effective and flexible strike bomber ever to see service in the USAF and Royal Australian Air Force (RAAF).

In many ways the F-111 was a combat aircraft born out of "commonality." It was a philosophy developed in the early 1960s in which versatile aircraft designs could be shared by the USAF, USN, and USMC. The driving force was cost reduction. Championed by Defense Secretary Robert S. McNamara, it would in the end prove costly and misguided.

The F-111 was designed from the outset to use one airframe to fill two very different roles. The navy wanted a fleet defense fighter, with long loiter time, good low-speed handling, and a crew of two. The air force wanted an all-weather low-level strike aircraft. While the variable geometry wing helped reconcile some of those requirements, too many problems remained.

The first F-111A rolled out on October 16, 1964, and it was followed by the navy's F-111B in May 1965. The F-111A was capable of 1,453 miles (2,338 kilometers) per hour at 53,450 feet (16,292 kilometers). At sea level it clocked in at 914 miles (1,4971 kilometers) per hour. Tests quickly revealed the new F-111B was unsuited for carrier operations and it was cancelled on July 9, 1968. Free to pursue their own version, the USAF developed the F-111A and ordered 158.

By 1967 the F-111 program was plagued by cost overruns and several accidents. Doubts about its innovative features and performance prompted much criticism, and proof of the aircraft's capability was required. In March 1968 six F-111As began operations over North Vietnam. Most of the missions were at night in poor weather using terrain-following radar. No aircraft were lost to enemy fire, but three crashes did cast a shadow. By the end of the war, the F-111 emerged as the USAF's foremost tactical strike aircraft. During the Gulf War in 1991, F-111Fs would fly 2,417 sorties and drop 4,596 bombs. Bombing targets for the F-111 crews varied from bridges, hardened aircraft shelters, and individual tanks. On one night twenty F-111Fs destroyed seventy-seven tanks with eighty laser-guided bombs. The F-111s would also drop the majority of the laser-guided munitions during the war—80 percent. It was a remarkable achievement, but the results were often overshadowed by the sexier exploits of the newer F-117A Nighthawks and F-15E Strike Eagles.

The F-111 was withdrawn from USAF service in 1998. It served another fifteen years with the RAAF as the country's principal long-range strike and antishipping aircraft.

PILOT IMPRESSIONS
Colonel William "Bill" J. Moran Jr., USAF (Ret.)

Going from a crew of six in the B-52 to just two in the F-111 was great. While on alert you could never get the six B-52 guys going in the same direction. Now it was just me and my navigator. That was my dream assignment.

The cockpit was superb. The FB-111 was equipped with vertical tape indicators marking airspeed, vertical speed, and altitude. A lot of people said I'd have trouble getting accustomed to the vertical tapes, but it didn't take long. We had a good simulator.

The cockpit instruments were easy to read and the controls close to hand including the wing sweep handle. During the design phase there was a great deal of discussion as to which way the wing sweep handle should move—forward to go faster like the throttles or backwards to move the wings back for high-speed flight. I think they got it right—aft to sweep the wings back.

The view from the FB-111 was pretty good, but there's a wall behind you making your six o'clock rather difficult. We sat

The F-111B was powered by two 12,900-pound dry/20,250-pound wet (5,851-/9,185-kilogram) TF30-P-12 turbofans. This F-11B carries a typical load of twenty-four 500-pound (227-kilogram) bombs. *National Museum of the USAF*

side-by-side so communication with your navigator was easier. The cockpit noise and comfort level wasn't bad. The FB-111 didn't have ejection seats, instead we had an escape capsule. I flew a twelve-hour operational readiness inspection mission one time and not being able to get out of that seat was a real workout.

The FB-111 was a fantastic aircraft and air-to-air refueling was a piece of cake. It was very easy to fly. The pitch roll harmony was exceptional. It had automatic parallel trim. All you had to do is hold the stick in one position for one second and the pitch would trim automatically.

One of the things you always had to be aware of in the FB-111 was wing position. Moving your wings meant the center of gravity and center of lift shifted as well. If you didn't watch out you could reverse the two. Going 250 knots and pulling the wings back to 72 degrees wouldn't work. You'd have to push the nose down or open the throttles to max afterburner to keep everything stable.

The FB-111 was equipped for terrain following and not terrain avoidance. The B-52 was terrain avoidance. It was a great system. We didn't lose anyone at low-level when terrain following, but you had to pay close attention. I almost crashed three times, but my vigilance kept us from hitting the ground. During a flight in the Rocky Mountains we were terrain following in weather when all of a sudden the low-altitude radar altimeter override came on. The radar altimeter signal was looking straight down and not off the terrain radars pointed forward. It wasn't supposed to happen, but I caught it. Pulling up we broke out of the clouds and saw this snow-covered mountain right in front of us. That mountain had so much snow it was absorbing all the terrain radar energy with no bounce back.

I wouldn't have changed anything in the cockpit except maybe for the terrain following e-scope. A better visual presentation would have been nice, but for the technology of the time is was a great cockpit.

An F-111E equipped with underwing SUU-21 practice-bomb dispensers prepares for another mission. This photo shows the distinctive "anteater" nose and canopy "ears" that inspired the F-111's "aardvark" nickname. *National Museum of the USAF*

HAWKER SIDDELEY HARRIER

Hawker Siddeley AV-8A | Canada Aviation and Space Museum | US Navy Registration No. 158966

Only in combat is a fighter's worth fully proven. After thirteen years of operational service, the world's first vertical/short takeoff and landing (V/STOL) jet fighter met the enemy and emerged victorious. During the Falklands War (1982), British Harrier GR.3s and Sea Harrier FRS1s battled the Argentine Air Force, shooting down twenty-six Argentine aircraft, the majority being Mirage III/Daggers.

Production of the single seat Harrier GR.1 (ground attack and reconnaissance) began in 1967. Powered by a Pegasus 101 engine developing 19,000 pounds of thrust (84,516 newtons), the GR. Mk 1 had a top speed of 746 miles (1,201 kilometers) per hour, but with a range of just 403 miles (649 kilometers). By 1972 four RAF Squadrons were fully equipped and ready for deployment.

The sole purpose of the Harrier centered on its ability to operate from the most basic of locations. With its V/STOL and STOL capability, small groups of Harriers could remain in operation long after their main base had been destroyed. The small, nimble Harrier could also provide valuable ground support just minutes from the battlefield.

Impressed by the Harrier's performance and capabilities, the US Marine Corps was the first foreign customer to order this unique fighter. The export model, broadly similar to the Harrier GR.1, was designated AV-8A. American radios were added along with the removal of all magnesium components, which corroded in the salt air, and the outer pylons were designed to carry the AIM-9 Sidewinder heat-seeking missile. The Marines ordered 122 AV-8As.

Since 1967 the Harrier has been extensively developed producing both the Sea Harrier and the GR.9/AV-8B Harrier II. As a light-attack aircraft, the Harrier has shown its unique versatility flying both from small aircraft carriers and land-based forward operating bases. It would be used extensively during the first Gulf War, and operations Enduring Freedom, Iraqi Freedom, Odyssey Dawn (2011), and most recently Inherent Resolve.

Other North Atlantic Treaty Organization (NATO) countries, including Spain and Italy, used different versions of the Harrier/Sea Harrier with India's navy purchasing thirty Sea Harrier FRS1s in 1988. In 2010 the RAF and Royal Navy finally retired their Harrier fleets. Between 1967 and 2003, 824 Harriers variants were delivered.

PILOT IMPRESSIONS
Ted Herman, USMC (Ret.)

I joined the Marine Corps in 1967, followed by flight school in 1968. I flew the early models of the T2A Buckeye and T-34B. I finished up flying F-9s and F-8s. I got my wings in August 1968 and went directly into the VMCJ Wing Composite Reconnaissance Squadron 2 at Cherry Point. There I flew the Douglas A-26 two-seat intruder. In 1971 I flew the A-6A Intruder for three months in Vietnam. I returned to the States and began flying the A-4 Skyhawk. In late 1972 I was selected for the Harrier program. I did a one-year tour in Spain as an AV8-A instructor. Retuned to the States for a tour on the USS *Tarawa* and then returned to Spain working with the Joint US Military Group. During Desert Storm I commanded a squadron of AV8-Bs and ended my career with 3,900 hours flying A-4s, A-6s, and AV8s.

The AV8-A was a day-attack, 1960s-configured airplane. It was very conventional with steamship gauges and circuit breakers that popped in and out. The British called it a fighter, but for us it was an attack airplane.

Coming from very busy cockpits, like the A-4 and A-6, the Harrier cockpit was wide and comfortable. In many ways it was a makeshift, sparsely constructed cockpit. The instrument placement had that shotgun approach. There were lots of knobs and levers associated with the throttle and nozzle lever. Although the

This close-up view shows the inflight-refueling hookup of a US Marine Corps AV-8A. The AV-8A was a "short-legged" aircraft with a radius of action of just 200 miles (322 kilometers) and a 4,000-pound (1,814-kilogram) bomb load. *National Naval Aviation Museum*

An AV-8A of Marine Attack Squadron (VMA) 231 drops a single Rockeye cluster bomb during a training mission. *National Naval Aviation Museum*

throttle, nozzle lever, and stick were optimized for pilot usage. The engine instruments are on the right side, altimeter and attitude instruments on the left. Right in the middle was the big fish bowl Ferrati navigation system, but we soon took it out. The stick grip was very different from what we'd seen before. It was a primitive, angular-looking kind of thing. The cockpit was very light in terms of construction. You sat in the bullet end of the engine. The bulkheads and canopy seemed extremely light. The skin between you and the engine had no padding or insulation.

The Harrier had a shoulder-mounted wing, which meant you sat low in the cockpit. Rear visibility was restricted. To get around that we'd do a 5 degree wing dip to see straight back. Most pilots suffered form what we called the "Harrier hunch." For hovering you had to jack your seat up for good downward visibility, but while flying you had to crouch slightly to see straight ahead through the HUD (Head Up Display). A sore neck was the result of any long distance flight. The Harrier was also a busy airplane. There was no room for complacency in cockpit. Things would come up and bite you if didn't pay attention.

The Harrier was powered by a fast-revving fan jet engine. When you pushed the throttle forward, it felt like you were actually sitting in it. We advised all new pilots during their first two or three flights to just focus on just two or three instruments and nothing else. The acceleration, noise, and vibration were so intense it could cause an ocular gravis vertigo effect. It felt like you were going over backwards. After three or four hops you learned to live with it. To counter the noise we wore earplugs and form-fitting helmets much to the chagrin of other non-Harrier pilots. They thought we were getting special treatment.

When we transitioned into the AV8-B model we did keep one feature from the AV8-A—the canopy parasol. When standing on alert on a hot summer day, the cockpit would get very hot. Mounted on the left bulkhead was a receptacle for an umbrella. It wasn't lacy, but a manly olive drab material.

MUTUALLY ASSURED DESTRUCTION 183

McDONNELL DOUGLAS/ BOEING F-15 EAGLE

McDonnell Douglas F-15A | National Museum of the US Air Force | Serial No. 76-0027

Today the F-15 Eagle remains one of the world's premiere fighters. Over the past forty-three years the Eagle has proven itself in combat with 101 aerial victories for zero losses! During Red Flag 15-2 in March 2015, the Eagle enjoyed a 111 to 8 kill ratio against the world's top fighters. Some may argue it is one generation behind, but at this major, multinational, combat-training excercise, the Eagle is still considered the best in the world.

The key to the F-15's success comes from its exceptional design, maneuverability, acceleration, range, weapons, and updated avionics. The Eagle is a big airplane. The pilot sits high in the front with a large 360-degree bubble canopy. A typical air superiority load consists of four AIM-9X Sidewinder heat-seeking missles and four AIM-7 Sparrow radar-guided missiles, all backed up by the M61A1 Vulcan six-barrel 20-millimeter cannon. Internally the F-15 has: a tactical electronic warfare system; an identification friend or foe system; an electronic countermeasures set; and a central digital computer.

The F-15C and D models (first introduced in 1979) continue to be improved with upgrades. An engine upgrade with the Pratt & Whitney F100-PW-100 replaced with the F100-PW-220E version gave the F-15 quicker acceleration and better fuel efficiency. The new Raytheon AN/APG-63(V)3 radar is slowly being added to the fleet, providing the F-15C with more precise and accurate radar capable of tracking more than one target simultaneously. The Eagle will also carry the new Talon HATE communications pod, enabling it to communicate with air, ground, and naval assets everywhere in the battle space. Ironically, even with this new upgrade, the F-15 can only communicate with the F-22 by voice radio.

Many pilots describe the F-15C to be easy to fly but difficult to use as a weapons system. The current cockpit is a mix of new and old, with a small radar screen, multifunction display, and a set of analogue steam gauge dials. But with the new upgrades, the F-15 has superior missiles and radar that can detect the enemy first and shoot multiple missiles at once. Many observers believe the upgraded F-15C/D and F-15E Strike Eagles will be just as capable as the new J-35A Lightning II Joint Strike Fighter at a fraction of the cost. With new top-of-the-line data links, engines, weapons, and radar, the F-15C/D will remain a world beater as "the perfect fighter."

During the past decade about half of the original F-15C/D Eagles have been retired. Currently the fleet remains at 249 aircraft (out of 408 F-15Cs and 62 Ds built).

> **"I knew we had a winner that day and we still do."**
> *—Irving Burrows, test pilot for the maiden flight of the McDonnell Douglas F-15A, July 1972*

F-15 pilot Cory Bower waves to the camera during an air-to-air refueling hookup. This view clearly shows the F-15's generous clear canopy and nearly 360-degree all-round vision. *Cory Bower*

An F-15D of the 65th Aggressor Squadron. Since 2005 the F-15C and D have been used to simulate Sukhoi Su-27 Flanker fighters during Red Flag exercises and simulated air-to-air combat maneuvers. *US Air Force*

PILOT IMPRESSIONS

Lieutenant Colonel Cory Bower, USAF (Ret.)

After pilot training I flew F-15s at Kedina Air Base in Japan. I was an instructor at Randolph Air Force Base in Texas as part of the Introduction to Fighter Fundamentals course. I again flew F-15s at Langley Air Force Base and ended my career flying with the Florida Air National Guard with over 2,000 hours in the F-15A/B/C/D aircraft models.

The F-15 cockpit is large compared to my previous experience flying the T-38 trainer. Built for the air superiority role with a big radar, the cockpit was naturally spacious. You've got lots of room to the left and right of your hips. To your right and near the back portion of the cockpit is a big metallic container. It's great for storing all your publications and for long flights you can store all kinds of stuff. The cockpit instruments are very easy to read, but they're a much older design.

All-round vision from the cockpit is excellent. Most pilots sit up high in the cockpit with just a small space between their helmet and canopy. It's easy to look down. Bank your wing a little and you can see almost directly below. The canopy was designed to aid in the quick acquisition of a visual target. To check your tail you simply turn in your seat and look straight back through the tails. The three dimensional view is exceptional.

To help acquire a target visually we would use the forward windscreen canopy bow as a visual aide. It's called using the "canopy codes." When the radar gave you a target that was 20 degrees to the left, you knew exactly where to look in relation to the canopy bow.

Cockpit noise is very low. You can actually hear the different airflow over your wings and tail. When you're dogfighting and max performing the aircraft, the F-15 generates different sounds based on the disturbed airflow across the wing. It can be a subtle sound or a roar. When you're pushing the aircraft at a high angle of attack you can hear the wind rush across the wing and the disturbed airflow depart from the trailing edge. Those auditory cues and the feel in the stick let you know you're max performing the aircraft. It's really cool.

During an intercept the workload flying the F-15 is not very high. The F-15 is extremely easy to fly, which allows you to devote your attention to employing the aircraft. Radar information is projected onto your HUD and into your helmet mounted cueing system. Once you have radar lock, the fire-control system calculates the target's distance, altitude, and speed in real time.

The F-15 is powerful. The engines are very responsive. During basic fighter maneuvers you can slow down quickly; acceleration is good, but not like the F-22.

The dual hydro-mechanical fly-by-wire systems are extremely reactive. Move the stick and the airplane goes exactly where you point it.

Designed over fifty years ago the cockpit layout is ergonomic and well thought out. Improved avionics along with a new display for the radar warning scope would have been nice. In the end the F-15 was designed for fighter pilots and it shows.

GRUMMAN F-14 TOMCAT

Grumman F-14 (1X) | NASA | NASA No. 991 | Navy Serial No. 157991

The introduction of the Grumman F-14 Tomcat fighter in October 1972 represented a quantum leap forward in fighter performance and a major blow to the Soviets. Designed as fleet air defense fighter (FADF), the F-14 was built to achieve two things. The first was to defeat Soviet long-range maritime bombers and both air- and submarine-launched antiship missiles. The second was air superiority, which required close combat maneuvering. For both tasks the F-14 was superbly equipped and was the most formidable warplane in existence at the time of its introduction.

Powered by two Pratt & Whitney TF30-P-412A turbofan engines delivering 12,500 pounds thrust (55,603 newtons) each, the F-14 proved unbeatable as it combined speed with maneuverability. Its variable sweep-wing design optimized lift and drag at all combat speeds. The extensive use of titanium greatly reduced weight and gave the F-14 a better thrust-to-weight ratio than the F-4 Phantom.

The F-14A's lethality centered around the Hughes AWG-9 radar system and the AIM-54 Phoenix air-to-air missile. This combination gave the F-14 the capability to track up to twenty-four targets and launch six AIM-54s nearly simultaneously. For medium and short-range launches, the F-14 was also equipped with AIM-7 Sparrow, AIM-9 Sidewinder missiles, and one internally mounted 20-millimeter cannon. F-14s have fired the Phoenix missile twice over Iraq in 1999, but without striking any targets.

After Operation Desert Storm in 1990, all F-14A and Bs were upgraded to the F-14D. With new digital avionics the F-14 was transformed into a multirole fighter with both reconnaissance and ground-attack capabilities.

In September 2006 the F-14 was finally retired from service. In all 712 Tomcats were built with more than 160 lost due to accidents.

Carrier operations run 24 hours a day. Here an F-14D makes a sunset arrested landing aboard the USS *Theodore Roosevelt* (CVN-71) in the Persian Gulf, January 2006. *US Navy photo/Photographer's Mate Airman Apprentice Nathan Laird*

PILOT IMPRESSIONS
Lieutenant Commander M. P. "Hal" Maloney

I went into the navy in 1986 and started flying the T-34 Mentor. I then moved onto the T-2 and TA4-J Skyhawk. In early 1988 I ended up going to Miramar and started flying the F-14A.

Compared to the TA4-J the F-14 cockpit was huge. In the TA4-J I could sit with my elbows squeezed against my torso with my biceps hitting the canopy rail. I'm 6 feet and was about 190 pounds (183 centimeters and 86 kilograms) and so for me the F-14 cockpit was nice, comfortable, and spacious.

Everything in the cockpit was where you needed it. A number of controls and levers, like the wing-sweep lever, had a distinctive shape. For the swing-wing lever it was an airfoil, for the tail hook leer it was shaped like a tail hook. That way if you're in the dark you could feel around and find what you were looking for. The fuel gauge was right above the throttle quadrant. Very appropriate. Everything about flying from a carrier is about gas. It's always about fuel management and getting back to the ship with plenty of fuel to at least have one pass and another if you bolter.

The view from the cockpit was good for the time period. The F-14 didn't have the front bubble like the current F-22. The front windscreen had a big, thick, metal frame around it. Because of that framing your inside/outside scan made landing on a carrier a little difficult, but you got used to it. If it wasn't there the view would have been phenomenal.

Visibility to the rear was restricted by the gigantic ejection seat. Sometimes it was a little difficult to get around, turn your head, and look backwards because you had so much metal back there. But the canopy certainly gave you a lot of rearward visibility.

Everything in my mind was about situational awareness (SA). How good is your SA for any given situation you could face? I always felt the cockpit layout gave us every opportunity available to have good SA. I always felt the F-14 was built in a manner that maximized your situational awareness in just about every phase of flight. The F-14 was a big machine. You've got 70 to 80 feet (21 to 24 meters) of airplane behind you and you're sitting so far out in front its like being in a little pod. Your ability to have good SA and visibility is phenomenal.

I thought the early HUD in the F-14 was fantastic; I loved the HUD in that airplane. They're much more complex now, but the HUD in the F-14, I thought was great.

One of the really scary things about the F-14 cockpit is the pilot actually sits in front of the nose wheel. When you're taxing on the carrier deck that can be an issue especially when you're on the bow. Deck crew would taxi you right to the limit and the next thing you know you're hanging over the edge! You have to remember the front wheel is behind you and because I have no SA as to where the edge of the deck is in relation to my front wheel just added to the pucker factor. If you got too close the airplane could slip and roll over the side. Those guys liked to taxi you right up to the edge with your front wheel just kissing the flange on the side of the deck.

As for changes to the cockpit, I would certainly have added a wrap-around front piece of glass and got rid of the metal framing. I would've also put in a better air-conditioning system as well. The system in the F-14 was a set of tubes that ran underneath the canopy rail. Getting cold out wasn't an issue, it was just so darn noisy and sometimes it really hampered my ability to hear what was going on. Other than that I thought the cockpit was nicely laid out.

The F-14 was a fun airplane to fly. It was a finesse airplane, though. You couldn't ham fist it. It was a seat-of-the-pants airplane. You had to feel what the airplane was doing. It wasn't always about planting the stick in your lap. It was about maintaining your energy on that platform. The F-14 was truly the last of the non-fly-by-wire airplanes.

An F-14A is loaded with AIM-54 Phoenix missiles for testing. The F-14 could carry up to six AIM-54s, but the more common load was four AIM-54s, two Sparrow, and two Sidewinder missiles. *National Naval Aviation Museum*

190 COLD WAR TO THE PRESENT

ABOVE: In full burner an F-14B of Fighter Squadron Three Two (VF-32) launches off the waist catapult aboard the carrier USS *Harry S. Truman* (CVN-75). *US Navy photo/Photographer's Mate Airman Apprentice Nathan Laird*

BELOW: The backseat of an F-14B. Both the Tactical Information Display (center) and the Multiple Display Indicator to the right are lit up in green. The weapon systems officer (WSO) would be responsible for tracking targets and manning the weapons system. In a close-in dogfight, the WSO provided a valuable second set of eyes. *Ted Carlson/Photodynamics*

FAIRCHILD REPUBLIC A-10 THUNDERBOLT II

Fairchild Republic A-10A | National Museum of the US Air Force | Serial No. 78-0681; combat veteran, Desert Storm

The A-10 was designed for one thing only—to destroy Russian tanks. In 1979 Russian and Warsaw Pact tanks outnumbered those of NATO by 2.8 to 1. This dominance on the ground put NATO forces at a distinct disadvantage. In response the USAF issued a requirement for an all-weather ground-attack aircraft designed specifically to carry the 30-millimeter rotary cannon. This would be the first air force fighter designed exclusively for close-air support. Six companies created designs with Northrop and Fairchild Republic building prototypes, the YA-9 and YA-10. After intensive trials and a fly-off, the YA-10 was selected for production.

Centered around the GAU-8/A seven-barrel 30-millimeter Gatling-type cannon, the A-10 can destroy a tank at ranges of 6,000 feet (1,829 meters) and lightly armored vehicles at 10,000 to 12,000 feet (3,048 to 3,658 meters). With a load of 1,350 rounds, the A-10 is capable of firing ten two-second bursts per sortie. Flying in the extreme low-level regime, the A-10 would be exposed to deadly light and medium antiaircraft fire. Designed to absorb a great deal of battle damage and still make it home, the aircraft has 2,900 pounds (1,315 kilograms) of special protection. The pilot alone sits in a 1,200-pound titanium armor tub, which varies in thickness from 0.5 to 1.5 inches (1.27 to 3.81 centimeters).

The A-10's first combat was not against a horde of Russian tanks but in the Middle East during the first Gulf War. The results were impressive with more than 900 Iraqi tanks, 1,200 artillery pieces, and 2,000 other vehicles destroyed.

The modern-day A-10 "Warthog" remains in service waiting to be replaced by the troubled F-35 Joint Strike Fighter. The pilots who fly the A-10 consider it easy, responsive, and safe to fly. In a long line of Republic aircraft to fly with the USAAF and USAF, the A-10 is the last of Republic's jet aircraft to serve.

PILOT IMPRESSIONS
Lieutenant General Jack Hudson, USAF (Ret.)

I started undergraduate pilot training in 1974 and finished in June 1975. My first assignment was as a T-38 instructor at Sheppard Air Force Base. After two years with the 80th Flying Training Wing, I was asked to fill out my dream sheet. Everyone who did a training command assignment was given the chance to state preferences for their next aircraft. My first choice was the A-10A.

As an operational A-10A pilot I went to RAF Bentwaters, UK, with the 510th Tactical Fighter Squadron. While there, I applied and was selected for the Air Force Test Pilot School Class 82-A, starting in January 1982, at Edwards Air Force Base. In January 1983 I was assigned to the A-10 Combined Test Force at Edwards, where I flew the YA-10B and the A-10A on test missions. Leaving Edwards in 1986, I went to the Air Command and Staff College. I then was assigned to the Pentagon, then a year at the US Naval War College, and then other acquisition program offices and more time at the Pentagon. As a major general, I managed the Joint Strike Fighter Program for just over two years. Over the years I've flown more than forty different types of aircraft with just over 1,000 hours in the A-10A and another 150 hours in the YA-10B.

The two things that really stood out for me about the A-10A cockpit were how roomy it was and how high off the ground it

The quintessential "ground pounder," the A-10 is the world's most effective ground-attack aircraft. These three A-10s show the weapons-carrying capability with 500-pound (227-kilogram) Maverick and cluster-bomb munitions. *National Museum of the USAF*

stood. It was a comfortable cockpit, but compared to the T-38 and others you really had to be careful when scaling the outside boarding ladder, especially in the rain.

The controls were logically arranged; the instruments were easy to read. In the early aircraft we didn't have an inertial navigation system. For the most part, we had to navigate the old-fashioned way using maps and terrain. In the low-level mission there's a lot to take care of. We typically flew with maps at the 1 to 250,000 scale. You became quite adept at the fine art of map folding. With a plastic overlay and grease pencil you could outline your flight path. Sometimes you could get a TACAN (tactical air navigation) fix, but that only worked if you were near a TACAN.

Operating the Maverick missile was easy. There was a screen on the front panel that showed you what the Maverick missile was looking at. Acquiring a target and firing the missile was done through the throttle and stick.

Visibility from the cockpit was very good, especially to the sides. The front windscreen is thick and sturdy and for good reason. Bird strikes at low-level were common. The bird strikes I had never penetrated the glass. There are a couple of metal supports in the front windscreen and sometimes you had to look around them, but the visibility in the A-10A was excellent.

Flying 250 feet (76 meters) off the ground required a great deal of concentration. When I flew at low-level, I always added one click of up trim. If I was momentarily distracted, the aircraft would climb rather descend.

The noise level in the cockpit wasn't excessive, but most of us wore earplugs under our helmets. You'd adjust your radio volume to compensate for the plugs and the wind rush around the canopy and aircraft in general.

In terms of workload, you had to keep your head up. Normally you're flying with other aircraft. Running into each other or terrain wasn't an option. You're always on the radio talking to the forward air controller (FAC) or other aircraft. You had to talk, write down frequencies, target coordinates, and fly the aircraft all at low-level.

When you fired the 30-millimeter cannon you could smell the residue, but it wasn't bad. Legend has it that when you fired the gun the airplane slowed considerably. That's not true. You might lose a knot or two, but it never affected the aircraft.

The A-10A had good flight characteristics. It was an honest airplane. Its design features made it a superb low-level ground-attack aircraft. The seat-of-the-pants feel, plus the feedback from the control stick, let you know what the airplane was doing.

MUTUALLY ASSURED DESTRUCTION

GENERAL DYNAMICS/ LOCKHEED MARTIN F-16 FIGHTING FALCON

General Dynamics F-16A | National Museum of the US Air Force | Serial No. 81-0663

The arrival of the F-16 Fighting Falcon in 1978 gave the USAF its first multirole "lightweight fighter" replacement for the venerable F-4 Phantom II. The F-16 was in many ways a reaction to the superb and big F-15 Eagle. (While the Eagle was still in development, proposals were made for a lighter, cheaper fighter to complement it.) After a fly-off with the Northrop YF-17, the General Dynamics YF-16 was declared the winner. In the years and decades that followed, the lightweight F-16 grew in capability. Today it's no longer light nor as cheap as advertised. It is, however, one of the world's best multirole fighters.

The Fighting Falcon's computer-powered cockpit features a reclining seat, giving the pilot the ability to cope with sustained 9g turns. One of the key features is the single-piece, bird-proof polycarbonate bubble canopy. With 360-degree all-round visibility it allows the pilot a 40-degree look-down angle over the side and 15 degrees over the nose. The canopy lacks the forward bow frame found on most fighters including some of the most modern, such as the Typhoon and Gripen.

The wings have an array of hard points, which allow for more than 20,000 pounds (9,072 kilograms) of external stores. As an all-weather multirole combat aircraft, the F-16 can handle a wide range of weapons giving it the ability to serve as an air superiority, close-air support, or deep interdiction fighter.

The F-16's first air-to-air victory occurred on April 28, 1981, when an Israeli Falcon shot down a Syrian Mi-8 over the Bekaa Valley. During the 1982 Lebanon War, Israeli F-16s along with the F-15 fought in one of the largest jet air battles since the Korean War. For two days Israeli F-16s battled Syrian MiG-21s and MiG-23s and were credited with forty-four air-to-air kills without a loss.

At present the F-16 is in service with twenty-eight nations. In terms of numbers (4,500) the F-16 is arguably one of the most successful jet fighter ever built. Matched with its performance the F-16 has proven itself as an attack aircraft second to none.

Scheduled to remain in USAF service until 2025, the F-16 will be replaced by the F-35A Lightning II. Delays in that program, however, may see the F-16 flying well past that date. To hedge their bets all USAF F-16s will get life service extension upgrades.

This AIM-9X Sidewinder is about to be loaded onto an F-16 of the 416th Flight Test Squadron, Edwards Air Force Base, California. The AIM-9 Sidewinder is the most advanced infrared-tracking, short-range, air-to-air missile in the world. *US Air Force*

PILOT IMPRESSIONS
Colonel Bill Harrell, USAF (Ret.)

I went to the Air Force Academy and finished flight school in 1971. I flew the A-37 Dragonfly in Vietnam in 1972 for a total of 366 combat missions over ten months. When I returned to the States, I flew the A-7D Corsair, the A-10 Thunderbolt II, and the F-5E before transitioning into the F-16 in 1980. I flew the F-16 from 1980 to 1997 from the Block 5 right up to the Block 52, the latest model.

I always wanted to fly the F-16. It was a dream airplane when it first came out and was the personification of a fighter pilot's airplane. It was small, fast, nimble, hard to see, overall a truly tremendous jet.

When I started flying the F-16 in 1980, it was one of the first US Air Force fighters to have a modern and reliable inertial navigation system (INS) and a heads-up display (HUD). Sitting in the cockpit for the first time I thought, "Wow!" The first thing that struck me was the absence of a control stick between your legs. It had a side controller, which didn't move. It was all pressure sensors. That was remarkable, and the other thing that struck me was no front windscreen! The canopy is all one piece giving you exceptional visibility. You also sit up high in the cockpit at a recline angle of about 30 degrees. It's very comfortable, sort of like sitting in a lawn chair.

The controls and instruments were easy to use, but the HOTAS (hands-on throttle and stick) was the most intuitive. It changed a little bit in the C model with additional items, but the most important switches were on the throttle and control stick. That meant you never had to take your hands off those two controls. In concert with the HUD you had a great deal of control over what was going on with the sensors and weapons. We called it "playing the piccolo." Later when I began working for Lockheed Martin on the F-22 and F-35 cockpits, there were different philosophies regarding HOTAS, but I thought the F-16 had already set the standard.

When I first started flying the F-16, the side-stick controller didn't move. It was called the "stiff stick." Flying the stiff stick wasn't a problem, but it was an art form. You flew with pressure inputs alone and that was in sharp contrast to the stick between your legs control found in other aircraft. In later models they introduced the "moveable stick," which had some movement and gave you a more conventional feel for the aircraft.

One of the very unique things about the F-16 compared to earlier US Air Force fighters I had flown is that you closed the canopy before engine start. After the engine came up to speed the cockpit climate control kicked in and you had instant heat or air conditioning. This made operations in very hot summer months and very cold winter months much more agreeable.

I think General Dynamics and late Lockheed Martin did a remarkable job on the cockpit. It was the most comfortable airplane I've ever flown and that was mostly due to the reclining seat.

I enjoyed flying the F-16. It was very nimble and quick, but you had to keep your wits about you. For me it was the most beautiful piece of machinery I've ever been associated with, and a love affair that lasted for seventeen years.

ABOVE: An F-16C releases a cluster of flares over Luke Air Force Base, Arizona. Burning at a temperature equal to or hotter than the engine exhaust, the flares are designed to guide any heat-seeking missile away from the aircraft. *US Air Force photo/TSGT Mathew Hannen*

BELOW: An impressive lineup of F-16 Fighting Falcons during exercise "Elephant Walk" at Kunsan Air Base, Republic of Korea, March 2012. *US Air Force photo/SRA Brittany Auld*

MIKOYAN MiG-29

Mikoyan MiG-29A | National Museum of the US Air Force | Serial No. 2960516761

When the MiG-29 first appeared in 1977, it was a startling revelation. As with the MiG-15 and MiG-19 before it, the Americans realized the Soviets were catching up.

The MiG-29 revealed itself through satellite photos taken in November 1977. For US intelligence it looked as if the Soviets had developed a fighter designed to take on the F-15, F-16, and F/A-18. Powered by two Klimov RD-33 turbofan engines, the new MiG-29 had a top speed of close to Mach 2.25. Armed with up to six air-to-air missiles and a single 30-millimeter cannon in the port wing, the MiG-29 was a clear and present threat to American fighter superiority. The US reaction was the development of the next generation of fighter technology, an advanced tactical fighter capable of tracking and shooting multiple targets simultaneously. That aircraft would later become the F-22 Raptor.

The MiG-29 made its first public appearance in Finland on July 2, 1986. This was followed by a display at the Farnborough Airshow in Britain in September 1988. By that time Western intelligence had a better picture of what the MiG-29 was really capable of. It wouldn't be long, however, before the West would know everything about the new MiG. With the fall of the Berlin Wall in 1989, Germany was reunified and with it came the East German air force's MiG-29s.

The early MiG-29s were very agile with a performance that matched the F-16 and F/A-18. Like most Soviet fighters (MiG-15, 17, and 21) it had a relatively low-fuel capacity, regulating it to short-range air defense. Its pilots were also tied to a tightly integrated ground-control intercept system, which meant the Fulcrum's systems were not highly developed and the SA for the pilot was nothing compared to his Western counterpart. But the MiG was still a highly capable dogfighter, and the one thing it did have over its Western counterparts was the Archer air-to-air missile and helmet-mounted sighting system. Introduced in the mid-1980s the Archer AA-11 was a heat-seeking missile that was better than the US Sidewinder. A simple monocular lens mounted on the pilot's helmet allowed him to lock a missile onto a target regardless of where the nose of the fighter was pointed. Many US pilots flying their F-15, 16, F/A-18, and navy F-14s were humbled after their first tangle with a Fulcrum. Further exposure to the MiG-29, however, revealed its limitations. If the MiG-29 and any of the American fighters mentioned above tangled in a dogfight, both would detect each on radar. For those American fighters armed with the AIM-120 AMRAAM they would have the first shot at more than twice the range of the Fulcrum's. American radars are also capable of tracking multiple targets at the same time. The Fulcrum can't. Indeed, the MiG-29 pilot must wait until about 13 miles (21 kilometers) before he can fire his beyond visual range (BVR) missile.

ROCKWELL B-1 LANCER

Rockwell B-1B | National Museum of the US Air Force | Serial No. 84-0051

In the mid-1960s a determined effort was mounted to find a replacement for the venerable Boeing B-52. Under the Advanced Manned Strategic Aircraft (AMSA) Program, the USAF chose a Rockwell International proposal for development. Like the F-111 before it, the B-1 Lancer suffered through one of the longest development periods of any modern combat aircraft. Policy regarding the future of manned bombers, specification changes, and political interference led to twenty years before the delivery of the first B-1B Lancer to an operational squadron. The first major stumble occurred in 1977 when President Jimmy Carter cancelled the B-1A. Many said it was too expensive and unable to penetrate Soviet air defenses. Fortunately for Rockwell the prototypes continued test flying. (Usually when an aircraft program is cancelled they rarely fly again.) When President Ronald Reagan took office, he agreed to revive the B-1 in 1981. Under the Long-Range Combat Aircraft (LRCA) Program, one hundred bombers were ordered.

Because of the years of flight testing, the new B-1B, while a little slower than the B-1A, was a more capable aircraft. And with new stealth technology, it had a radar cross section only 1 percent that of the B-52. Its large variable swept wing also gave it exceptional performance at high speed and low-level. Powered by four General Electric F101-GE-102 augmented turbofan engines, the B-1B has a top speed of Mach 1.25 at 50,000 feet (15,240 meters) and Mach 0.92 at 200 to 500 feet (61 to 152 meters). The B-1 holds sixty-one Fédération Aéronautique Internationale (FAI) world records for speed, distance, payload, and time-to-climb.

A full load of avionics including terrain-following radar, sophisticated navigation equipment, and a comprehensive electronic warfare suite make the B-1B a formidable all-weather bomber capable of hitting targets anywhere in the world.

In September 1991 President George H. W. Bush ordered SAC to stand down their alert forces, and in June 1992, SAC was dissolved. Soon after a $3 billion refit was ordered to transform the B-1 from a nuclear penetrator into a conventional bomber. By the mid-1990s the B-1 was cleared to carry general purpose (GP) along with various cluster bomb units (CBU). Internally, the B-1 can carry eighty-four 500-pound (227-kilogram) conventional bombs and another twenty-four on external racks. At present the B-1 is capable of deploying an array of conventional weapons, most notably the GBU-31 2,000-pound (907-kilogram) joint direct attack munition (JDAM). During the invasion of Iraq in 2003, B-1s played a big part dropping some 3,900 JDAMs in the first six months of operations. In 2007 the B-1Bs precision bombing capabilities were enhanced even further with the addition of the Sniper XR targeting pod. This pod provides advanced imagery and allows crews to detect tactical-size targets well away from air defense systems and outside jet noise ranges.

How long the B-1B will remain in service has yet to be decided. With upgrades it could remain viable well into 2030. Like the B-52 the B-1 has switched roles from nuclear penetrator to conventional bomber with impressive results.

At present the USAF has sixty-six B-1Bs in service with four squadrons.

PILOT IMPRESSIONS
Colonel William "Bill" J. Moran Jr., USAF (Ret.)

Transitioning from the FB-111 into the B-1 was easier than the B-52 into the FB-111. Both swing-wing bombers were equipped with vertical tape instruments so it wasn't a great change.

When I began flying the B-1, I never got a training check flight. At the time the B-1 wasn't ready for operational testing. As an operational SAC pilot, I was brought into the test program to see if the B-1 was ready for service. I wasn't a test pilot per se and my check-out flight was actually a test mission. I flew a lot of terrain-following flights along with offensive and defensive avionics testing.

We knew we had a great airplane, but a lot of politicians at the time weren't so sure. Today the B-1 has a huge payload, speed,

A B-1B with wings swept fully forward. Forward-swept settings are used for takeoff, landings, and high cruise. For high-subsonic and supersonic speeds, the wings are swept fully back, giving the B-1B a low-level penetration speed of 700 miles (1,127 kilometers) per hour. *National Museum of the USAF*

A B-1B Lancer flies a test mission for the Sniper Advanced Targeting Pod. Located just aft of the cockpit, the pod gives the B-1B enhanced targeting capability for a whole range of precision-guided weapons. *US Air Force*

and its on-station loiter time is phenomenal. Right now we have guys taking off in the morning not knowing if they're going to Afghanistan, Syria, or Iraq. Armed with twenty-four 2,000-pound (907-kilogram) joint direct attack munitions (JDAM), in conjunction with ground tactical parties, a B-1 can drop a bomb with pinpoint accuracy. They call it "warheads on foreheads."

The cockpit layout in the B-1 was great. The fuel panel was unbelievably easy. Two computers ran the whole system. Like the F-111 you always had to be aware of your wing sweep while flying the B-1. The B-1 didn't have an automatic swing wing like the F-14. When you moved the wings, the fuel computers moved your fuel, fore and aft, to maintain the center of gravity (CG) on the target number. In the F-111 the CG moved 9 inches (22.86 centimeters), in the B-1 it was 90 inches (228.6 centimeters). You have to remember the B-1 was not lift limited, but limited longitudinally. In other words, when it departed controlled flight it pitched up. If you didn't have it in the correct CG envelope you would lose control.

With those big windows up front, the view from the cockpit was very good. The B-1 was easy to refuel air-to-air. On a scale of one to ten with ten being the worst, the B-52 was a ten, the F-111 a one, and the B-1 came in at three.

The noise level was fine, but the comfort level was absolutely terrible. The ejection seat had a contoured panel and your butt would always slide into the middle. There was a gap between your lower back and the back of the seat. We tried all kinds of cushions from the U-2, F-15, T-38, and F-111 trying to figure out which one would work. Nothing did. It was a problem for everybody.

Workload in the cockpit was fairly light. Like the F-111 we could have used some type of scope or display that give us a better situational awareness instead of strictly relying on your defensive systems officer.

The B-1 cockpit was very good. Compared to the three different types I flew—B-52, FB-111, and B-1—I preferred the FB-111 cockpit.

MUTUALLY ASSURED DESTRUCTION

LOCKHEED F-117 NIGHTHAWK

Lockheed YF-117A | National Museum of the US Air Force | Serial No. 79-10781

The Lockheed F-117 is one of the most specialized and sophisticated aircraft to ever enter US Air Force service. Born out of the lessons of Vietnam, where USAF losses mounted to 1,737 aircraft shot down in combat and 514 lost to operational causes, the air force needed a fighter/attack aircraft capable of flying through well-defended air spaces unscathed. The key to defeating radar-guided guns and surface-to-air missiles (SAMs) was simple: reduce your aircraft's radar cross-section.

In 1975 the Lockheed Skunk Works began working on a computerized program that married radar cross-section technologies with aerodynamics. What they came up with was a concept called faceting, a design process that enabled 99.9 percent of the directed radar energy to be deflected away from the sending receiver.

In 1977 Lockheed received a contract to build two prototypes under the code name "Have Blue." These prototypes proved virtually undetectable. Though they were not completely invisible, most ground tracking radars could not detect it until it was well within a SAM's minimum range. In 1978 Congress authorized full-scale production, ordering fifty-nine examples.

The F-117 is an ugly aircraft. Purpose built, it has no smooth contours like the F-15 or F-16. It is all squares and flat panels and inherently aerodynamically unstable. Without its quadruple-redundant computer fly-by-wire control system, the F-117 would never leave the ground.

The cockpit is equipped with a conventional HUD, which is more efficient than the F-15C's but not as capable as the F-15E's. The main panel is well equipped, with two standard 5-inch multifunction CRT displays, while the main FLIR CRT has a 12-inch screen.

The F-117 was declared operational on October 28, 1983, but it remained secret. It would remain so during its first operational sortie during the Invasion of Panama in December 1989, and it wasn't until the Gulf War in 1991 that the world be introduced to the world's stealthiest aircraft. Assigned to penetrate the most heavily defended targets in and around Baghdad, F-117As proved their worth dropping the first bombs of the war. Flying approximately 1,300 sorties, not one F-117A was lost.

The only F-117A ever shot down during the aircraft's operational history occurred on March 27, 1999, over Yugoslavia during Operation Allied Force.

After just twenty-three short years of service, the F-117 retired in 2006. The fleet, however, remains intact, carefully mothballed for possible reactivation.

PILOT IMPRESSIONS
Major General Greg Feest, USAF (Ret.)

I started my career as a weapons-system officer and navigator in the F-111 Aardvark. After pilot training, I flew the F-15C. I was then chosen to go into a black-world program flying the Lockheed F-117. I spent a tour flying the F-117 and flew combat in both Operation Just Cause and Operation Desert Storm. I retired in November 2012.

One of these fighters is not like the others. While designated as a fighter, the F-117A was in fact a strike aircraft with no air-to-air capability. Its unique diamond shape stands in sharp contrast to the more conventional layouts of the F-22 Raptor, F-4 Phantom, and F-15 Eagle. *US Air Force*

When we first started the F-117 program, we needed some convincing that it would actually fly. After a short video, we realized it was for real and went from there.

There's no two-seater version, so your first sortie is a solo flight. There is a chase aircraft, but it's just you in the F-117. The first flight is enlightening. You know the aircraft will fly, but when you actually get it airborne, that's when you can really trust it for yourself.

One advantage the F-117 cockpit had was its avionics. Most of them came from other aircraft and were familiar. The engineers, after speaking with other fighter pilots, put the displays and control boxes in the right place making it easy for the pilot to operate. We had a heads-up display, and the radios were in the right place. It was a good-sized cockpit, much like the F-15, with lots of space on both sides. You could stretch your legs and lift yourself off the seat—it was very comfortable, especially on long flights. Everything was accessible, with no need to reach down or behind.

The view from the F-117 cockpit was different. The view to the rear was nonexistent, but we never planned to have anyone behind us. Visibility during the day was good, but at night any flashing lights reflected off the flat panels and were a little disorienting, but you got used to it.

Noise level in the cockpit was low. The F-117 is a subsonic aircraft, but as your speed increased there was only a slight change in the cockpit noise. You could actually accelerate without knowing it. It was that quiet.

The F-117 was not a demanding aircraft to fly, but keeping the infrared cursors on the target while everyone was shooting at you was a challenge. We were well trained, and going into combat our goal was to fly right over the target, drop a laser-guided bomb, and get out. We couldn't launch and leave but had to fly right into the threat. Our biggest initial concern was with the stealth technology—we didn't know if it was going to work. It obviously did, but those first few Desert Storm sorties were a little nerve wracking.

During the bomb run, you're not looking outside of the aircraft; your head is buried in the cockpit. We didn't want to look outside anyway. Everything at night, antiaircraft artillery and surface-to-air missiles, looks like it going to hit you. You just lower your seat, concentrate on the target, and get out as fast as you could.

The F-117 was not built for aggressive maneuvering like the F-22 or F-35. It didn't have afterburners and was strictly a subsonic aircraft. Our job was to limit any excessive maneuvering, because any time you turned the aircraft it changed the radar cross-section.

People asked me, "What's your favorite aircraft?" In peacetime it's the F-15C—you can dogfight all the time. For combat it's the F-117. Once we figured out the stealth technology actually worked, that was the aircraft for me.

COLD WAR TO THE PRESENT

Aircrew from the 49th Fighter Wing prepare an F-117A for its final flight. The F-117 was retired from service in a farewell ceremony at Wright-Patterson Air Force Base on March 11, 2008. *US Air Force*

A 7th Squadron F-117A undergoing maintenance at Holloman AFB. The arrowhead-shaped F-117A was designed to reflect radar signals at different angles as seen by the multifaceted fuselage. Directly in front of the cockpit is the forward-looking infrared sensor. *US Air Force*

MUTUALLY ASSURED DESTRUCTION

LOCKHEED MARTIN F-22 RAPTOR

On September 23, 2014, the F-22 Raptor made its combat debut as the world's only fifth-generation air superiority stealth fighter, and it was an inauspicious start. Instead of being charged with engaging and defeating a sophisticated air defense system complete with enemy fighters, the F-22 was given the task of slinging bombs at an Islamic State target in Syria. As one of the most expensive fighters ever built (the production run was limited to 178 examples), the F-22 has had a troubled past whose procurement and continued development has been shaped by politics rather than strategic requirements.

At present the F-22 remains the deadliest fighter aircraft ever produced. Its overall capabilities will surpass those found in the F-35 Lightning II Joint Strike Fighter even when it finally enters service.

The Raptor's ongoing development has seen the jet transformed from an air superiority fighter into a fighter attack aircraft capable of knocking down enemy fighters all the while destroying a combatant's integrated air defense system. The F-22 can also act as a mini RC-135 ELINT (electrnic signals intelligence) aircraft, AWACS (airborne warning and control system), or electronic air warfare aircraft, something the F-15, F-16, F-35, Euro Typhoon, Saab Gripen, and Dassault Rafale cannot do.

Powered by two Pratt & Whitney F119-PW-100 pitch-thrust vectoring turbofans, the F-22 has exceptional performance and is one of only a few fighters that super cruise—they fly at supersonic speeds without using afterburners. Equipped with three internal weapons bays, the F-22 can carry six AIM-120 AMRAAM and two AIM-9 Sidewinders for the air-to-air role; and two 1,000-pound (454-kilogram) JDAM bombs, or eight 250-pound (113-kilogram) GBU small-diameter bombs and two AIM-120s and two AIM-9s for ground attack. Mounted in the right wing root is a M61A2 Vulcan 20-millimeter cannon.

Just as well equipped is the F-22's all-glass digital cockpit. The monochrome HUD serves as the primary flight instrument with six liquid crystal display (LCD) panels. One of the original objectives for the F-22 was to give its pilots a first-look, first-shoot, first-kill capability. Using the inter/intra flight data link (IFDL), all Raptors can be linked together giving them the ability to trade target information without radio calls.

For all its expense the F-22 Raptor is the world's most sophisticated and lethal fighter. The amazing part is, it has yet to show its real capabilities.

PILOT IMPRESSIONS
Lieutenant Colonel Clayton Percle, USAF, 525th Fighter Squadron Commander

I always wanted to fly the F-15, and after pilot training in 2001, I got my wish. During the invasion of Iraq in 2003, I flew the F-15C with the 58th Fighter Squadron. In 2005 I was selected for the F-22 Raptor program. I'm now based at Elmendorf Air Force Base, Alaska.

I've also flown both the F-16 and F-18, and when I got into the cockpit of the F-22 for the first time I noticed two things. The first was seat angle. The seat is actually reclined a little bit. In the Eagle it's almost straight up. In the F-22 the seat recline is about half way between the F-15 and F-16 and very comfortable. The padding on the seat is also much better. The second thing I noticed was how close to the ground you are. Compared to the

F-15 the landing gear is shorter. When you pull up to an F-15 you're actually looking up.

When you first get into the cockpit there's no power and there's not a single old-fashioned round steam gauge anywhere. It's all multifunction displays and very sparse. Not a lot of switches compared to the F-15. It has about one-fifth the switches found in the F-15. The stick was in the wrong place as well. As a good old-fashioned fighter pilot, I was very comfortable with it right there in the middle. Like the F-16 it's a side stick. It took me about six months flying the plane before I stopped reaching for the stick between my knees instead of on the right.

Everything in the cockpit is close to hand. It's very HOTAS (hands-on throttle and stick) driven. The throttles are very large and the stick is fairly comfortable. It's not a rounded grip like the F-15. It's kind of beveled.

The heads-up display (HUD) its slightly bigger than the F-15C. It's a monochrome green display and carries lot more data than the Eagle.

The cockpit displays are very large. The primary multifunction display is about 14 inches (36 centimeters) diagonal. The others are more traditional in size. It's pilot friendly and you can cycle through each display using the HOTAS.

Visibility is similar to the F-16, but not as good as the F-15. The front canopy has a kind of triangular shape, which restricts your view left and right. Rearward visibility is about 90 percent of what you'd get in the Eagle, but fortunately for us we don't spend a lot of time with fighters on our tail.

On the ground the F-22 is a little bit louder than the Eagle. Most of us fly with double-hearing protection. We also use molded earplugs that have a COM link. Even though it's louder than the Eagle, the sound quality in the cockpit is actually better.

Compared to the F-15 the workload in the cockpit is not high. In the F-15 the radar was manual and the workload intensive. In the F-22, with its integrated sensors, the computer decides where the radar should look. As a Raptor pilot you're basically a voting member. You don't have the final decision. You can override the system in some cases, but that just messes up the computer. You're better off just leaving it alone.

The flight control system in the F-22 is brilliant. In the original flight manual it said you could fly the F-22 with "carefree abandon." They took that out, but it's almost true. If you try to put the aircraft into an out-of-control situation, the flight control system will take the aircraft away from you. The Raptor can outsmart the pilot, it's that good.

ABOVE: An F-22 dispenses flares. For all its stealth capabilities the F-22 still incorporates flare and chaff countermeasures in order to defeat heat-seeking and radar-guided missiles. *US Air Force photo/SRA Clay Lancaster*

OPPOSITE PAGE: The F-22's ability to accelerate quickly makes for some great photos. The aircraft's near supersonic speed changes the temperature and pressure around the airframe, causing ambient moisture to condense and surround the aircraft in a blanket of mist. *US Air Force photo/TSGT Justin D. Pyle*

BELOW: An F-22 pilot from the 95th Fighter Squadron readies himself for another flight. The GEC-built Head-Up Display (HUD), standing out here in bright green, offers a wide field of view and serves as the pilot's primary flight instrument. *US Air Force photo/TSGT Ray Crane*

MUTUALLY ASSURED DESTRUCTION 215

LOCKHEED MARTIN F-35 LIGHTNING II JOINT STRIKE FIGHTER

Lockheed F-35 AA-1

The F-35 Lightning II is the world's most expensive and controversial weapons system ever devised. Designed to the replace the America's F-16, A-10, and F/A-18 Hornet and Britain's AV-8B Harrier tactical fighter and attack aircraft, it's been in development since 2001. Technical problems and cost overruns have plagued the program since the beginning. Critics often describe the F-35 as a "turkey" or a failure when compared to the F-16 or F-15 as a pure air-to-air fighter. But the key concepts behind the F-35 have always focused on other jets taking care of the most severe air-to-air threats. The F-35 was never designed to be the primary air-to-air fighter for the USAF, USN, and USMC. Although the "F" stands for fighter, the initial requirement was 70 percent weighted toward air-to-ground missions.

While not as fast or nimble as a "clean" F-16 Falcon, the new F-35's helmet-mounted sight and sensor fusion, matched with the AIM-9X block II missile, make the hard-maneuvering dogfight a thing of the past. The aircraft's advanced avionics and missiles make its agility less important.

As a strike-attack fighter, with the secondary role of interceptor, the F-35 has been designed with three distinct versions; the F-35A for the air force; the F-35B STOVL (short takeoff/vertical landing) for the marines; and the F-35C for the navy. The British Royal Navy has ordered the F-35B, and ten other countries have ordered the F-35A.

In terms of armament the Lightning II packs a hefty punch. Internally it can carry two 2,000-pound (907-kilogram) JDAM bombs and two AIM-120 AMRAAM air-to-air missiles. Later versions will be able to carry two B61 nuclear weapons. Only the F-35A will carry the GAU-22/A 25-millimeter cannon with 180 rounds of ammunition.

Powered by a Pratt & Whitney F135 engine, the F-35 will have a limited super cruise of Mach 1.2 for 150 miles (241 kilometers) with a maximum of speed of Mach 1.6.

In the cockpit the F-35 will not have the traditional HUD. In its place will be a glass cockpit and the HMDS. Matched with a cockpit speech-recognition system, the F-35's cockpit is the most advanced in the world with a true "through-the-floor" view of the battle space.

To date the F-35 Lightning II program has flown more than 30,000 flight hours, completed more than 65 percent of its test program, delivered more than 120 jets, and trained more than 200 pilots. As the world's most advanced multirole fighter its capabilities have yet to be fully tested.

PILOT IMPRESSIONS
Daniel Toftness, USAF, F-35A Instructor Pilot

I did Air Force ROTC in college and I was lucky enough to join the US Air Force Pilot Training Program. There I flew the T-6 Texan II and went onto fighters flying the T-38 Talon. After that I was selected for the F-16. I flew the F-16 in Korea and Japan for four years. Just over a year ago, I was chosen for the F-35A transition program and I've been flying it ever since.

Like any other aircraft that you jump into for the first time your situational awareness is low. You're task saturated and it's a little overwhelming.

When I started the motor I thought, "Wow, this thing is vastly different from any other airplane I've flown." You could tell there's a big motor behind you and that's at idle! Once I got past that and took the runway for the first time, I basically felt at home. The F-35 is very stable. It has a lot of autopilot modes, which I wasn't used to, but the airplane does what you ask it to do. Once you get past the first sortie, it's really easy to fly.

Looking into the cockpit you'd be amazed at how few switches there are. I think there's less than ten actual flip switches. Right in front of you is a big flat TV screen.

It's divided in half giving you two panoramic touchscreen crystal displays. That was the biggest change coming from the F-16. To activate a switch you simply touch the screen.

The controls are close to hand and very similar to the F-16. It was the simplicity of the cockpit that really struck me. One of the

ABOVE: Testing the ability of the F-35 to fly safely on instruments with no external visual references was the responsibility of the F-35 Integrated Test Force. *Lockheed Martin photo/Tom Reynolds*

OPPOSITE PAGE: Unlike the F-15 and F-16, the F-35's canopy hinges forward. This simpler, lighter design allows for easier maintenance at a lower cost. The ejection seat can be removed without removing the entire canopy. With no HUD, the F-35's forward visibility is superior to those of the F-15 and F-16. *Lockheed Martin*

first things I noticed was the side-stick control. Compared to the F-16 the side control had less movement.

The view from the cockpit is good. Coming from the F-16 I wasn't used to having a canopy bow. You sit a little higher in the F-16 than you do in the F-35, but not by much.

Noise in the cockpit is considerably less compared to the F-16. Our helmets have active noise-reduction headphones. The F-35A is just as loud as any other jet fighter, but you don't hear it because of the noise cancelling. Radio communication is crystal clear.

Comfort level in the cockpit is comparable to the F-16. The biggest leap forward is the custom-fit helmet. Made from carbon fiber it's light at less than 5 pounds (2 kilograms).

Compared to the F-16 the workload in the F-35A during an intercept is very low. In the F-16 I had to work my radar, situational awareness display, radar-warning receiver, and targeting pod. The F-35A uses a concept called "fusion." It takes all that information, without any work from the pilot, and displays it on one screen.

I think they did a really great job on the cockpit. I was apprehensive about the touchscreen at first, but it really is intuitive. Older pilots, not having grown up with computers, are little apprehensive when they first jump into the F-35, but the transition is straightforward.

The cockpit interface, to my knowledge, is not going to change. What will change as this airplane matures is the software that they put in. It really is a remarkable aircraft.

MUTUALLY ASSURED DESTRUCTION

BIBLIOGRAPHY

BOOKS

American Warplanes of World War II. London: Aerospace Publishing, 1995.

Bond, Steve. *Wimpy: A Detailed History of the Vickers Wellington in Service, 1938 to 1953*. London: Grub Street, 2014.

Bowman, Martin W. *The B-52 Story*. Gloucestershire, UK: History Press, 2012.

———. *USAF Handbook 1939–1945*. Mechanicsburg, PA: Stackpole Books, 1997.

Brown, Eric M. *Duels in the Sky: World War II Naval Aircraft in Combat*. Shrewsbury, UK: Airlife Publishing, 1989.

———. *Wings of the Luftwaffe: Flying the Captured German Aircraft of World War II*. Manchester, UK: Crecy Publishing, 2010.

———. *Wings of the Weird & Wonderful*. Manchester, UK: Crecy Publishing, 2010.

Carter, William, and Spencer Dunmore. *Reap the Whirlwind: The Untold Story of 6 Group, Canada's Bomber Force of World War II*. Toronto: McClelland & Stewart, 1991.

Clark, R. Wallace. *British Aircraft Armament, Volume 1: RAF Gun Turrets from 1914 to the Present Day*. Somerset, UK: Patrick Stephens, 1993.

Coombs, L. F. E. *The Aircraft Cockpit: From Stick-and-String to Fly-by-Wire*. Northamptonshire, UK: Patrick Stephens, 1990.

———. *Fighting Cockpits 1914–2000*. Osceola, WI: MBI Publishing Company, 1999.

Donald, David., ed. *Warplanes of the Luftwaffe*. London: Aerospace Publishing, 1994.

English, Allan D. *The Cream of the Crop: Canadian Aircrew, 1939–1945*. Montreal: McGill-Queen's University Press, 1996.

Ethell, Jeffrey L. et al. *Great Book of World War II Airplanes*. New York: Bonanza Books, 1984.

Everitt, Chris, and Martin Middlebrook. *The Bomber Command War Diaries*. London: Penguin Books, 1990.

Freeman, Roger A. *B-17 Fortress at War*. New York: Charles Scribner's Sons, 1977.

Greenhouse, Brereton, and Steven, J. Harris, William C. Johnston, and William G. P. Rawling. *The Crucible of War 1939–1945: The Official History of the Royal Canadian Air Force, Vol. III*. Toronto: University of Toronto Press in cooperation with the Department of National Defense and the Canada Communications Group, Publishing, Supply Services of Canada, 1994.

Gunston, Bill. *Classic World War II Aircraft Cutaways*. London. Osprey Publishing, 1995.

Halliday, Hugh A. *Typhoon and Tempest: The Canadian Story*. Toronto: CANAV Books, 1992.

Hardesety, Von. *Red Phoenix: The Rise of Soviet Air Power, 1914–1945*. Washington, DC: Smithsonian Institution, 1982.

Holder, William. *The B-1 Bomber*. Blue Ridge Summit, PA: Aero, 1998.

Holmes, Tony. *Hurricane Aces 1939–40*. Oxford, UK: Osprey Publishing, 1998.

Isby, David C. *Jane's Fighter Combat in the Jet Age*. London: Collins Reference, 1997.

Jane's Fighting Aircraft of World War II. Avenel, NJ: Crescent Books, 1994.

Jarrett, Philip. ed. *Aircraft of the Second World War*. London: Putnam Aeronautical Books, 1997.

Kaplan, Philip, and Jack Currie. *Round the Clock: The Experience of the Allied Bomber Crews Who Flew By Day and Night from England in the Second World War*. New York: Random House, 1993.

Lake, Jon. *Halifax Squadrons of World War 2*. Oxford, UK: Osprey Publishing, 1999.

Larry, Davis. *F-86 in Action*. Carrollton, TX. Squadron/Signal Publications, 1992.

Mackersey, Ian. *No Empty Chairs: The Short and Heroic Lives of the Young Aviators Who Fought and Died in the First World War*. London: Weidenfeld & Nicolson, 2012.

March, Daniel, J. *British Warplanes of World War II*. London: Aerospace Publishing, 1998.

Middlebrook, Martin, and Chris Everitt. *The Bomber Command War Diaries*. London: Penguin Books, 1990.

Murray, Ian R. *Vickers Wellington Owners' Workshop Manual*. Somerset, UK: Haynes Publishing, 2012.

Murray, Williamson. *The Luftwaffe, 1933–45: Strategy for Defeat*. Washington, DC: Brassey's, 1989.

Nijboer, Donald. *Cockpit: An Illustrated History of World War II Aircraft Interiors*. Erin, ON: The Boston Mills Press, 1998.

———. *Cockpits of the Cold War*. Erin, ON: The Boston Mills Press, 2003.

———. *Graphic War: The Secret Aviation Drawings and Illustrations of World War II*. Erin, ON: The Boston Mills Press, 2005.

The Official World War II Guide to the Army Air Forces. New York: Bonanza Books, 1988.

O'Leary, Michael. *Long Reach VIII Fighter Command at War*. Oxford, UK: Osprey Publishing, 2000.

Pace, Steve. *The F-22 Raptor: American's Next Lethal War Machine*. New York: McGraw-Hill, 1999.

Perkins, Paul. *The Lady: Boeing B-17 Flying Fortress*. Charlottesville, VA: Howell Press, 1997.

Price, Alfred. *Aggressors: Patrol Aircraft vs. Submarine*. Charlottesville, VA: Howell Press, 1993.

———. *The Last Year of the Luftwaffe: May 1944 to May 1945*. Osceola, WI: Motorbooks, 1991.

———. *The Luftwaffe Data Book*. London: Greenhill Books, 1997.

———. *Luftwaffe Handbook*. New York: Charles Scribner's Sons, 1977.

———. *Spitfire Mark I/II Aces 1939–1941*. London: Osprey Publishing, 1996.

Remington, Roger R. *American Modernism Graphic Design, 1920 to 1960*. New Haven, CT: Yale University Press, 2003.

Sakaida, Henry. *Imperial Japanese Navy Aces 1937–1945*. London: Osprey Publishing, 1998.

Scutts, Jerry. *German Night Fighter Aces of World War 2*. Oxford, UK: Osprey Publishing, 1998.

Shores, Christopher, and Chris Thomas. *2nd Tactical Air Force, Vols. 1, 2, 3, and 4*. Surrey, UK: Classic Publications, 2004, 2005, 2006, and 2008,

Stepfar, Hans-Heiri. *MiG-19 Farmer in Action*. Carrollton, TX. Squadron/Signal Publications, 1994.

Weal, John. *Bf 109F/G/K Aces of the Western Front*. Oxford, UK: Osprey Publishing, 1999.

Williamson, Murray. *The Luftwaffe, 1933–1945: Strategy for Defeat*. Washington, DC: Brasseys, 1996.

PERIODICALS

Brown, Eric M. "Valediction for Veteran Vought," *AIR International*, December 1978.

Buttler, Tony. "Database de Havilland Mosquito," *Aeroplane*, November 2000.

Chorlton, Martyn. "Database North American P/F-82 Mustang," *Aeroplane*, April 2014.

Davies, Peter. "Database General Dynamics F-111," *Aeroplane*, November 2013.

Donald, David. Editor. "International Air Power Review, Volume 1," Airtime Publishing, 2001.

Eleazer, Wayne. "Supercharged," *Airpower*, November 2001.

Farara, Chris. "Database Hawker Siddeley Harrier GR.1/3 & T.2/4." Aeroplane March 2011

Gordon, Yefim. "Database Ilyushin Šturmovik," *Aeroplane*, June 2001.

Hall, Tim. "Cutaway Kings Peter Endsleigh Castle," *Aeroplane*, November 1999.

———. "Cutaway Kings Roy Cross," *Aeroplane*, September 2000.

Harrison, Bill. "Database Fairey Firefly," *Aeroplane*, December 2001.

Holmes, Tony. "Famous Fighters of World War I," Key Publishing, 2015.

Lumsden, Alec. "Database Vickers Wellington." *Aeroplane*, September 2001.

Mitchell, Fraser-Harry. "Database Handley Page Halifax," *Aeroplane*, May 2003.

O'Leary, Michael. "Database Boeing P-26 Peashooter," *Aeroplane*, August 2006.

Price, Dr. Alfred. "The First Cruise Missile," *Aeroplane*, March 2001.

MILITARY REPORTS

"Flying Safety in the Japanese Air Forces," Report No. 251, Air Technical Intelligence Group, Advanced Echelon Far East Air Forces, Tokyo, Japan. December 15, 1945.

Air Defense Pamphlet Number Eight "Barrage Balloons," November 1942.

"Air Crew Training Bulletin No. 19," August 1944.

"Air Crew Training Bulletin No. 22," February 1945.

"Japanese Aircraft Carrier Operations Part I," Air Technical Intelligence Group, No. 1, October 4–5, 1945.

WEBSITES

aerocinema.com
airforcemuseum.ca
casmuseum.techno-science.ca
donaldnijboer.com
flyinghistory.com
lockheedmartin.com
sabre-pilots.org
theaviationhistorian.com
vintagewings.ca
warplane.com
wwiiaircraftperformance.org

ACKNOWLEDGMENTS

To my partner, Janet Walker, for her patience and encouragement; Madelaine Winsor for all her transcribing work; and to Nick Cosco, Nick Stroud, Phil Osborn, Elvis Deane, Moreno Aguiari, Brett Stolle, Stephen Quick, Chris Colton, Jon Guttman Mike Potter, Tony Holmes, Warren Thompson, István Toperczer, and to all the pilots who gave so freely of their time, especially Eric Brown, whom I had the privilege and honor to interview for this project back in 2013.

–D.N.

Such a project as this could not happen without the assistance and understanding nature of a group of colleagues and friends who make the creation of photographs like these possible: Donald Nijboer is a fountain of ideas and enthusiasm and also is willing to "haul the freight." Nick Cosco, my good friend and advisor. A new addition to the crew, Christopher Ljungren, referred to by the Air Force Museum restoration staff as my "apprentice." In Ottawa at the Canada National Museum of Air and Space, director general Stephen Quick and his staff, particularly Matthew Bruce. At the National Museum of the United States Air Force, public affairs director Diana Bachert, special events director Teresa Montgomery, and the new guy, public affairs specialist Ken LaRock, a fine and talented photographer. From Restoration, restoration division chief Roger Deere and restoration specialists Chad Vanhook, Geno Toms, Jason Davis, Brian Lindamood, and Casey Simmons. Also, Robert Ljungren and Dean Alexander.

This project and the new method of shooting panorama images also meant seeking the advice and talents of craftsmen who helped turn conceptual inventions into actual tools: Tom Patterson, my brother and a serious photographer, and John Goode, my old friend who can build anything.

–D.P.

ABOUT THE AUTHOR

Donald Nijboer is a best-selling aviation author, historian, documentary writer-producer, and Smithsonian Speaker who lives in Toronto, Canada. He is the author of *Air Combat 1945*, *The Illustrated History No 126 Wing RCAF D-Day to VE-Day*, *Spitfire Mk V vs. C.202 Folgore*, *Gloster Meteor vs. V-1 Flying Bomb*, *Seafire vs. A6M Zero*, *P-38 Lightning vs. Ki 61 Tony*, *No 126 Wing RCAF*, and *Graphic War: The Secret Aviation Drawings and Illustrations of World War II*. He is also the co-author with photographer Dan Patterson of *Cockpit: An Illustrated History of World War II Aircraft Interiors*, *Gunner: An Illustrated History of World War II Aircraft Turrets and Gun Positions*, *Cockpits of the Cold War*, and *B-29 Combat Missions*. Currently, he writes and produces full-length aviation documentaries for the online broadcaster Aerocinema. He has also written articles for *Flight Journal*, *Aviation History*, and *Aeroplane Monthly*.

ABOUT THE PHOTOGRAPHER

Dan Patterson has spent a lifetime making photographs and airplanes have often been his subjects. Self employed for nearly forty years in a career tlihat has also included graphic design and writing, Dan has created and published nearly forty books about the rich history of flight and human history. He worked closely with Ron Dick to publish the landmark series *Aviation Century* and many other books and was honored with the first Harry B. Combs Award for Excellence in the Preservation of Aviation History by the National Aviation Hall of Fame in 2003. He often lectures about aviation history for colleges and universities, the National Park Service, and the Smithsonian Institution.

INDEX

AEG G.IV, 40–41
aerial reconnaissance, 12, 41, 72, 83
air-launched fighters, 66
airborne intercept radar, 82, 134
Arado Ar 234 Blitz, 154–157
armaments, 12–13, 20, 24, 41, 62, 80
armor plate, 80–81, 83
avionics, 161
Avro Lancaster, 82, 100

basic six panels, 54–55, 58
Blériot XI, 11
blind-flying panels, 53, 58
 See also flight instruments
Boeing B-17 Flying Fortress, 138–141
Boeing B-29 Superfortress, 83, 142–145
Boeing B-52 Stratofortress, 168–171
Boeing P-26A Peashooter, 64–65
Bristol F2.B, 24–27
bubble canopies, 81–82, 84, 160

cantilever wings, 46, 52, 70
close air support (CAS), 168
cockpit controls, 11, 13, 32, 53, 58, 80
 See also flight instruments
cockpit ergonomics, 162
Curtiss F9C Sparrowhawk, 66–69
Curtiss SB2C Helldiver, 130–133

dive-bombers, 80, 130
Dornier Do 335 Pfeil, 146–149

ejection seats, 122, 125, 160–161
enclosed cockpits, 54, 70, 80–81
escape capsules, 161, 178

Fairchild Republic A-10 Thunderbolt II, 192–195
Fairey Battle, 58, 80
Fairey Firefly, 112–115
Fiat CR.32, 62–63
Fiat CR.42, 116–117
flight instruments, 11, 13, 32, 34, 52–53, 58, 161

Focke-Wulf Fw 190 Würger, 81, 108–111
Fokker Dr.I, 28–31, 46
Fokker D.VII, 46–50

General Dynamics F-111 Aardvark, 176–179
General Dynamics/Lockheed Martin F-16 Fighting Falcon, 162, 196–199
glass cockpits, 162
Gloster Meteor, 160
ground-attack aircraft, 44, 72, 116, 118, 192
Grumman A-6 Intruder, 172–175
Grumman F-14 Tomcat, 188–191

Halberstadt CL.IV, 44–45
Handley Page Halifax, 100–103
Hawker Hind, 58–61
Hawker Hurricane, 54, 76, 80
Hawker Siddeley Harrier, 180–183
heads-up displays (HUDs), 161–162
Heinkel He 219 Uhu, 122–125

Ilyushin Il-2 Šturmovík, 118–121

jet engine technology, 150, 152, 154, 160

Kawasaki Ki-45 Toryū, 126–129

Lockheed F-117 Warhawk, 208–211
Lockheed Martin F-22 Raptor, 212–215
Lockheed Martin F-35 Lightning II Joint Strike Fighter, 216–219

Martin B-10, 53–54
Martin MB-2, 56–57
McDonnell Douglas/Boeing F-15 Eagle, 162, 184–187
Messerschmitt 262 Schwalbe, 150–153, 160
Messerschmitt Bf 109, 54, 76, 80, 88–91
Mikoyan MiG-29, 200–203
Mitsubishi A6M Zero, 80
Morane-Saulnier MS 405, 54
multifunction displays (MFDs), 162

Nieuport 28, 16–19
night fighters, 122, 126, 134, 146
North American F-86/F-86D Sabre, 160, 164–167
North American P-51 Mustang, 96–99
Northrop P-61 Black Widow, 134–137

open cockpit design, 12, 52, 80

parachutes, 12, 52
point-and-shoot helmets, 162–163, 216
Polikarpov I-16, 54
pressurized cabins, 53, 83, 142, 160
PZL P.11, 76–78, 80

radar, 82, 134, 172, 178
radios, 80, 82
Republic P-47 Thunderbolt, 92–95
Rockwell B-1 Lancer, 204–207
Royal Aircraft Factory B.E.2, 11
Royal Aircraft Factory S.E.5/S.E.5a, 13, 20–23

self-sealing fuel tanks, 80
Sopwith Camel, 20, 32–35
Sopwith Triplane, 32, 36–39
SPAD VII, 16, 42–43
SPAD XIII, 13–14, 16
stealth technology, 208, 212
Supermarine Spitfire, 54, 76, 80, 84–87

throttles, 16, 20, 36, 46
triplanes, 28–31, 36–39

unmanned combat air vehicles (UCAV), 163

vertical/short takeoff and landing (V/STOL) fighters, 180
Vickers Wellington, 104–107
visibility, 46, 52, 72, 81–82, 160, 162
Vought SB2U-2 Vindicator, 70–71

Westland Lysander, 72–75

MUTUALLY ASSURED DESTRUCTION 223

Quarto Knows

Quarto is the authority on a wide range of topics.
Quarto educates, entertains and enriches the lives of our readers—enthusiasts and lovers of hands-on living.
www.quartoknows.com

© 2016 Quarto Publishing Group USA Inc.
Text © 2016 Donald Nijboer

All photography © Dan Patterson except as noted otherwise.

First published in 2016 by Zenith Press, an imprint of Quarto Publishing Group USA Inc., 400 First Avenue North, Suite 400, Minneapolis, MN 55401 USA. Telephone: (612) 344-8100
Fax: (612) 344-8692

quartoknows.com
Visit our blogs at quartoknows.com

All rights reserved. No part of this book may be reproduced in any form without written permission of the copyright owners. All images in this book have been reproduced with the knowledge and prior consent of the artists concerned, and no responsibility is accepted by producer, publisher, or printer for any infringement of copyright or otherwise, arising from the contents of this publication. Every effort has been made to ensure that credits accurately comply with information supplied. We apologize for any inaccuracies that may have occurred and will resolve inaccurate or missing information in a subsequent reprinting of the book.

Zenith Press titles are also available at discounts in bulk quantity for industrial or sales-promotional use. For details contact the Special Sales Manager at Quarto Publishing Group USA Inc., 400 First Avenue North, Suite 400, Minneapolis, MN 55401 USA.

10 9 8 7 6 5 4 3 2 1

ISBN: 978-0-7603-4956-4

Library of Congress Cataloging-in-Publication Data

Names: Nijboer, Donald, 1959- author.
Title: Fighting cockpits : in the pilot's seat of great military aircraft from World War I to today / text by Donald Nijboer ; photography by Dan Patterson.
Description: Minneapolis, MN : Zenith Press, an imprint of Quarto Pub. Group USA Inc., [2016] | Includes bibliographical references and index.
Identifiers: LCCN 2015051053 | ISBN 9780760349564 (hardcover)
Subjects: LCSH: Airplanes, Military--History. | Airplanes--Cockpits.
Classification: LCC UG1240 .N54 2016 | DDC 623.74/6409--dc23
LC record available at http://lccn.loc.gov/2015051053

Acquiring Editors: Elizabeth Demers, Dennis Pernu
Project Manager: Madeleine Vasaly
Art Director: James Kegley
Cover Designer: Rob Johnson, Toprotype, Inc.
Layout: Karl Laun

Front cover: Boeing B-29A Superfortress, New England Air Museum
Endpapers: Shutterstock/Ensuper

Printed in China